✦ GHOSTLY RUINS ✦

I met a traveler from an antique land

Who said: 'Two vast and trunkless legs of stone

Stand in the desert. Near them, on the sand,

Half sunk, a shattered visage lies, whose frown,

And wrinkled lip, and sneer of cold command,

Tell that its sculptor well those passions read

Which yet survive, stamped on these lifeless things,

The hand that mocked them and the heart that fed.

And on the pedestal these words appear—

"My name is Ozymandias, king of kings:

Look on my works, ye Mighty, and despair!"

Nothing beside remains. Round the decay

Of that colossal wreck, boundless and bare

The lone and level sands stretch far away.'

Ozymandias

Percy Bysshe Shelley

Ghostly Ruins

America's Forgotten Architecture

Harry Skrdla

Princeton Architectural Press, New York

To Marilyn and Elizabeth, who followed me down into the Niagara Gorge
without knowing what they were getting into.

Published by

Princeton Architectural Press

37 East Seventh Street

New York, New York 10003

Visit our web site at www.papress.com.

Acquisitions Editor: Clare Jacobson

Editor: Scott Tennent

Designer: Jan Haux

Special thanks to: Nettie Aljian, Dorothy Ball, Nicola Bednarek, Janet Behning, Becca Casbon, Penny (Yuen Pik) Chu, Russell Fernandez, Sara Hart, Mark Lamster, Nancy Eklund Later, Linda Lee, Katharine Myers, Lauren Nelson, Jennifer Thompson, Paul Wagner, Joseph Weston, and Deb Wood of Princeton Architectural Press

—Kevin C. Lippert, publisher

Skrdla, Harry.

Ghostly ruins : America's forgotten architecture / Harry Skrdla.

224 p. : ill. ; 26 cm.

ISBN-13: 978-1-56898-615-9 (alk. paper)

ISBN-10: 1-56898-615-7 (alk. paper)

1. Photography, Artistic. 2. Abandonment of property—United States—Pictorial works. I. Title.

TR655.S58 2006

779.092—dc22

2006010357

❧ *Contents* ❧

Chapter 7

REINCARNATION

Chapter 8

EPITAPHS

INTRODUCTION

I.

This is a book of bones.

Between these covers lie the vast skeletal remains of thirty enterprises which, rather than having the decency to vanish when their time was past, have lingered on as crumbling, petrified remains.

Poe or Lovecraft would have cherished these places. The prevailing climate is one of damp and chilly darkness. The prevailing mood is somber and desolate. If we believe in ghosts, then these are the places we would expect them to walk. And if we profess not to, we might still find ourselves looking back over our shoulders—just in case.

These sites are neither foreign nor ancient. The ruins of Europe and the East are somehow unreal to us. They are the fairy tale castles of bedtime stories, the Coliseum of Ben-Hur and the pyramids of Elizabeth Taylor's Cleopatra. They were built by beings so distant from us, both geographically and chronologically, that their builders may as well have been the aliens of Verne or Wells.

No, these places were created by our grandparents, or their parents, to perform functions and fulfill needs that we can understand. That they still survive, even in advanced states of decrepitude, is perhaps surprising. But it shouldn't be. Because one thing our ancestors did have in common with the ancients was their desire to build for longevity—not the eternity of the pyramids nor the millennia of Rome, perhaps, but for the foreseeable future, certainly. That these structures outlived their usefulness is to the credit of their builders, for in most cases the factors that combined to overwhelm them were beyond their creators' ability to foresee.

Automobiles proliferated and railroads ceased operation, their cavernous terminals and ravine-spanning trestles forgotten. Private fortunes succumbed to the vagaries of Wall Street and evaporated, leaving empty the palatial mansions of marble and granite once intended as dynastic seats—now reduced to ivy-covered shells. Technological advances rendered giant steam engines, Bessemer converters, and dynamos obsolete, though sometimes their massive cast-iron frames still loom in the darkness of forgotten powerhouses and factories. Population centers shifted, and almost before they knew what was happening, theaters, department stores, and hotels, left without customers,

closed their doors. Ultimately, inescapably, fire and water took their toll. From spark to blaze to inferno, the crimson flower blooms rapidly, and seldom can man-made structures withstand its terrible spread. Water, its polar opposite, is just as blindly destructive. Rain seeping into long-neglected roofs performs the structural equivalent of the Chinese water torture, slowly, inexorably, eroding its way through a building's fabric until we are left with only the deranged and ruined remains.

The bones.

There are literally hundreds of thousands of abandoned buildings across the United States, if we count every gutted inner-city bungalow, rust-belt factory, and turnpike-exit gas station. The city of Philadelphia alone claimed 54,000 abandoned buildings in the year 2000; Detroit and Baltimore an optimistic 10,000 and 15,000, respectively. Most of these derelicts are familiar and prosaic: houses by the thousands, groceries, dime stores, gas stations, fast food restaurants, factories, strip malls—as mundane and undistinguished as a Bic lighter crushed on the sidewalk, and for the most part just as interesting. They inspire no awe or sadness or fear. They evoke no emotion at all. Not even curiosity. We don't know why they are abandoned, and we don't care.

But there are exceptions...

II.

Picture this:

It's a summer night. You and your date are driving down a secluded back road, looking for a little privacy along an unfamiliar route. You pass by the last outpost of life: an old power plant sulking behind its towering coal piles, its silhouette dimly outlined by dirty vapor lights.

As the dull roar of its boilers fades into a silence broken only by the chirping of a million crickets and the crunch of gravel beneath your wheels, you glimpse the shimmer of moonlight on the lake directly ahead.

"Perfect," you think.

The road is straight and the way dark as the tall roadside grass is replaced by trees. You're in the woods now, but the lake is visible just ahead, and at its edge a small clearing just big enough to turn around in.

You decide to take advantage of the view and wheel the car around to the left, so that the lake is clearly visible thorough a gap in the high grass and reeds. But as your headlights sweep across the forest edge, you see why there is a road here, in the darkness at the edge of a lake, in the middle of nowhere.

You stop the car—but not the engine—and the two of you stare with widening eyes at the ruined stone and concrete pillars of entrance gates tilting crazily in the headlights' glare; the bent and overgrown ornamental iron fence, and in front of the fence, a long-extinct streetlight high on a toppling utility pole, its transformer dead and its wires dangling ineffectually toward the ground. Behind it, above the gate, an iron sign once lit by this long-extinct fixture proclaims: "Camp Lady of the Lake."

A weed-choked road leads through the ruined gates and vanishes into the blackness beyond.

Chills crawl up the back of your neck as you and your date exchange a wordless glance.

You lock the doors.

Or picture this:

You see a house.

It's twenty-five years ago, on a nondescript country road outside of a small Midwestern town, and next to the road stands a brick house. It's a ranch-style, probably built while Eisenhower was in office. Its front door is closed. Its garage door is also sensibly shut, and no car occupies the driveway.

There are similar houses nearby, but this one is different. The plate-glass picture window is scarred by a large, almost perfectly circular hole in its center, as if the victim of a well-thrown stone. Spider web cracks radiate from it. The lawn is overgrown and weed-filled, and the concrete driveway, incredibly, ends short of joining the street. The gap between is filled with grass, and in the only sign of human intervention, rocks have been piled at the end to prevent its use.

Sometime later, you ask a friend who has lived all his life in the town about the house.

He says it was once the home of a young married couple and their child. He doesn't know much about them—it was before his time—except that their lives ended suddenly and tragically in the rending metal and shattered glass of a car accident. Afterward, their grief-stricken parents closed up the house, refusing to sell or demolish it. So there it stood.

Years pass. You think of the house sometimes and wonder what ever became of it. Did a subsequent generation sell it? Was a new family living there, unaware of the sad fate of the original occupants? Or was there no more house, but only a grassy lot where it had once stood?

Then one day, while driving an unremembered back road, you find yourself there again; not realizing until you are upon it, that this is the spot and that there, off the road

in the twilight, is the severed driveway—refusing all cars because of the one that will never return. And at its end, the closed garage door of a nondescript brick ranch house with a large, almost perfectly circular hole in its plate-glass picture window. Unrepaired. Empty.

Or how about this:

You're a child riding in the car with your grandmother. It's a pleasant spring afternoon many years ago. Your trip, perhaps to a relative's house, has taken you to the semi-rural outskirts of the city; to a landscape dotted with farms, greenhouses, and the occasional roadside stand.

As you watch the passing scenery through your open window, slowly something different begins to take shape. Instead of the steady parade of trees and houses, a park becomes visible through occasional gaps in the greenery.

Sensing your interest, your grandmother slows the car.

A long, grassy road leads back into the grounds. It has obviously seen little use. The park itself is odd. It is mostly grass, but is dotted with an assortment of wooden buildings of various shapes and sizes; all apparently boarded up and long neglected.

Although curious, you are unable to make sense of it until, through the new vista afforded by a sudden retreat of the last obscuring trees, you see... what? It looks like the standing skeleton of some huge extinct saurian. Is it a railroad trestle? No.

It's a rollercoaster.

It's a rollercoaster, but this one isn't open for business, nor will it ever be again. Its dark wooden spine towers half-obscured in the underbrush, and parts of it are either missing or hidden by the forest gloom. But the sinuous curve of track arcing through the trees on its elaborate latticework of bents and bracing leaves no doubt as to its purpose.

Your grandmother explains that the amusement park closed down years ago after a fire damaged the rollercoaster and gutted several other buildings and attractions. The rollercoaster was renowned, it seems, for being one of the most thrilling in existence. In those days there was less worry about possible danger to the customers, and the Cyclone, for that was its name, plunged and rocketed and whipped its riders with such ferocity that several had to be taken to the hospital, victims of its manic contortions. On one occasion the city actually ordered it closed and demanded that changes be made to curtail its potential for mayhem. Whether this was ever done has been lost to history, but it was shortly back in operation and continued to terrify white-knuckled riders until fire closed the park a few years later.

As the progress of the accelerating car carries the old park back into obscurity, you imagine what it must have been like; the smell of popcorn and cotton candy, the laughter

of children on the merry-go-round reaching out for the golden ring, whirling colored lights and music in the warm summer evenings—now only a memory.

The children become phantoms and the music an echo as the park recedes into the distance.

These stories are true, and everyone knows stories like them. So how are these places different from empty gas stations and gutted convenience stores?

III.

Although turrets, marble columns, and mansard roofs impress us, it's not the building but the story that fascinates.

Everyone has seen, at sometime in their life, some decaying old house at the end of a dirt road, some echoing shell of a former railroad station, its tracks brown with rust; some overgrown mill standing silently beside a gurgling stream deep in the woods, and wondered about it and its former inhabitants. We hunger for its story because we know that a building reflects its inhabitants and that interesting buildings often imply unusual stories. Even one of those seemingly mundane gas stations or garages may have tales to tell. After all, where did the Saint Valentines Day massacre take place?

Certainly the more spectacular the ruin, the more intriguing it is. Probably because we recognize that someone invested tremendous time and effort bringing it into existence. What powerful motivation did they have? And what terrible fate overcame them and their aspirations, that their once-grand edifice is now returning to the earth?

Buildings, it seems, often share the mortality of their creators.

We construct buildings not just as shelter, but as frameworks for life—templates within which to conduct the business of living. Each one is designed for its purpose: a place to reside, a place to bank, a place to make things. They are occupied by, and surrounded with, living, breathing humans... as long as they serve a purpose. But when their reason for existence is gone and the people drift away, only memories remain.

Paradoxically, the most important thing about an abandoned structure is that at one time it was not abandoned. A building that was constructed but never used is sterile—like a model home that is never lived in. It's bereft of the echoes of laughing children, of pencil marks on a door frame charting growth spurts over the years, of oil stains on the garage floor. A building like that is empty and lifeless. It has no soul.

No, we recognize a building, consciously or not, as a place within which there is life. That is what we care about, and that is why we are fascinated by abandoned places.

When we see photos of the wreck of the Titanic resting on the floor of the Atlantic we don't think about what is really, in the most pragmatic sense, there: tons of corroded scrap iron. What we think of is Thomas Andrews, the ship's chief designer, telling Captain Smith that his ship has no hope of staying afloat; John Jacob Astor donning evening attire and giving away his life jacket; the scores of men, women, and children in third class, trying in vain to escape from below-decks while the icy water rushes up to meet them; and of the ship's slow upending before plunging below the waves for the last time. The rusting hulk is only important because of the images it conjures. Its ghosts.

This imbuing with meaning isn't limited to elderly structures or those of frightening aspect. Consider for a moment a boarded-up 7-Eleven convenience store. It obviously belongs to that class of uninteresting buildings, right? Perhaps. But what if you know about the murders that occurred there during a robbery late one night and how the bodies of the two employees were found stuffed in the walk-in cooler the next morning? Would you shop there? It's the same building, but now one regards it very differently.

Of course we do this kind of thing all the time. It's our nature. Things are only important in how they relate to us. A piece of paper on which ink is scribbled is of little worth, if the scrawl is that of a child. But if it's the signature of a Gandhi or Hitler... that's different. But the difference is in us, not the paper.

Perhaps the ultimate extension of this is the human body itself. A few pounds of chemicals and several gallons of water comprise what is to us the most supremely valuable thing on Earth. Even when no longer animate, it is still revered. Why? Not because of the value of its constituents, but because of the meaning it holds for us, because of who and what it once was, a living being, possessed of a soul.

An abandoned building is dead—as dead as any corpse left decaying in a field. But it too once lived, was animate, and in a sense, had a soul. Except the soul was us. We gave it life and meaning, motion and warmth. We put the spark of light behind shade-lidded windows and the circulation in its corridors. It consumed supplies and it excreted waste. The thing was alive and the life force was us.

IV.

In America few buildings are really abandoned. Someone owns every square foot of real estate, and if you don't believe it, just try claiming an "abandoned" building as your own. Perhaps "unused" is a better word for what we're interested in. Certainly "ruined" describes many of them fairly well, although some are remarkably sound and could be made serviceable again without too much effort.

Whatever we choose to call them, they are ephemeral. Transitory. These structures exist in a limbo between utility and complete collapse. We encounter them during the relatively brief time before they are no longer recognizable and lose all meaning for us.

This period lasts much longer for, say, the pyramids than for our structures—we build much less robustly—but the end result is the same. Either mankind or the elements will eventually destroy them.

Occasionally some lucky few may win a reprieve and, with the help of the preservation-minded, be restored to some version of their former greatness. But these are the minority, and even after "restoration," they are never quite the same.

In even the best-intended and executed restorations, something is lost—some reality is replaced by our version of reality. The new paint is ours, not theirs. Wood floors, sanded fresh and smooth and shiny again, are like an erased blackboard, robbed of the scratches and depressions earned by years of footfalls. Brass doorknobs, their decorative surfaces smoothed by the touch of a thousand turning hands; wood paneling, darkened with age and the cigar smoke of vanished industrialists—these are part of a building's personality. The imprint of humanity. A permanent record of the people who came and the events that occurred there. Restoration, in its striving for a "perfect" version of a building, often removes these imperfections, and in so doing sterilizes it; negating the part of humans in the building's life.

Oddly, this only seems to be the case in structures that experience complete restoration. If a building is always occupied to some degree, the occupants gradually contribute their own imprint to the environment. They may repaint when the walls become too soiled, but it is their paint, not ours. A worn lock mechanism may need replacement, but only as part of regular maintenance. Continuity is maintained. Life goes on—and the building retains its soul.

Part of the charm of abandoned structures is that they are honest. They have reached the end of their lives, no matter what the cause, in their own way, and we respect them for it. They are the revered elders of their race, wearing their wrinkles without regrets. There are no facelifts here. No fountain of youth. We witness their decline and passing as that of aged loved ones, with sorrow, but because of what they mean to us, not their decrepit appearance.

V.

Have you ever stood in a building which is soon to be demolished? It's an odd feeling. Probably because we know that the place where we are standing will soon cease to exist, and that disturbs us.

It's disturbing because a building viewed from the outside is only an object; a discreet something. But a building viewed from the inside becomes a place, an environment—if large enough, a landscape. It surrounds and envelops us. A building viewed from the outside has a location in space. From the inside it is the space and we are located within it .

In many ways man has not traveled far from his primitive forebears, and for the duration of our existence we have inhabited relatively fixed, immutable environments. We exist in a terrain, be it primitive jungle or urban canyon, and track ourselves, those we love, and all others, within this landscape. Our distant ancestors understood that there would always be change: trees are felled by the wind, rivers swell in the spring, seasons come and go. The expectation of this kind of change in the objects in our environment is wired into us. But the primitive who awoke one day to find the jungle gone, would be at a loss.

Let's suppose though, that our hypothetical primitive has had occasion to roam, and has seen jungle, savannah, and desert. And let us suppose further that he is one day shot with a tranquilizer dart by some experimenter of scientific or sadistic inclination, and spirited from jungle lair to desert wilderness, where he eventually awakens. Although confused, he would quickly realize that he was now somewhere other than where he fell asleep.

We, however, are not afforded the comfort of that knowledge. Although a building that is demolished, when seen from the outside, is just another felled tree, when seen from the inside it is a whole vanished environment. It is not just a different place, but a place that no longer exists at all. Our primitive psyches were not wired for that knowledge. Where once existed a familiar home, favorite shop, or longtime office, a place whose microcosm of geography we could easily and comfortably navigate (it's out the door, down the hall, on the left...), now there is a void. Demolition robs us of place and reduces once-necessary internal information about that pace to irrelevance. In some cases the disjuncture is even more extreme. We may be aware, when admiring the view from some lofty eminence on a building soon to be destroyed, that no one after us will ever enjoy this vantage point again. We are robbed not only of the geography of the building, but the ability to view the remaining world the same way.

Wandering through a partially demolished building can be more disconcerting than seeing one vanish completely. Walking down a familiar hall to a doorway, beyond which there is nothing but empty space, or turning a corner and finding not a familiar room but a pile of rubble, renders portions of our recollected geography invalid, while taunting us with others which are seemingly unchanged. We are suddenly Rip Van Winkle or George Bailey, longing for normalcy in a now drastically altered world.

VI.

Next time you enter an abandoned building, notice how quiet it is. It's the silence of the tomb. If you have a companion, do the two of you converse in hushed tones, as out of instinctive respect? Or perhaps you are bravely exploring alone. Do you find yourself being unusually quiet, so as not to break the stillness? And is the sudden flapping of a startled bird's wings like the report of a gunshot?

Perhaps it's some vestigial, subliminal, survival instinct—to listen carefully for threats in a potentially dangerous environment. Yet, if this were an empty new building, you wouldn't hesitate to converse in loud, clear tones. Why?

It's the ghosts.

An abandoned building is rather like a theatrical set, still standing after the play's end; not yet dismantled. The actors have gone, but the flats and painted backdrops are still standing. The residual smells of makeup and paint, of perfume and sweat, still hang in the air. We feel that if we could but call the actors back in, perhaps we could see the play that was missed. But everyone is gone, and it's not within our power to bring them back. So the stage is empty and dark, but for the dim radiance of the one bare light bulb on a metal pipe stand at center stage. The fixture that theatre tradition calls the "ghost light."

It's there to keep them away.

Objectively, there is little difference between a new building and an old one. But we, as individual humans, are not objective, and we know the difference.

Perhaps its that primitive lurking deep in our subconscious again. It knows that an empty cave showing signs of past habitation is empty for a reason. Something is wrong. Why did the inhabitants leave? Or did they? We'd best examine those bones on the cave floor more closely. Wait—is that breathing we hear, way back in the darkness?

So, is our reaction to abandoned structures purely based on imagination and superstition, or do we perhaps perceive, at some deeper level, something more in the decaying walls than our five senses and conscious mind reveal to us?

Accounts of haunted buildings go back to the beginnings of recorded history. In some cases, ghosts are blamed for the abandonment. In others, such as our 7-Eleven, a traumatic event involving violence and death precipitates the abandonment and fulfills all of the requirements of a textbook haunting.

If buildings acquire value and meaning from their connection with and proximity to us, might hauntings also be a residue of occupancy? Leaked Karma in the paint? The faint, dissipating perfume of the soul?

It gives one pause.

Thankfully, it is not for us to decide here if ghosts are real. A lack of evidence has kept skeptics and believers battling it out for some time, and no doubt will continue to do so long into the future. Rather it is for us, as individuals, to decide how we feel about these buildings and their "ghosts."

The line between the ghosts of our imaginings and the possibility of real haunts seems perilously thin. Psychology and parapsychology may have to hold hands as they venture into that old, dark house together. For a person who scoffs in the daylight may have serious second thoughts in a ruined building at midnight.

We are descended from primitives, after all, and somewhere within retain those atavistic fears which must occasionally crawl out and stretch their many legs.

Remember, not all of the monsters that our ancestors thought dwelt in the dark of the forest were imaginary.

So in the end, it's up to the observer to decide. Is that dark shape in the corner only a pile of debris... or is it something else?

You see, it doesn't matter if ghosts are a real phenomenon, scientifically proven to the last decimal point. Not for our purposes. Because they exist inside our skulls, and that's what counts. And only the least imaginative among us won't feel them lurking in the shadows, just out of sight.

Perhaps that's what the structures within these pages have in common. They are abandoned—but in a sense, still occupied.

So grab your flashlight and come along. Better bring a spare—just in case. And dress warm; the stone really holds the cold and damp.

It's time to explore...

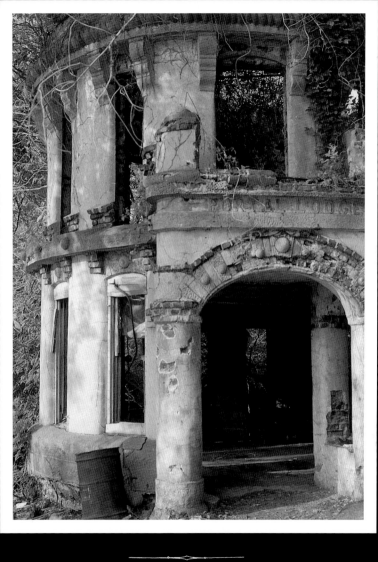

The Portal Lodge, Bannerman's Castle,
Dutchess County, New York

DISCLAIMER

This is not a how-to book for exploring abandoned buildings. Instead I hope that it will take the place of a hike through the mud to some remote site, and convey the flavor of a place without the inconvenience and danger of actually going there. I have been intentionally vague in describing the location of some of these ruins in an effort to discourage visits, which might result in damage to the structure or the visitor. Nevertheless, I know that a dedicated few will be in the car and peeling rubber down the driveway before they finish reading the introduction. So be it. But if you must go see for yourself, please keep the following in mind:

1. Someone owns these structures. It may be the state, the city, a huge corporation... or the huge next-door neighbor who keeps a loaded shotgun next to his back door.

2. Abandoned structures are dangerous. They will all eventually experience structural failures, and you don't want to be there when they do. Walls topple, roofs cave in, floors give way. Try not to experience it firsthand.

3. Exploring abandoned buildings is a great way to meet new people: junkies, derelicts, psychopaths... If you do make a new friend, don't corner him and don't let him corner you. Oh yeah, and look out for rattlesnakes... and rats.

4. Vandalism is for adolescents. If the only way you can feel important is by spray painting "Vinnie" on a limestone ashlar wall laid by men with ten times your value to society, then wait until you grow up to visit.

5. Some derelict structures are not "abandoned," but merely awaiting restoration by dedicated individuals who are even now desperately trying to raise the funds to do so. Don't make it worse. If you must visit, look but don't touch. And don't take "souvenirs."

Abandoned structures are like the dead. Show them respect.

Requiescat in Pace.

AUTHOR'S NOTE

Although time appears to have slowed to a stop in and around these structures, this is but an illusion.

In reality, the forces that brought them to this state continue unabated. Year in, year out, water trickles, freezes, and thaws. Wood silently rots. Rust thickens. Slowly, slowly the pull of gravity overwhelms the will of man. Entropy, unchallenged, always wins.

Except where otherwise noted, all of the structures in this book were standing as of this writing. But by the time you read this, some of them will certainly have vanished. Worse, the further you and I are separated in time, the fewer of these ruins will remain. Eventually this book may be but a memorial.

Very well.

Let each photo then preserve a moment in time during which things were as they are presented here. For those ruins that crumble or are crushed to dust, let this be a record of what we have wasted. For those few that may be saved and restored, let this show how far from the brink they have been dragged—and the depths of that abyss.

H. S.
2006

Chapter 1

Transportation

Imagine a vast country crisscrossed by a network of fast, efficient railroads. Hundreds of trains carry thousands of passengers in speed and comfort between villages and cities every day. In the greatest cities, terminals of monumental proportions, fashioned of marble, steel, and brass, teem with busy travelers. Their vaulted waiting rooms are never quiet, filled with the echo of footfalls and voices of the multitudes.

Within the cities electric trains are available to shuttle travelers to and from their day's business. For those who must travel to nearby towns, high-speed electric "interurban" trains whisk the commuter to and from outlying regions.

On the coasts are moored great ocean-going vessels; merchant ships heavy with cargo and luxury liners with accommodations rivaling the finest hotels. Freighters and ferries ply the lakes, while tugs escort barges through inland waterways.

That was America until about fifty years ago.

Before the automobile and the bus and truck supplanted them, steam locomotives, streetcars, and steamships held sway as our transportation of choice for over a century. They were fast and efficient; clean and modern. And while one might argue that the smoke and soot from coal-fired boilers was far from clean, we must remember that they came into a world of horse-drawn wagons and rutted mud roads. So what was a little soot? After all, a horse couldn't whisk you cross-country in palatial comfort at seventy miles per hour!

Unfortunately we are not a patient people, so the airplane killed the ocean liner. And we are a self-centered people, wanting to travel when and where we please, so the car and truck killed the train. And, unfortunately, we are a trusting people, so that when companies fronting in secret for the automobile, rubber, and petroleum interests bought up and dismantled the streetcar lines—explaining, sadly, that they were no longer profitable and had to go—and replaced them with diesel busses, we believed them.

And here we are.

So sit back, whether you're shoehorned into steerage class airline seating or trapped in rush hour gridlock, and let's explore the ruins…

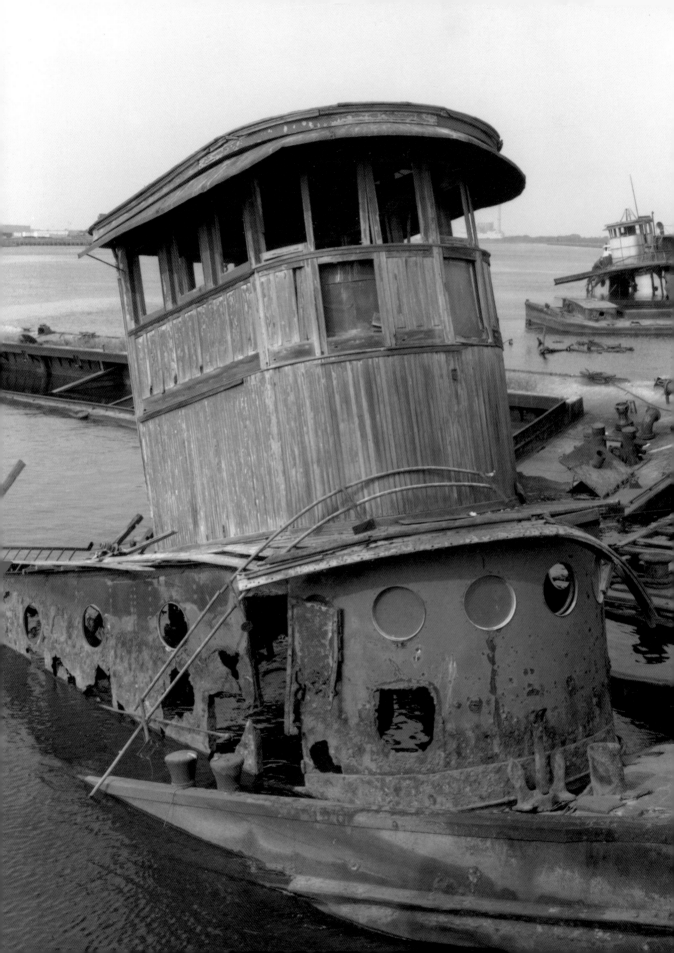

THE SHIP GRAVEYARD

STATEN ISLAND, NEW YORK

The Sargasso Sea. The name once struck fear in the hearts of sailors. It was believed that somewhere in the Atlantic Ocean a region of dense seaweed and feeble winds waited to ensnare unsuspecting ships, creating a graveyard of stranded, derelict hulks, manned only by the lifeless remains of their doomed crews.

Although the Sargasso Sea was only legend, a real ship's graveyard does exist, only much closer.

In 1931 entrepreneur and scavenger John Witte began acquiring boats and ships of all kinds for his Staten Island scrap yard. Old vessels were cheap, and it was worthwhile for him to find and store them until such time as buyers could be found for their engines, boilers, or fittings. Often these boats were elderly, even then, and the varied assortment included steam tugs, fire boats, and even paddle wheelers.

Ships floated, and sometimes sank, in the shallow waters of Witte's harbor until such time as they could be plundered for their valuable contents. But once scavenged, there was no incentive to do any more than leave their empty hulls to slowly rot in place. Because Witte never cleaned house and discouraged visitors, his inventory expanded and grew into an ever larger, ever more decrepit ghost fleet.

Decades passed. By the time John Witte died in the 1980s, over two hundred derelicts littered the shallows adjacent to his salvage yard.

His family owns the business now. And although the occasional ship is still scrapped, they are fewer and fewer. Recently an effort has been under way to thin out these rusting dangers to navigation and monuments to maritime history. But although its heyday has passed, it is still possible for the attentive traveler to spot the rusted stacks and broken spars of Witte's ghost fleet, sometimes visible through the high grasses of the Arthur Kill on Staten Island's north shore.

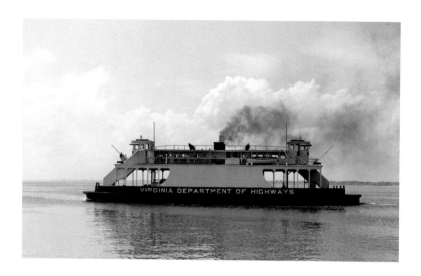

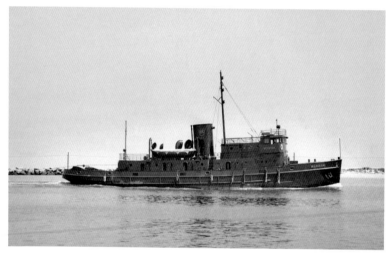

TOP: The double-ended ferry *Jamestown*, c. 1950. She and her twin the Seawells Point both had lengthy careers as car and passenger ferries.
BOTTOM: The navy tug *Bloxom*, built in 1944, would eventually see service as a tug for the Pennsylvania Railroad.

OPPOSITE
Hulks crowd the water at Witte's, c. 1980s

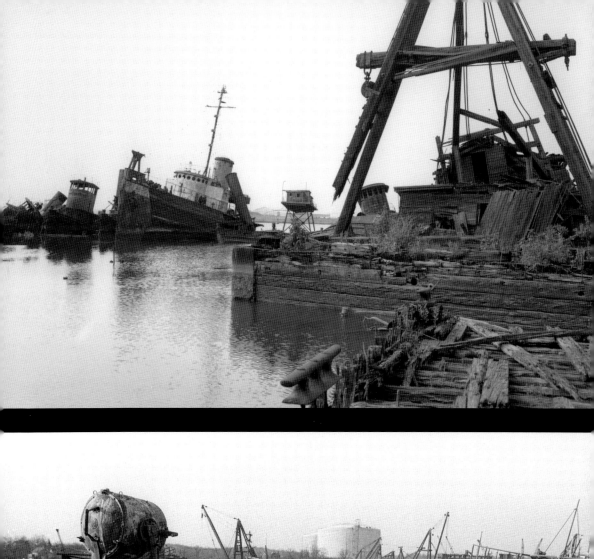
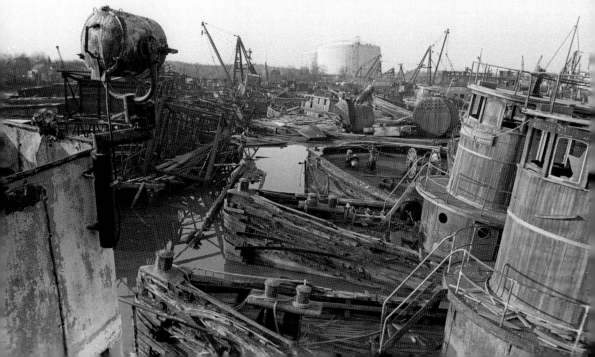

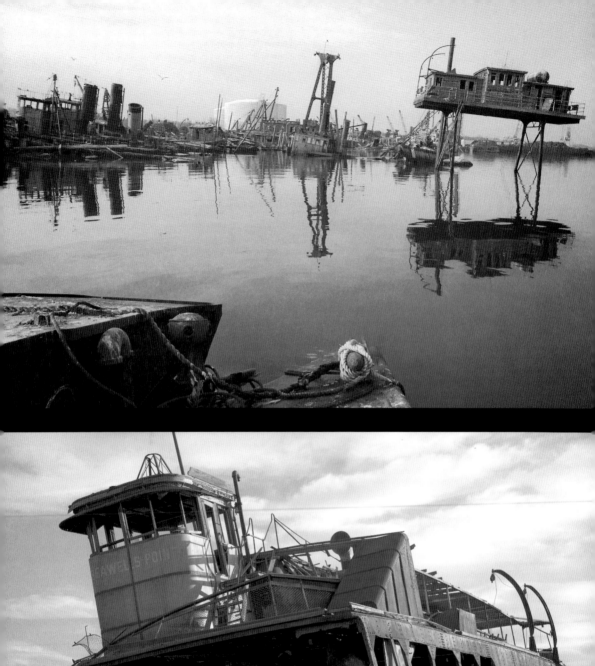
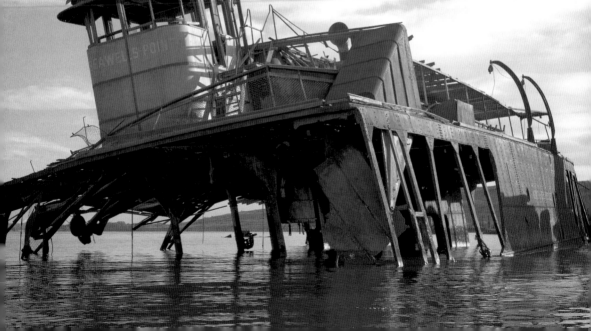

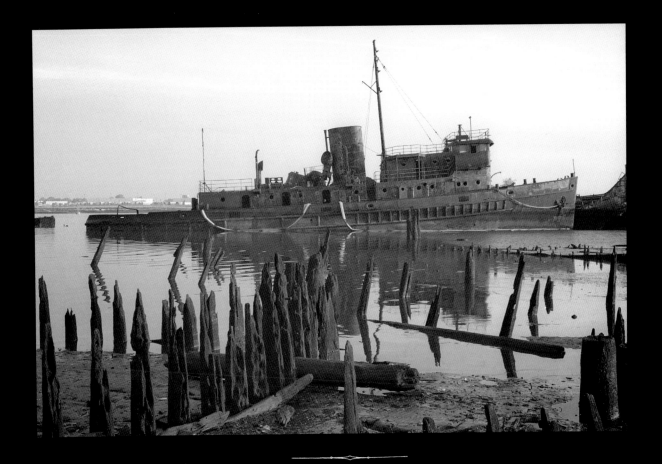

The *Bloxom*, a war hero no more.

Opposite

Top: The real Sargasso Sea.
Bottom: The *Seawell's Point*, now resting at the bottom.

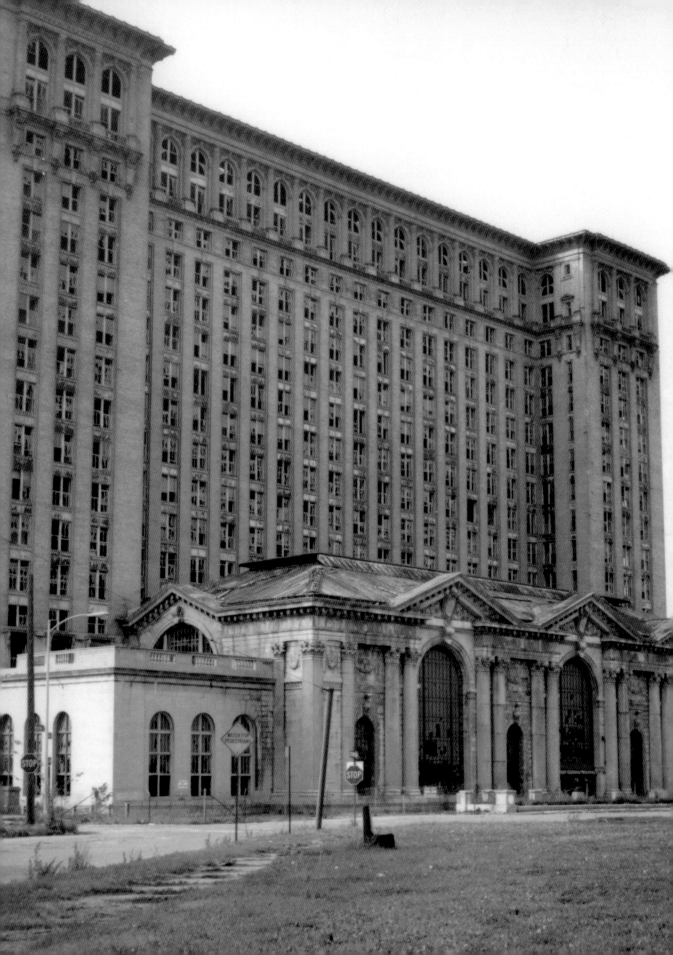

THE MICHIGAN CENTRAL DEPOT

DETROIT, MICHIGAN

The Michigan Central railroad station in Detroit opened unexpectedly in 1913. Originally its opening was planned for January of the following year, and it was essentially complete before Christmas. This proved fortunate when, on December 26, the old station, still in use, caught fire and was furiously ablaze when it was decided that the new station should be pressed into immediate service to take its place.

Designed by the same architects as New York's Grand Central Terminal, and owned by the New York Central railroad, the new station was backed by the financial resources of the Vanderbilts and designed to be as grand as any station in the country. Like the great Pennsylvania Railroad Station of New York, its main waiting room was based on the Roman baths of antiquity—only on a massive scale. The barrel-vaulted ceiling of the waiting room was over fifty feet high. The walls and floors were marble. The ladies waiting room was paneled in mahogany. It was spectacular. And above the station itself, an office building towered seventeen stories and housed the accounting and personnel offices for the entire railroad.

At its peak, sixty-four trains came and left every day and over one hundred redcaps provided service to the thousands traveling to and from one of the greatest cities in America.

But eventually the railroads faded. Penn Station was torn down and the New York Central's successor companies cut back. Despite fitful, occasional renovations, Amtrak decided, in 1988, to close the station.

Since then it has passed through a succession of private owners with a succession of grandiose, unfunded, plans. For years it has stood open and slowly succumbed to theft and the elements, until only immutable memories and vast expanses of dingy marble remain.

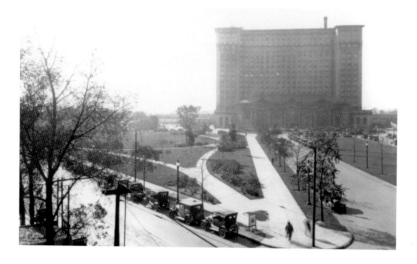

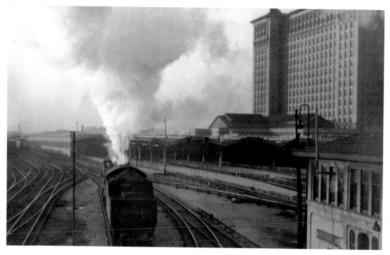

TOP: In the best Beaux Arts tradition, broad boulevards and manicured lawns lead to
the imposing station, c. 1920s.
BOTTOM: At the station's rear, a lone engine approaches the sprawling
train sheds, c. 1920s.

OPPOSITE
TOP: The train sheds still sprawl, but no engines approach them, c. 1992.
BOTTOM: Victorian ironwork supports the empty cab stand, c. 1992.

OVERLEAF
A visitor's first impression upon entering the main waiting room was one of
breathtaking grandeur, c. 1914.
Eighty years later, the same spaces echo with dripping water and falling shards of glass.

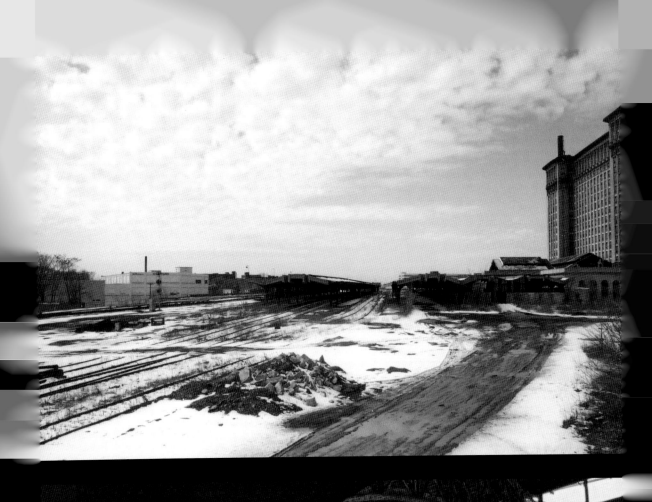

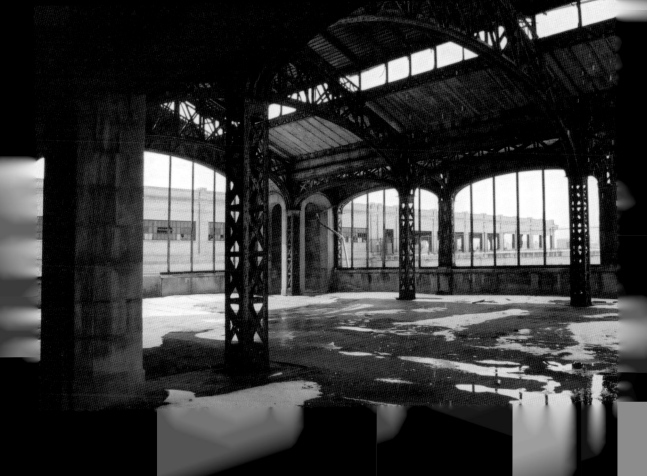

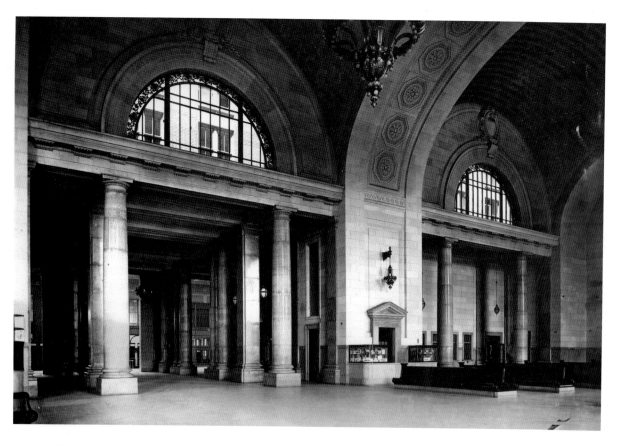

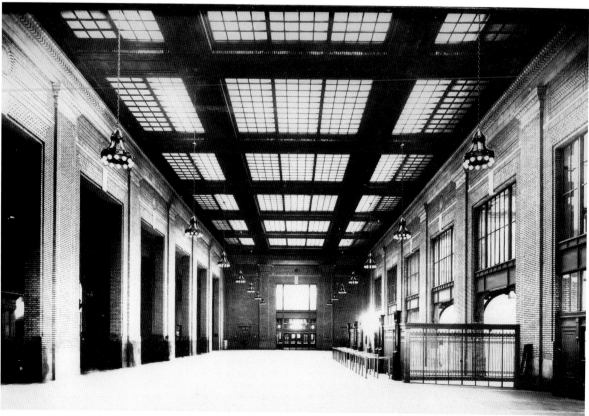

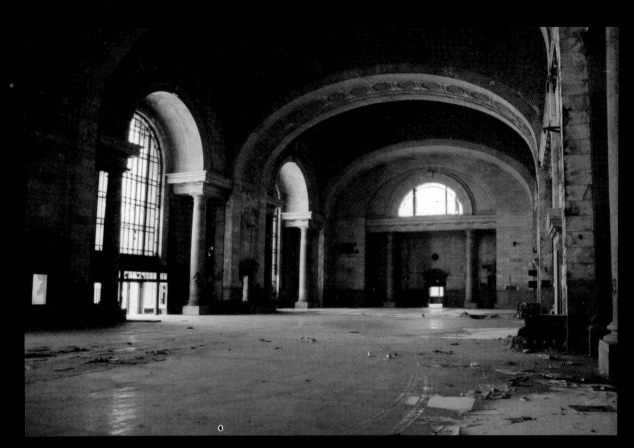

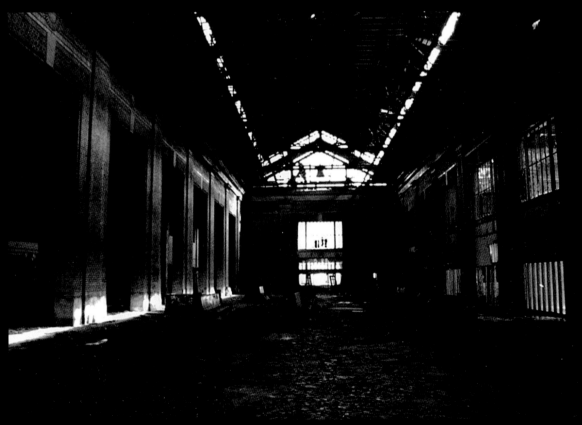

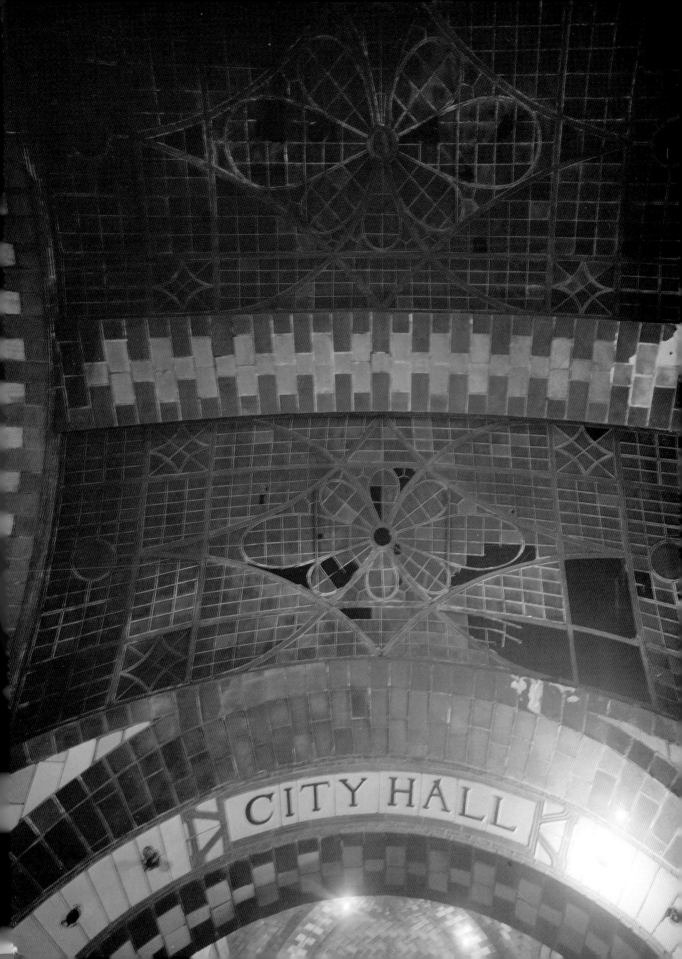

THE CITY HALL IRT STATION

Upon completion of the new Interborough Rapid Transit system in 1904, the city of New York had reason to celebrate. The new system had been years in planning and construction, and it promised to be not only a swift and practical solution to a nagging transportation problem, but a pleasant and attractive addition to the city.

The centerpiece of the system was the new City Hall Station. Although all of the stations were, by the standards of the day especially, clean, well lit, and tastefully decorated, the City Hall Station was something to marvel at.

More highly decorated and uniquely designed than any other in the system, the City Hall Station was designed by the noted architectural firm of Heins and La Farge and overseen by Spanish-born architect Rafael Guastavino. Guastavino employed terra cotta tiles in hues of buff and cream and chocolate brown to construct a curving vaulted ceiling over the tracks and platform. Three ornate leaded-glass panels admitted light from above to the center of the station, while chandeliers equipped with the new Edison electric light illuminated the rest. One writer of the time compared the effect to a "cool little vaulted city of cream and green earthenware, like a German beer stein."

When the new subway was officially dedicated, it was from the City Hall Station. It was the pride of the system.

But the City Hall Station had one major drawback: the sinuous curve which made for such an interesting design, and which was necessary because of its position as a turnaround in the system, made it impossible to use with the train cars that were introduced in later years. The large gap between the center of the longer cars and the platform immediately rendered the station unusable, except as a turnaround.

So it was to this service that the most beautiful station in the system was relegated, and which it still performs today. Its entrances were long ago sealed and its skylight covered, but it survives, in slumber, under City Hall Park.

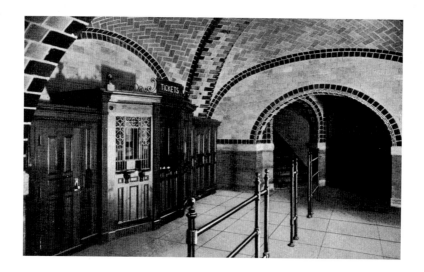

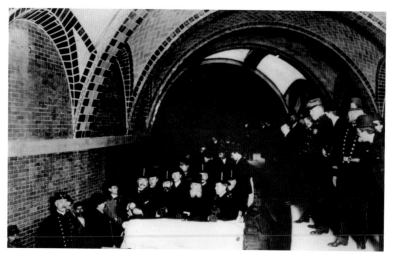

Top: Fares were paid on the mezzanine level from which a broad stair led to
the platform below.
Bottom: Dignitaries make their first official inspection of the station in February 1904.

Opposite
The mezzanine and platform, forlorn and still beautiful in 1978.

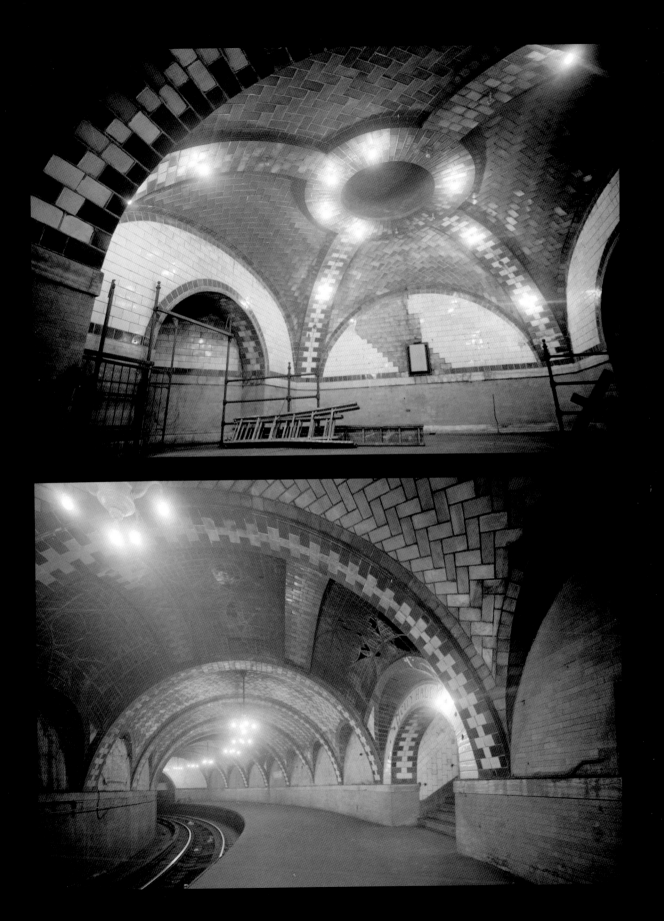

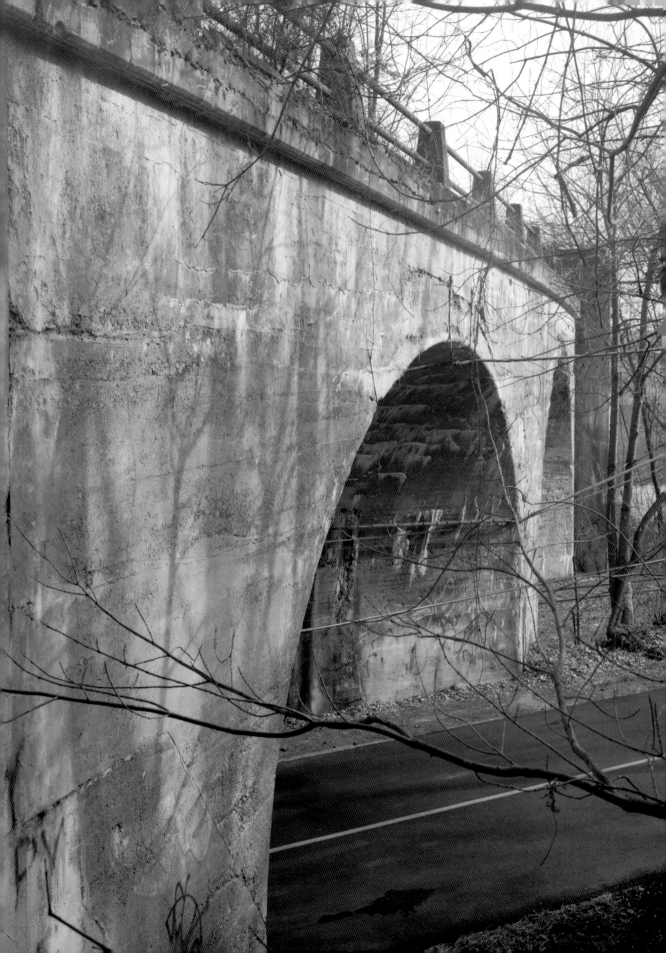

ᔰ⊦ SPANNING THE VOID ⊦ᔮ

Although bridge construction spans recorded history, the greatest proliferation of bridges began with the growth of the railroads.

The iron horse could neither ford rivers nor navigate steep inclines unassisted, so to its rescue came the bridge. But for every situation it seems that a different type of bridge was chosen; so great was their variety.

At the beginning of the twentieth century, one type of bridge that gained in popularity was that constructed of reinforced concrete. Concrete was inexpensive, strong, permanent, able to be easily molded into structural and decorative shapes, and quickly applied. The Romans had used it to good effect—why couldn't we?

So, presented here are two very similar, yet different, concrete bridges which fulfilled their function perfectly—for a time—and then were abandoned. Now they stand as poignant reminders of a time when the railroad was king, and engineering its servant.

In 1908 the Lima and Toledo Traction Company, an interurban line, constructed a 1,220-foot bridge across the Maumee River near Toledo, Ohio. The Roche de Boeuf Bridge, named after the ancient rock which the Indians had used as a meeting place, the French had named, and on which the bridge was partially constructed, was said upon its completion to be the longest reinforced concrete bridge in the world.

For almost thirty years it dutifully served its purpose, conducting high-speed interurban trains safely across the river until 1937, when the railroad ceased operation. It was briefly revived in the 1940s, after another nearby bridge failed, but this was short lived. Since that time it has stood unused and crumbling—as much sculpture as bridge.

Just as the Roche de Boeuf Bridge was being completed, construction began on a concrete arch bridge across the Delaware River, connecting Pennsylvania and New Jersey.

This bridge, part of a route diversion being constructed by the Delaware, Lacka-wanna and Western Railroad, was to be even longer, at 1,452 feet, and at sixty-five feet, much taller. It too was built of reinforced concrete, but because of its groundbreaking size, and because only five years earlier the longest concrete bridge the railroad had built was only forty feet, the design was quite conservative.

It was solid.

So solid, that even though abandoned sometime after 1976, it still stands, elegant and imposing, towering above the nearby turnpike, a striking reminder of a railroad now long gone.

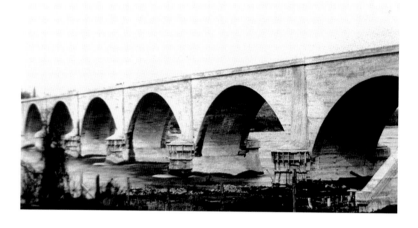

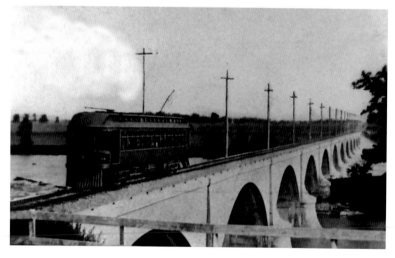

Top: Formwork is still in place as the Roche de Boeuf Bridge nears completion in 1908.
Bottom: An interurban train speeds across the newly completed structure.

Opposite
Top: More planter than bridge in 1999.
Bottom: As concrete spandrels fail, the earthen-fill construction is revealed.

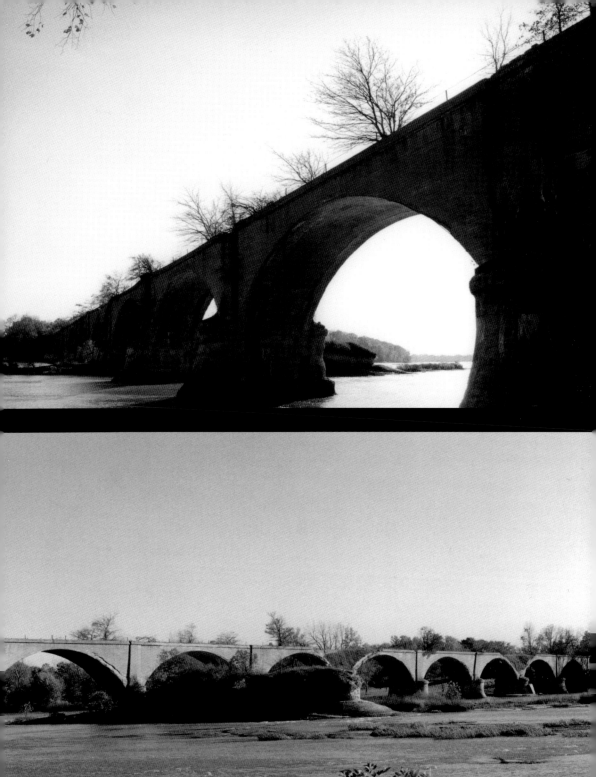

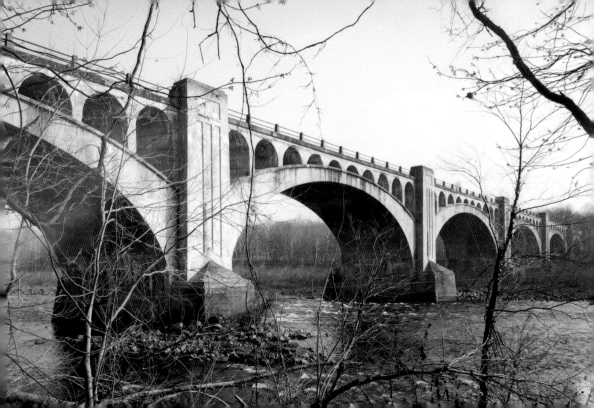

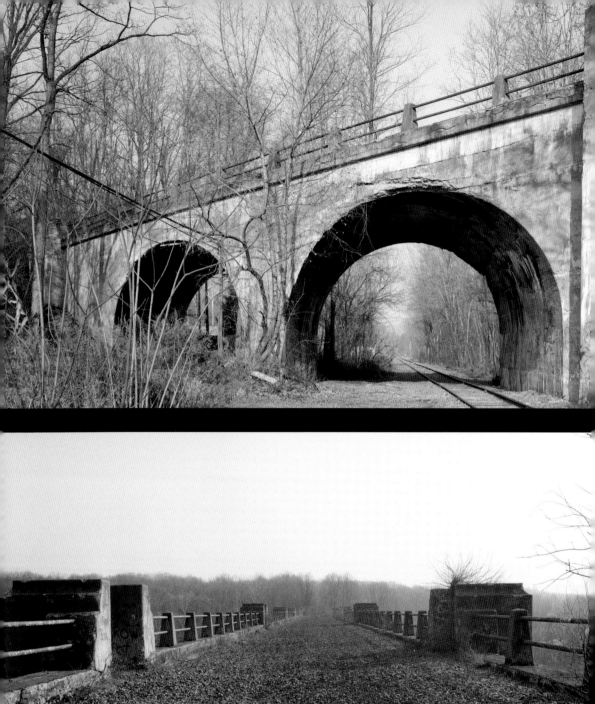
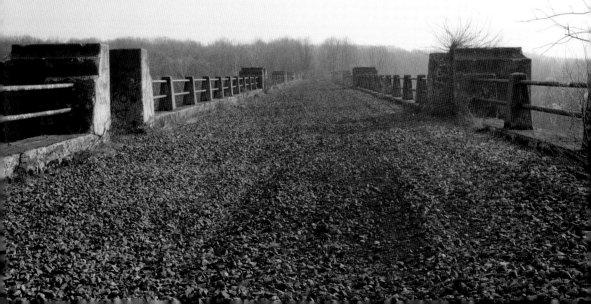

Chapter 2

INDUSTRY

Once upon a time, the United States made things. We harnessed the energy of coal and the power of mighty rivers to run factories. Steam engines spun and generators hummed and we used the electricity to smelt iron and aluminum, to light homes and shops, and to power chemical plants and mills. Cities sprang up. Cities with names like Cleveland and Chicago, Detroit and Buffalo, Pittsburgh and Newark. In these cities the iron was made into I-beams and thumbtacks and Buicks, and the chemical plants turned out dyes and plastics and penicillin. The wheels of industry turned. Cities grew. America prospered. We made everything from a pocket watch to a battleship, and we were proud of it.

But things changed. Industry, which had never worried about its byproducts, faced new laws limiting pollution. Foreign competitors, not hobbled by such laws or the need to pay their employees the high wages that American workers enjoyed, began to garner a greater share of the market. Eventually money-hungry capitalists began to move their factories overseas to take advantage of this same laxness, thus profiting at the expense of their workers and the cities that they had called home.

Now the steel mills of Pittsburgh and Cleveland are dark; their blast furnaces and coke ovens gone cold. Massive steam engines and dynamos stand still and silent, when they stand at all.

Now we live virtual lives in an "information age." We've convinced ourselves that we are somehow above the mere manufacture of goods and that only backward countries still "make" things. Gazing down from our Olympian perch, we forget that cars are still made of steel, that somewhere mills must weave the fabric for our clothes, and that even computers have to be built by someone, somewhere. It's just not us—and it isn't here.

So let's follow the old railroad siding and the fallen power lines to the base of a lonely brick chimney that used to darken the sky. Let's make an inspection tour...

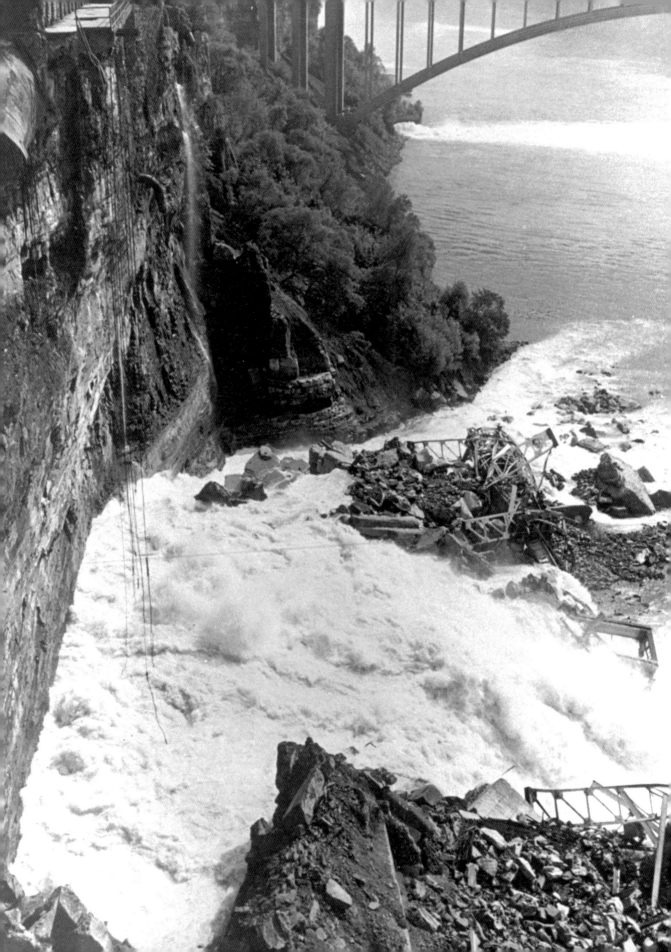

THE SCHOELLKOPF
POWER STATION

NIAGARA FALLS, NEW YORK

Upon its completion in 1925, the Schoellkopf hydroelectric plant at the base of Niagara Falls was the most powerful in the world. The last three generators installed were the largest in existence and were twice the size of the previous three, which had been, in their turn, the world's largest when they were installed five years earlier. Together the plant's nineteen generators were capable of producing 450,000 horsepower worth of electrical energy, and were doing so when, on June 7, 1956, leaks appeared in the cliff above the plant.

Workers were brought in to try to stop the water, which began to issue from more and more cracks around, and within, the plant. Ultimately, a little after five o'clock that evening, a rumbling was heard in the generator room, followed by the sound of rocks striking the powerhouse roof. As windows began to pop out of their frames, the workmen ran for the exits, and all but one were safely away when a two-hundred-foot-long sheet of rock separated itself from the cliff wall and crushed the south end of the plant. Short-circuited generators exploded, hurling debris across the river, and the ruptured penstocks inundated the rubble with a flood of water from above. The southern end of the plant, with its six generators, was a total loss.

Although much of the rubble was eventually removed by the utility that owned the site, much remains. Giant tunnels, hidden staircases, and even the half-buried, explosion-damaged carcass of one of the generators, still huddle in the debris at the bottom of the Niagara gorge.

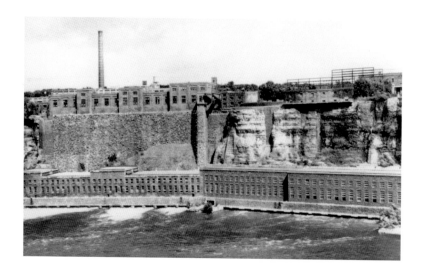

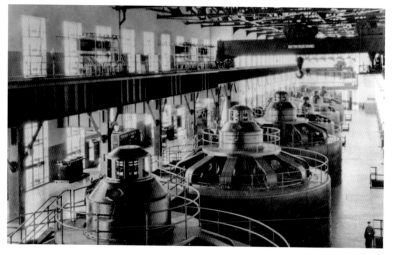

———◇———

Top: The completed Schoellkopf power plant sprawls at the bottom of the Niagara gorge.
The right half contains the newer, larger generators.

Bottom: The vast generator room as seen from the south end. The three closest
generators were the largest, the next three somewhat smaller. Those in the older half of
the plant are lost in the distance.

———◇———

Opposite

Top and Center: A tourist's camera recorded the demise of the ill-fated plant, as the cliff
gave way above it, June 7, 1956.

Bottom: A later view of the overgrown remains in the 1980s.

58

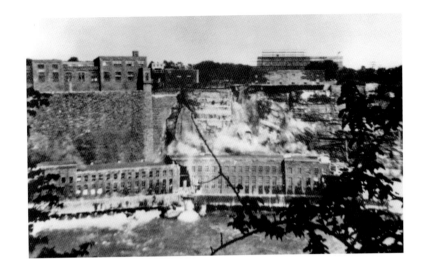

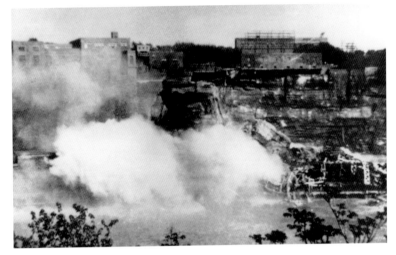

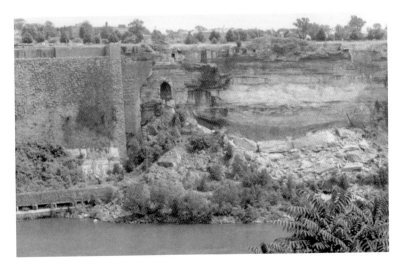

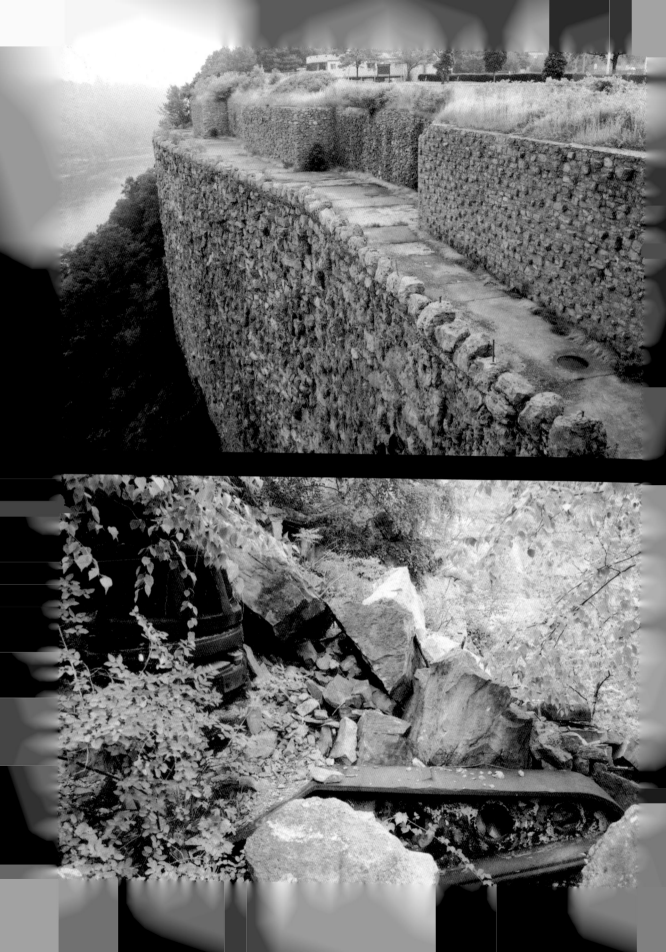

Little remains to show that the world's largest hydroelectric plant once existed on this spot. At the top of what was once the elevator shaft, from which this photo was taken, a plaque commemorates the Schoellkopf plant's contribution to history.

OPPOSITE
Top: By 2002 only the stone wall that once towered above the older half of the plant is still standing.
Bottom: The sad remains of one of the mammoth generators, partly buried under tons of rock, still resides within the rubble of the plant.

❧ THE PACKARD PLANT ❧

DETROIT, MICHIGAN

During the early decades of the twentieth century there was no finer automobile than the Packard. Movie stars drove Packards, as did royalty. Captains of industry favored their rich appointments, fine materials, and elegant design. When Henry Ford died, he was driven to his final rest in a Packard.

Although Packard began before the turn of the century in tiny Warren, Ohio, it wasn't until the factory moved to Detroit that its star began to ascend. German-born architect Albert Kahn, who would go on to build nearly all of Ford's factories, was engaged to design the Detroit plant. He tapped his brother Julius, an innovative engineer specializing in reinforced concrete construction, to perfect the building's structural design.

Only ninety days after the start of construction, the company took possession of the two-story factory complex, and in late 1903 production began. By 1911, after many additions and enlargements, the plant had grown to over 1.6 million square feet.

Throughout the 1920s, Packard's preeminence was undisputed. But by the mid 1930s, the economics of the Depression had caused a slump in luxury auto sales, and Packard was forced to focus its efforts on the design of mid-priced cars.

During the war years, Packard added a wing to the plant for the construction of Merlin aircraft engines. Despite wartime-induced shortages, by 1948 Packard's now mile-long assembly plant comprised seventy-four buildings on eighty acres and was turning out seventy cars per hour. But by this time a Packard was not too unlike a Buick or a Pontiac—hardly the automobile of distinction it had once been.

By the 1950s, Packard was in dire straits. High production costs and mediocre sales brought the company to the brink of bankruptcy. In 1954, in a last-ditch effort to survive, a merger was negotiated with the Studebaker Company, in South Bend, Indiana. In 1956, all production was moved from Detroit to South Bend, effectively ending the life of Kahn's sprawling facility. The company that had introduced such now-standard innovations as the automatic transmission, air conditioning, and power windows, was gone.

For a time, portions of the plant were leased to small manufacturing and commercial concerns, but they only occupied a tiny fraction of the vast complex. In the 1990s, the city of Detroit tried to demolish it, but was prevented by a lawsuit instituted by the property owners.

It exists now in limbo—still standing, unused; an automotive icon and an empty tribute to an era long gone.

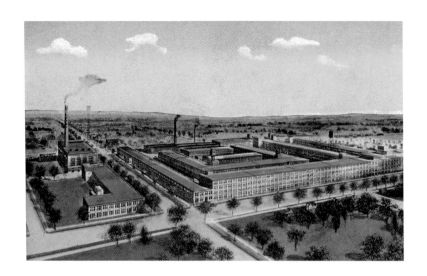

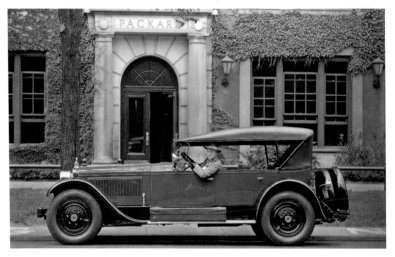

Top: A postcard shows the early portions of the growing plant. The powerhouse is on the left with the administrative offices opposite across East Grand Boulevard.
Bottom: General Billy Mitchell accepts delivery of his new 1925 2-36 "Sport Model" in front of the factory's main entrance.

Opposite
Top: Building number ten of the complex had the distinction of being the first reinforced concrete factory building in Detroit. Designed by Julius Kahn, it is shown after the addition of two stories. Much of the original plant was enlarged in this manner.
Bottom: Engines undergoing assembly travel by overhead conveyor through the sprawling plant, 1935.

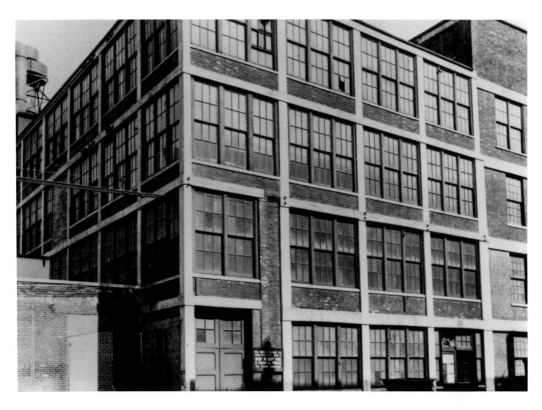

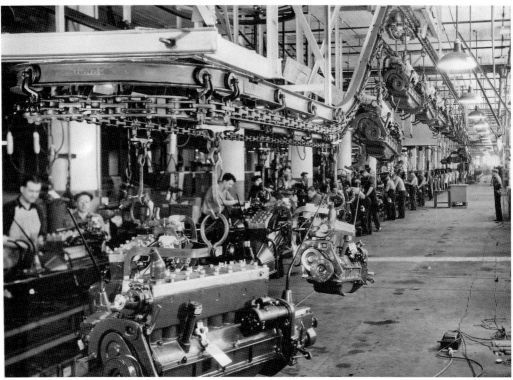

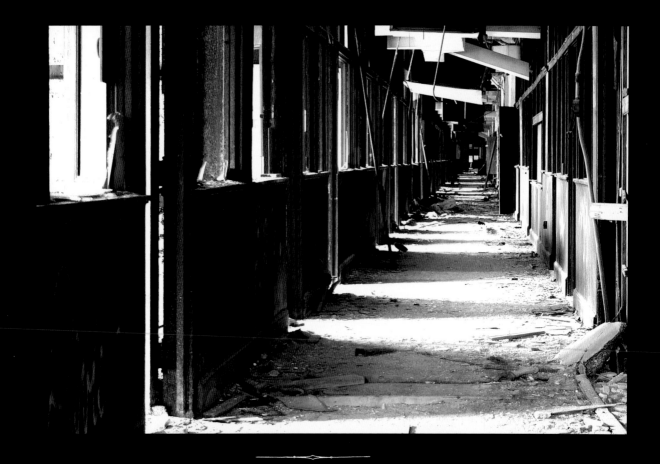

The corporate offices of one of the world's finest automobile manufacturers.

TOP: A small portion of the sprawling, desolate factory complex. The low building
on the left is building number ten.
BOTTOM: By 2004, the elegant foliage and sconces are gone, and Billy Mitchell is
nowhere to be found.

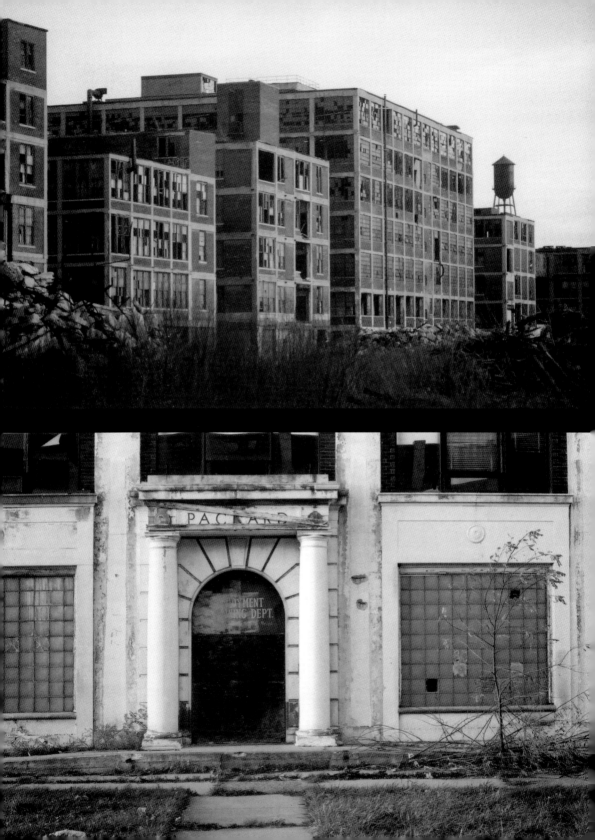

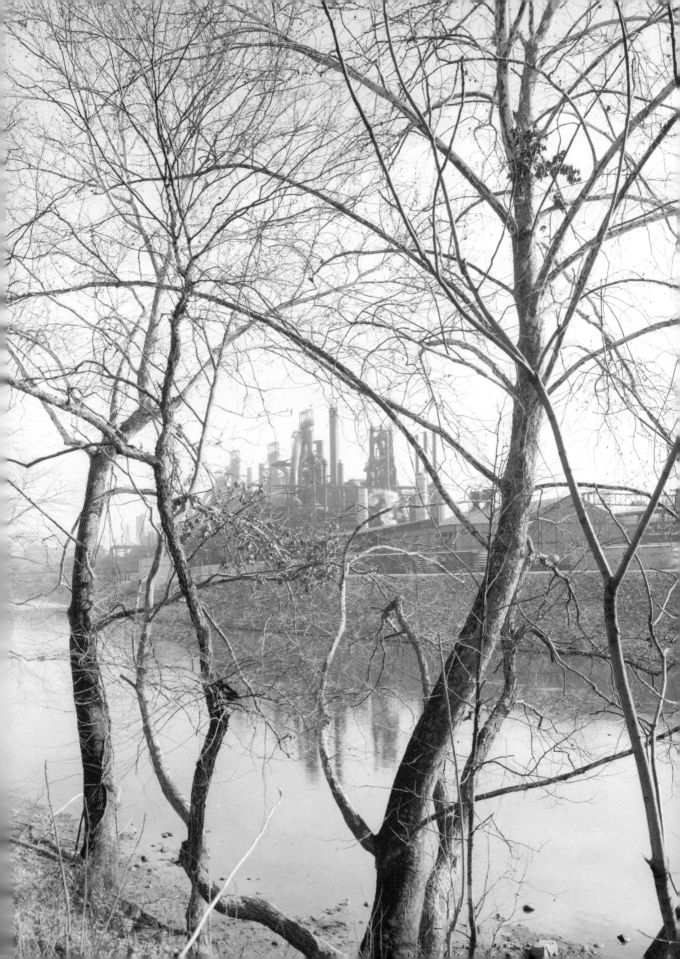

THE BETHLEHEM STEEL MILL

What does one think of when picturing heavy industry? Steel. Nothing demonstrates man's dominion over the very primal elements of nature better than a massive ladle of white-hot liquid metal, flaming and showering sparks, poured into phone booth-sized ingots. Their future might be as structural steel, railroad rails, or any other of the millions of goods manufactured from this most basic and essential of metals.

Of the great steel manufacturers, none was greater in its day than Bethlehem.

The original charter for what would become the Bethlehem Steel Company was issued in 1857, with ground broken in 1860. But disruptions caused by the Civil War delayed the start of production until 1863.

By the turn of the century the Bethlehem Steel facility was the largest in the country, producing a great variety of products, from high-speed tool steel to military armor plate and pumping engines. At that time the plant comprised 1,500 acres, seven blast furnaces, thirty-three open-hearth furnaces, seven machine shops, blooming mills, rolling mills, and a wide variety of other specialized tools and facilities.

In the 1920s Bethlehem produced much of the structural steel used in the great skyscrapers and bridges, including the Chrysler Building and the Golden Gate Bridge. During World War II, Bethlehem produced much of the armor plate and ordnance for the military. After the war, the plant produced structural steel and forgings for heavy equipment.

But fewer skyscrapers were being built, and those that were used lighter methods of construction than the more robust methods popular before the war. Gradually, lower priced imported steel, aging facilities, and increased manufacturing costs all conspired to strangle the venerable concern. By the 1980s the writing was on the wall, as operations began to cut back at the old mill.

On November 18, 1995, one hundred and forty years after steel production began at Bethlehem, it came to an end. The plant that extended four and a half miles along the shores of the Lehigh River and once employed 30,000 men was closed.

In recent years an effort has been underway to develop the former Bethlehem Steel property into a combination of retail and residential, along with an industrial history museum – preserving the old blast furnaces and portions of the steel-making complex. Soon a Starbucks or Wal-Mart may stand where mighty engines once rolled hot steel and where men toiled to help create the world we now take for granted.

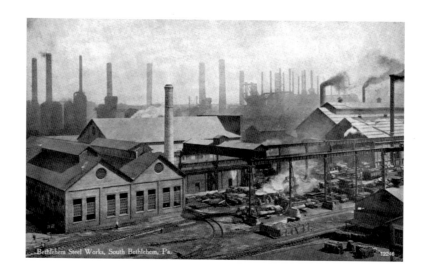

Bethlehem Steel Works, South Bethlehem, Pa.

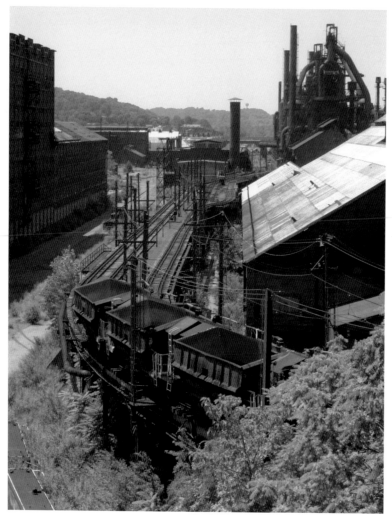

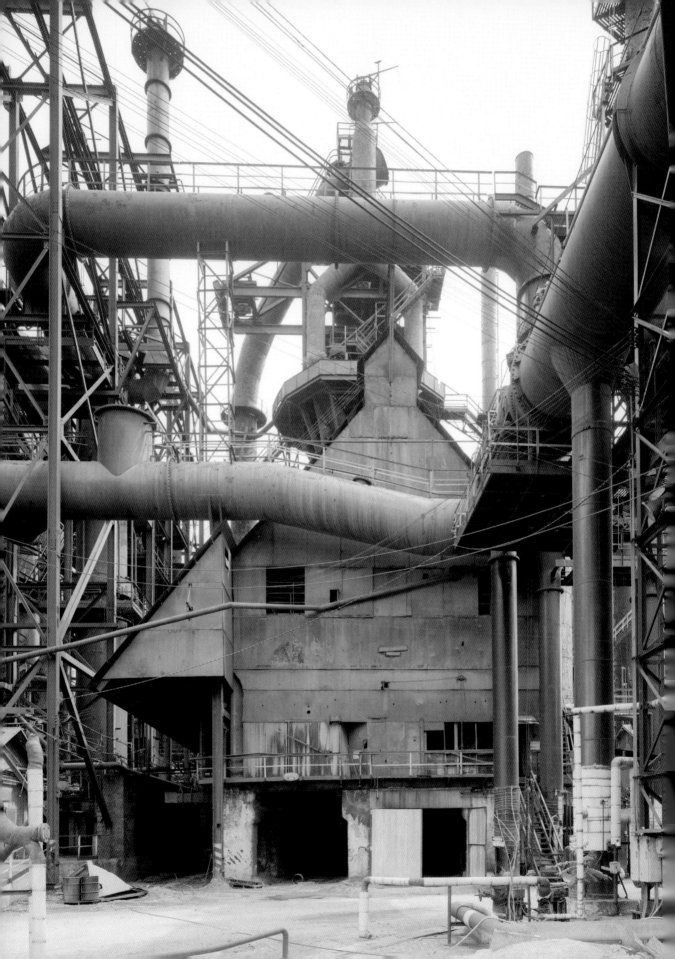

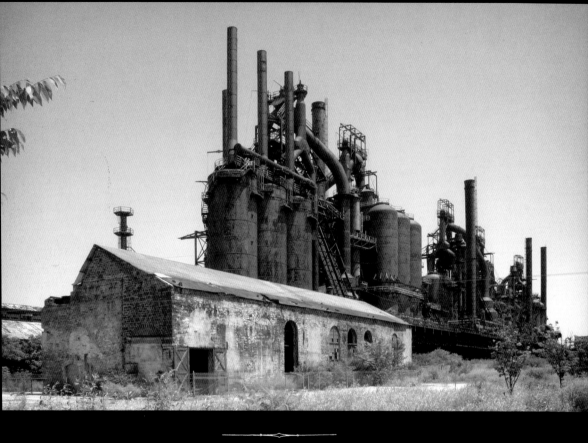

Only small portions of the complex remain in 2005.

Sunlight streams into the interior of Forge Shop No. 1 in summer, 1990.

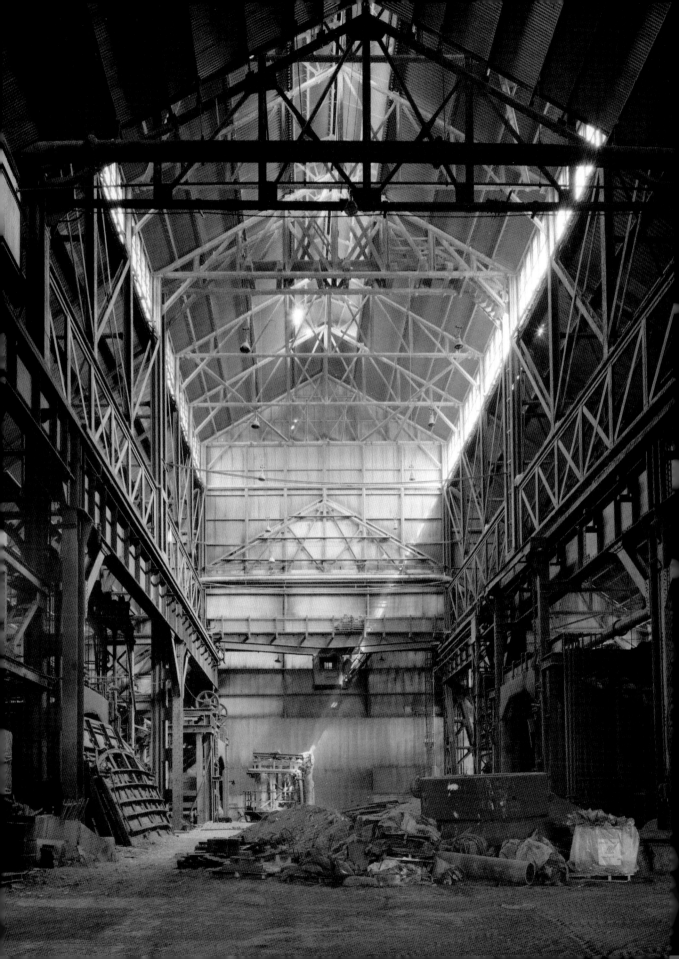

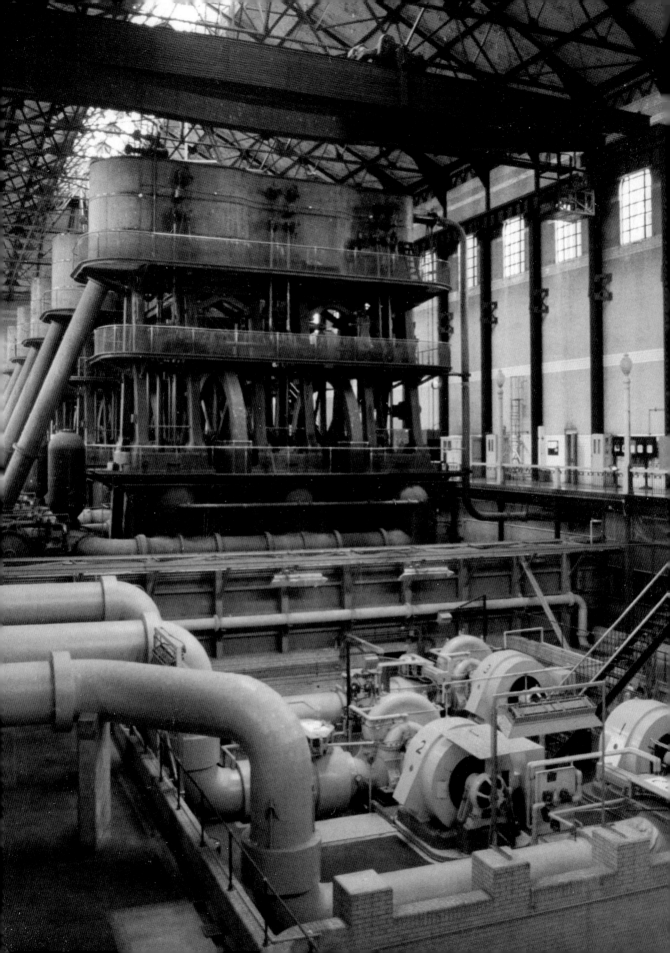

THE COLONEL WARD
PUMPING STATION

BUFFALO, NEW YORK

At the beginning of the twentieth century, the steam engine was king. When work had to be done the steam engine did it, and seemingly without effort. Because steam engines were powerful. They were heavy, true, and sometimes quite large and inefficient, compared to today's alternatives, but powerful nonetheless. So in 1909, when the city of Buffalo decided to build a new municipal pumping station to provide fresh water to its burgeoning environs, it naturally chose the only technology that was up to the job.

The Colonel Francis G. Ward pumping station, completed in 1916, was named after the then-commissioner of public works, and was the largest municipal pumping plant in the country, with five gargantuan steam pumping engines at its heart.

Built by the Holly Manufacturing Company and completed a year earlier, the engines were immense. Each one weighed over a thousand tons and stood nearly six stories tall. The flywheels alone were twenty feet in diameter and each weighed thirty tons. Individually rated at 1,200 horsepower, each engine was capable of pumping 30 million gallons of fresh water per day, 24 hours per day, 365 days a year. They were a spectacular achievement, especially when one considers that they were constructed without the benefit of today's heavy-lifting and transport machinery. They were essentially built by hand.

But as with much machinery of mythic proportions, it was efficiency and maintenance that eventually did them in. The Holly engines, built to last forever, were not as efficient as the new electric motor-driven pumps that began to gain popularity at about the same time. Steam engines required boilers, and stokers to feed them, and engineers and oilers to operate and adjust them—and electric motors did not. Just a few years after the Holly engines were installed, they were already obsolete.

But the engines were massive, and they were already there, and they worked, so they stayed. For nearly half a century they did their job. Flywheels quietly spun, valves clicked, and billions of gallons of water swirled and churned through their innards and to the city beyond. They ran until 1963 when, their duties long since rendered redundant by electric pumps, the last of the Holly engines was shut down. Although they remained operable to a limited extent for some time and, given an adequate supply of steam, could be today, they have not turned for decades.

Unused, too expensive to scrap, and still a source of awe to the men who work in their shadows, the Colonel Ward engines stand like a row of sleeping giants, only waiting—perhaps forever—to be called into service again.

The Holly pumping engines were over five stories tall, with their bases two stories below grade. The tremendous scale of the engines can be appreciated by comparing the size of the workman leaning against the pump cylinder in the lower right corner of the photo.

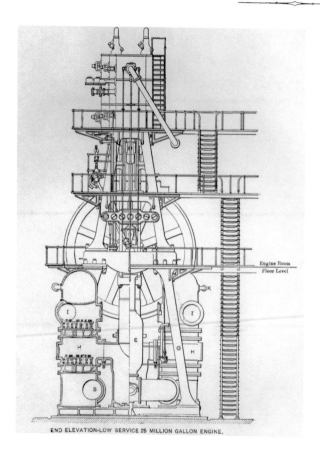

END ELEVATION-LOW SERVICE 25 MILLION GALLON ENGINE.

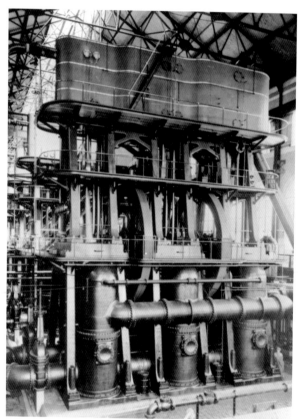

OPPOSITE

TOP: Concrete foundations for the engines being poured, one wheelbarrow at a time, c. 1909.

CENTER: The shining new 364-by-90-foot engine room with its state-of-the-art steam pumping engines, c. 1916. Space was left for three additional engines, which were never installed.

BOTTOM: An engineer adjusts the valve gear on the high pressure cylinder of one of the engines. High pressure steam was expanded in three successive cylinders of increasing size for maximum efficiency. The largest cylinder is over eight feet in diameter.

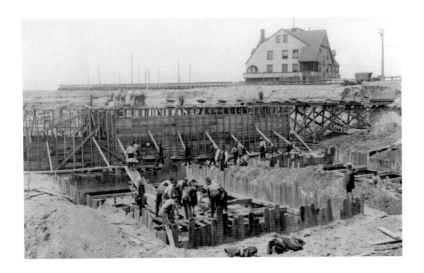

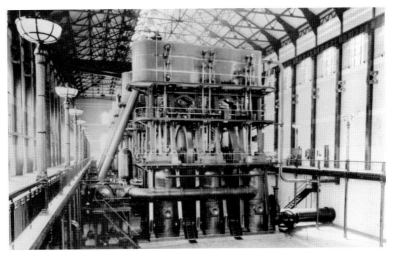

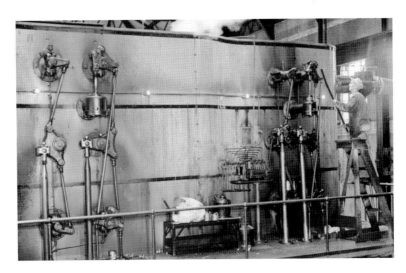

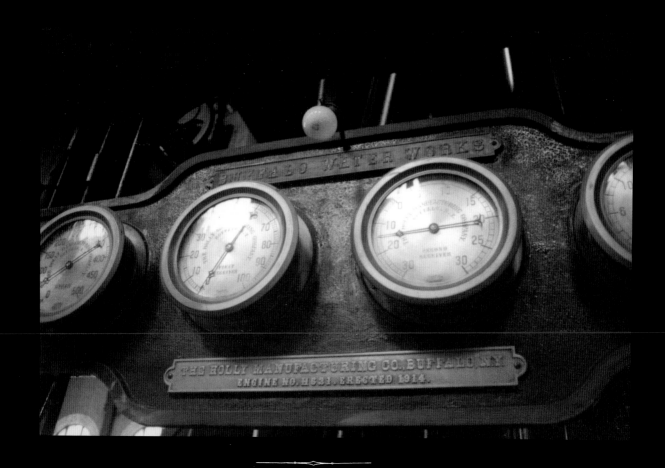

The gauges indicated steam pressures, water pressure, vacuum and revolutions.

Opposite
By the time of this photo in the early 1990s, neglect has taken its toll and the massive
flywheels have been still for nearly thirty years. Now engineers
only venture onto the vertigo-inducing cylinder heads to place poisoned grain for
the troublesome pigeon population.

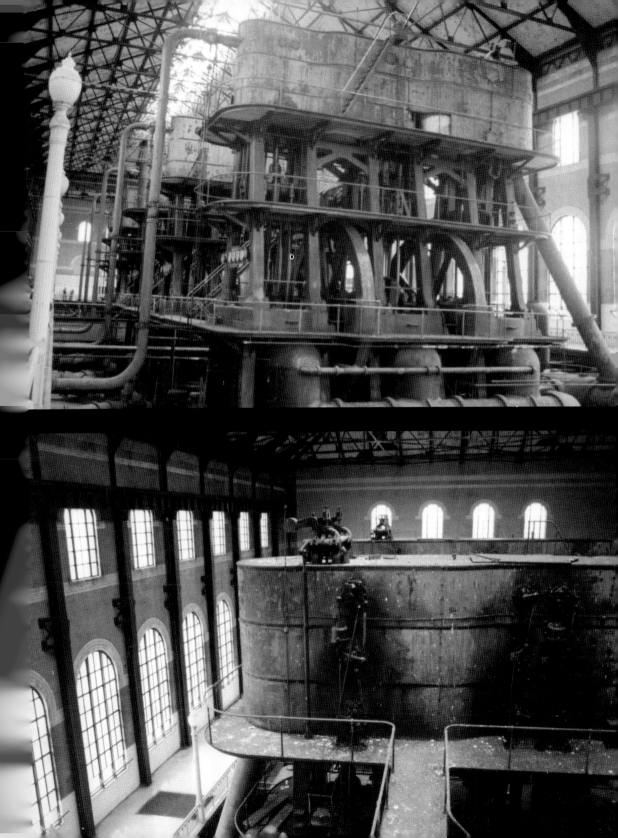

Chapter 3

Commerce

The Industrial Revolution was the engine that drove the United States to new, previously unimagined levels of prosperity. At first, water-powered mills in the north manufactured goods, and barges on the Erie Canal transported them. Later, steam engines made it possible to build factories anywhere, and the railroads took over from the canals. People were employed. Goods were produced and sold. The merchants and the buying public flourished.

Between the end of the Civil war and the stock market crash of 1929, America experienced growth unprecedented in its history. Almost overnight it was transformed from an agrarian to an industrial society, and the flood of jobs and goods fed the migration to, and growth of, the cities.

Office buildings and banking houses sprang up. Warehouses were built to store goods, and stores were built in which to sell them. Larger and more opulent hotels were constructed to service the businessmen and newly mobile middle class. Haberdashers, restaurants, drugstores, barbershops, furniture stores, bakeries, grocers—all grew and multiplied when, with a minimal investment, anyone could start a business of their own.

Although the Great Depression of the 1930s rendered commerce comatose for a bit, wartime prosperity revived it. But by the 1950s dark forces were afoot. Urban blight, racial unrest, and high taxes drove many businesses out of the cities and into the growing suburbs. Corporations increased in size, and having no vested interest in the community, based all decisions on the bottom line. Huge chains, driven by profits, reached out their invisible hands and throttled one mom-and-pop store after another. Fast food chains did their part by killing small restaurants and all but wiping out regional cuisine, homogenizing food from coast to coast. Locally owned drugstores, groceries, department stores, and hotels all withered and died in the blinding radiance of the shining new chain stores and the antiseptic purity of the mall.

Well, you get what you pay for and nothing is free. So before we motor over to the Galleria to pick up the trendy fashions du jour, let's get ourselves a processed beef byproducts burger and take a look...

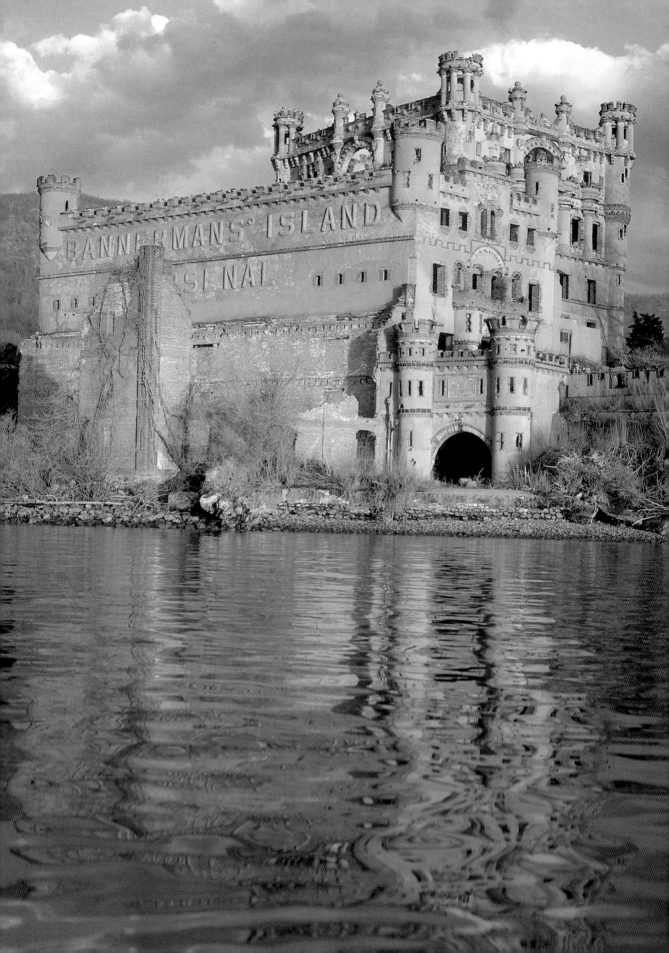

BANNERMAN'S CASTLE

DUTCHESS COUNTY, NEW YORK

In the mist-shrouded highlands of the Hudson River valley, on an island long shunned by the Indians as haunted, a ruined castle stands. Treacherous currents and hidden rocks discourage visitors, and precariously settling walls warn of peril to those foolish enough to set foot within.

Welcome to Bannerman's Castle on Pollepel Island.

Francis Bannerman VI was a Scottish immigrant who made his fortune selling military surplus acquired after the American Civil War. By the turn of the century, Bannerman's company had accumulated more weaponry than most countries, and when it eventually became necessary to warehouse his growing arsenal, Bannerman decided to move the more dangerous portions of his inventory to a safer, less populated locale. Lonely Pollepel Island, isolated in the distant Hudson River highlands, in the haunted land of Rip Van Winkle and Ichabod Crane, seemed the ideal locale.

In 1901, Bannerman began construction of what would eventually be a fantastic amalgam of castellated architecture. Slowly walls grew, capped with eclectic battlements, bristling with elaborately decorated turrets, encrusted with ornamentation that referenced Scottish baronial castles and Moorish fortifications. Bannerman employed no architects or engineers, sought no permits, and drew no blueprints, save the occasional sketch on an odd scrap of paper handed off to a stonemason or carpenter.

Building continued without pause for years. In addition to the arsenal buildings, Bannerman's crews erected workshops, breakwaters, a "portal lodge," a powderhouse and, at the island's highest point, a private residence for Bannerman and his family.

As the castle grew, so did the business. In 1900 two of Bannerman's three sons assumed responsibility alongside their father, and it was they who took control when, in 1918, with his eccentric redoubt still unfinished, Francis Bannerman died. But the business began a slow decline. A new storage facility was built on Long Island, and as law changed over time, Bannerman's became less a munitions dealer and more a purveyor of military antiques. In 1967, after years of disuse, Bannerman's left the island and its castle. In 1968 it was sold to the State of New York. In August of 1969, a disastrous fire visible for miles gutted the principle structures, essentially bringing to an end the history of Bannerman's Castle.

The non-profit Bannerman Island Trust now oversees and strives to maintain the ruin, so that it may survive to be appreciated by future generations. For now, the castle stands as another ghostly silhouette in the Hudson River highlands.

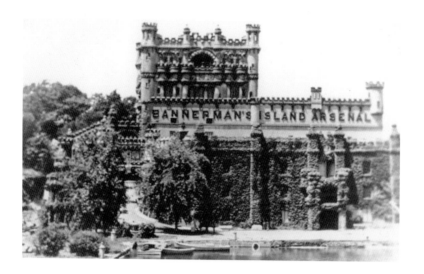

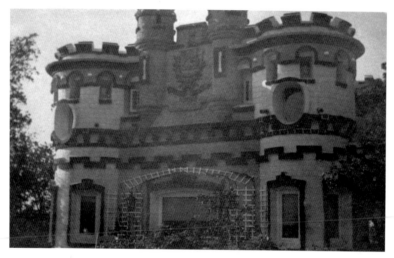

Top: The already ivy-covered face of the castle in the 1920s.
Bottom: Francis Bannerman's family residence stood at the island's highest point.
It too ascribed to Bannerman's eccentric architectural vision.

Opposite

Top: Once ivy-covered, the castle is now overgrown and empty.
Bottom: The Bannermans moved out long ago.

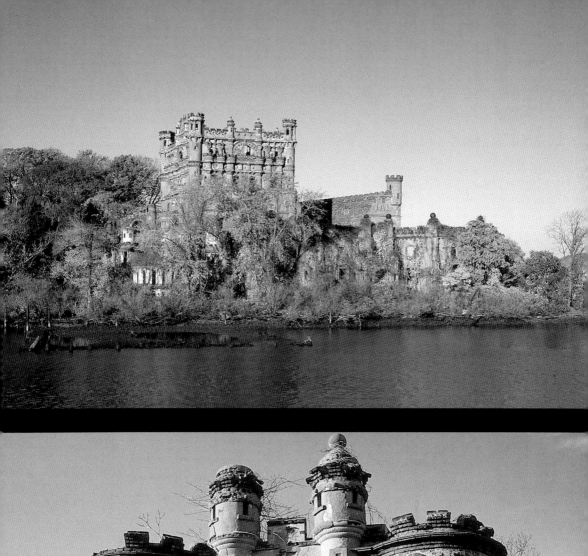
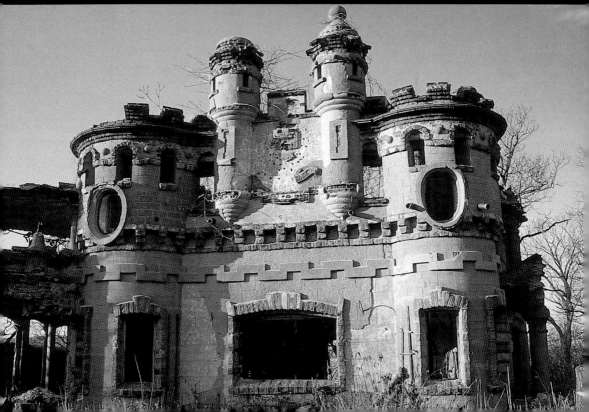

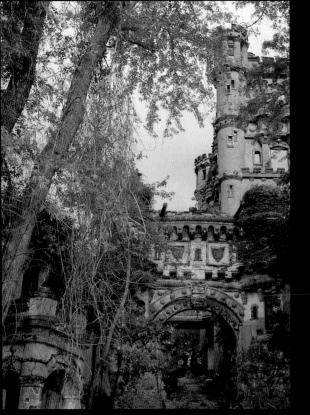

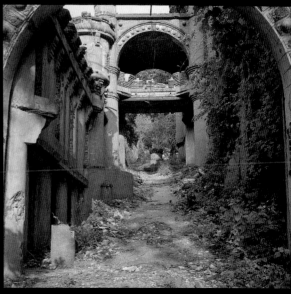

Visitors to the castle would have crossed the drawbridge and
proceeded through the portcullis to the compound within. Now the drawbridge and
portcullis are gone, replaced by rubble and weeds.

OPPOSITE
As if caught in a perpetual cry of surprise, a corner of the
Bannerman residence seems to possess strangely human features as it overlooks
the ruins below.

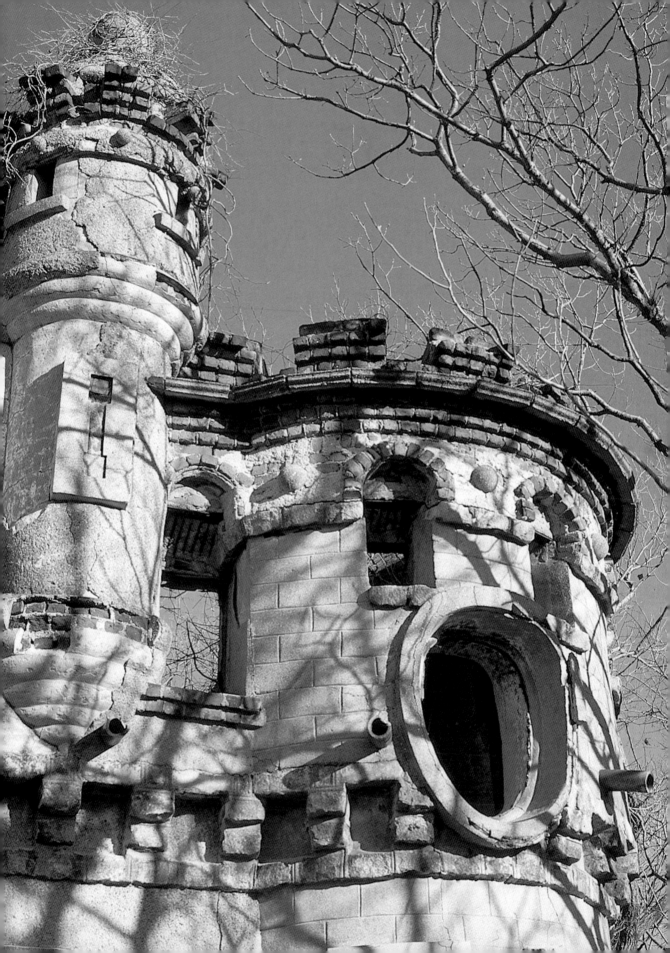

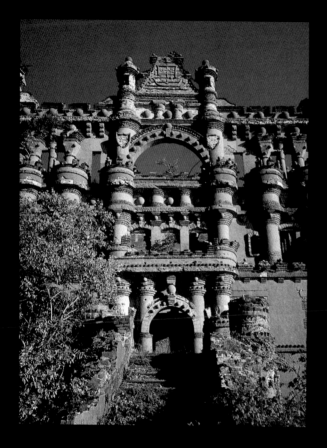

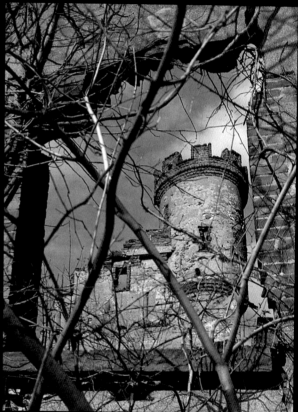

Despite explosion and fire, Bannerman's romantic vision endures.

Opposite
Of the breakwater which once provided safe harbor, only vestiges remain.

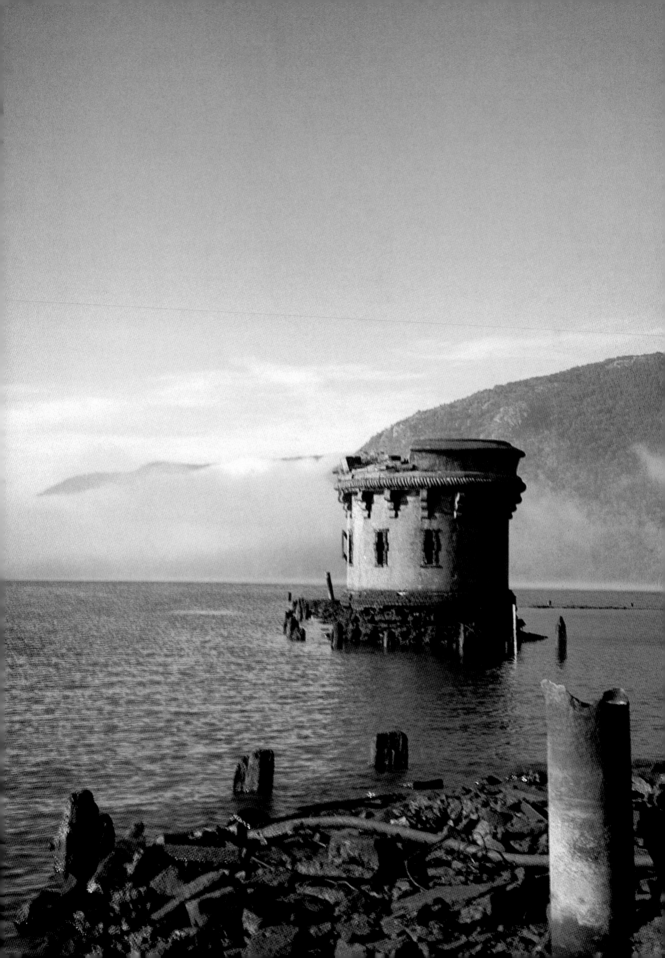

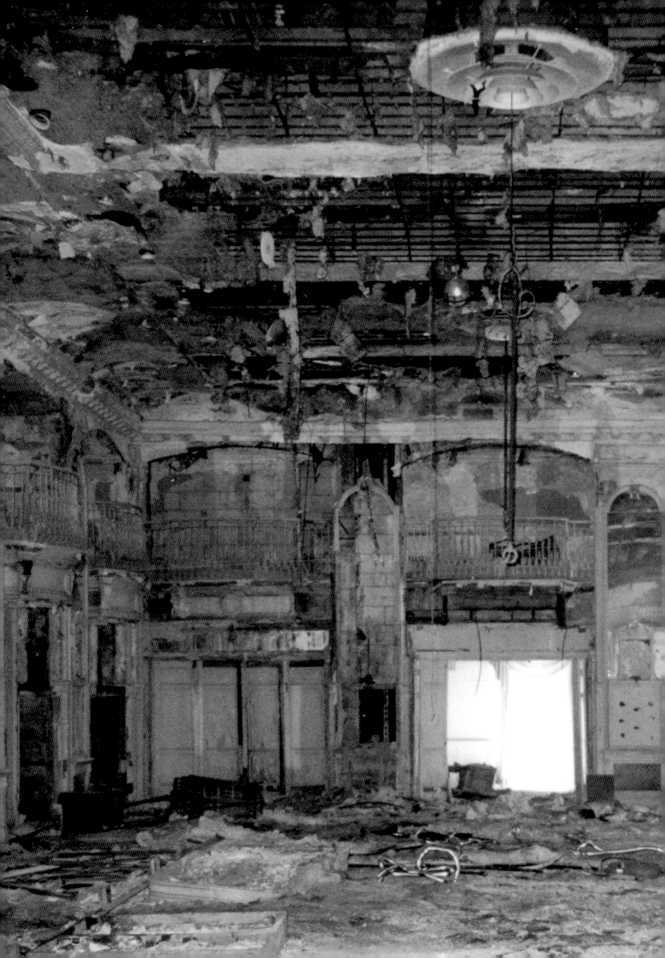

THE BOOK-CADILLAC HOTEL

DETROIT, MICHIGAN

In the days when all of America's major cities were vital and teeming with life, when the sidewalks were full and the buildings occupied, every great city had its grand hotel. Detroit's was the Book-Cadillac.

In 1922 the Book brothers asked architect Louis Kamper to design a first-class luxury hotel as part of a massive boulevard project they were developing. The hotel was intended to rival any in America in size and luxury. Kamper studied the finest hotels around the country, borrowing from them the latest in modern convenience and old world elegance. He took two years to design it, and the construction took just over one more. When the Book-Cadillac was completed and opened in December, 1924, it was a marvel beyond the dreams of hostelry.

To begin with, at 1,200 rooms it was the second largest hotel in America, and at thirty-three stories it was the tallest. From its lobby of breche violette marble, ornate iron railings, and gold-leafed ornamentation, to its wide variety of crystal-chandeliered ballrooms, wood paneled restaurants, and luxurious lounges, its appointments were unsurpassed.

Every room had a private bath—a luxury at the time—and most had a spectacular view of the city. There was a shopping arcade on the first floor, a twenty-chair barber shop, and a beauty salon, along with a children's shop and a wide variety of private dining rooms, writing rooms, a tea room, telegraph office, and even a stock exchange. There was no more complete facility of its kind in any city in America.

It was a tremendous success.

Although the Book family lost control of the hotel during the Great Depression, under new management it continued to prosper. Presidents and nobility stayed there, as did movie stars and captains of industry. But despite decades of prosperity, the golden age did not last forever. During the 1960s, the downtown population began to dwindle as businesses migrated to the suburbs. In order to appear more "modern," the hotel remodeled some of its restaurants and public areas—a move that would only prolong the inevitable. In 1984, after several ownership and name changes, the hotel closed for renovations, never to reopen.

So for twenty years it has stood empty. For a time the city posted guards to protect its treasures, but that was ultimately deemed as too expensive. So, one by one, the treasures vanished. Now no guests register at the desks. No white-tied diners sup in the vaulted, brocade-draped restaurant or waltz in its crystal-chandeliered ballrooms.

These days it keeps to itself.

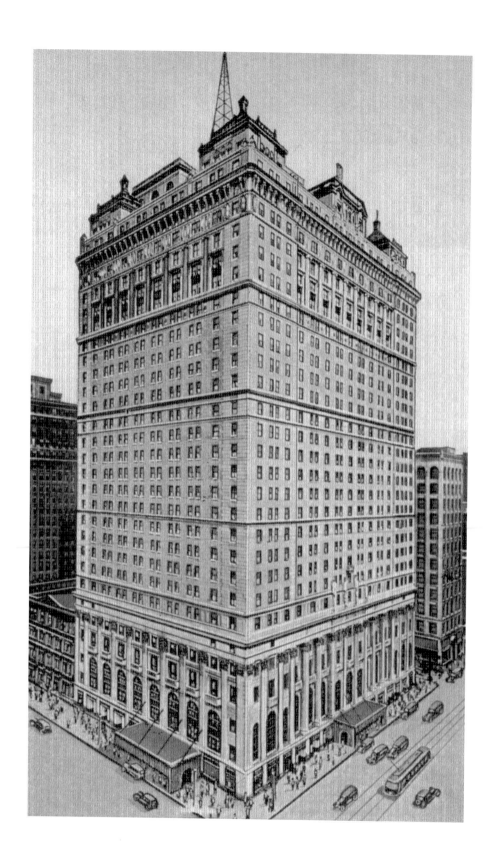

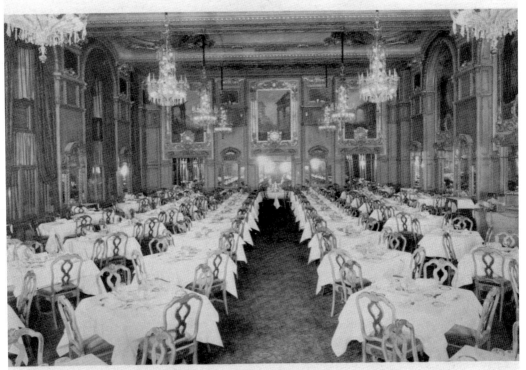

Venetian Dining Room, Hotel Book-Cadillac, Detroit, Mich.

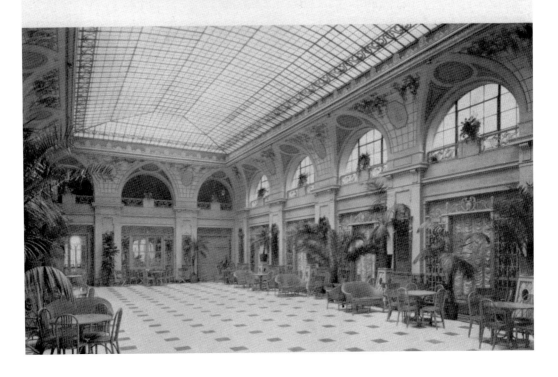

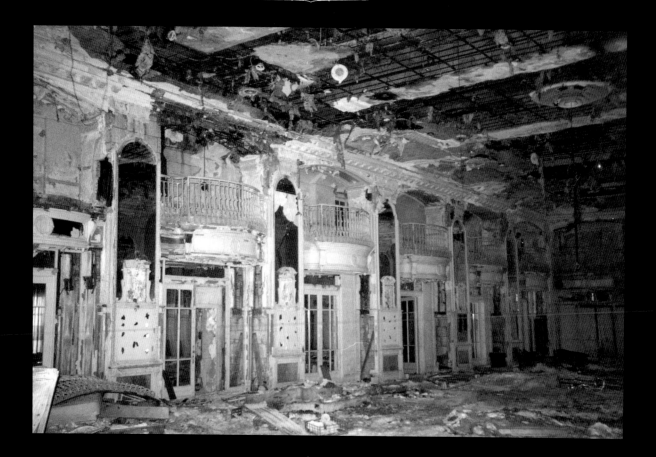

Two chandeliers, each containing over a ton of crystal, once graced the Grand Ballroom.

OPPOSITE
TOP: A grand staircase of Breche Violette marble once climbed to the lobby. Subsequent
renovations replaced it with escalators.
BOTTOM: A second staircase led from the ground floor retail arcade to the lobby. Except for
signage, it escaped the ravages of modernity. Photos c. 2000.

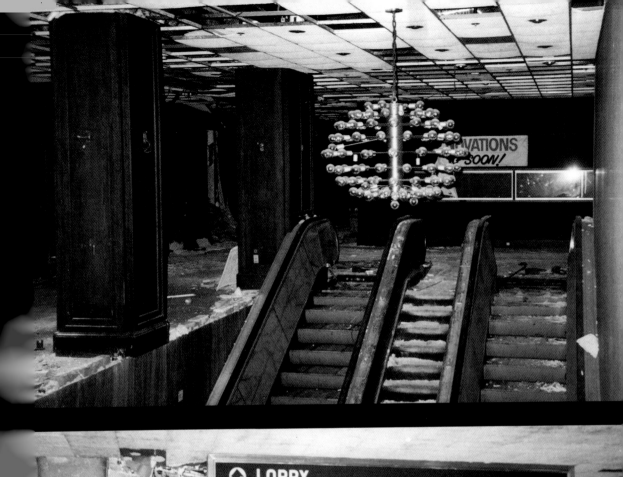

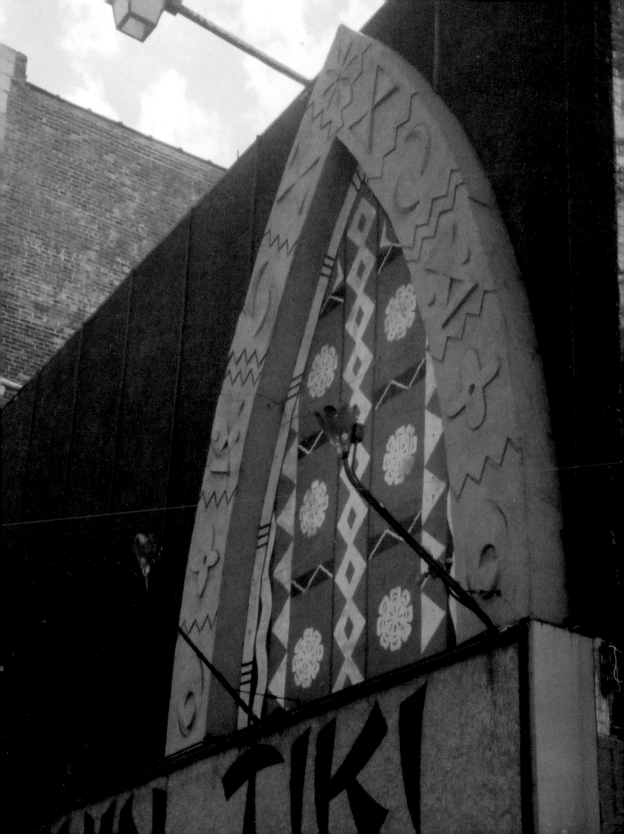

❧ CHIN TIKI ❧

DETROIT, MICHIGAN

Sometimes businesses don't die, but go into hibernation.

Marvin Chin opened Chin Tiki in 1967. Chin Tiki was a combined supper club, banquet hall, and bar, built at the height of the postwar mania for all things Polynesian.

The Polynesian craze, spawned by soldiers returning from the South Pacific with tales of strange tiki gods, grass-skirted nubiles, and luaus with roast pig, pineapple, and poi, resulted in everything from Polynesian-themed Broadway musicals to parasol-sprouting cocktails.

Tiki-themed hotels appeared, and pseudo-Pacific lounge music, and faux-Polynesian cuisine and a panoply of absurdly exotic drinks, and all manner of rattan-covered, hibiscus-garnished, deity-masked falderal, all intended to evoke the languid mystery of a Pacific island culture that never quite existed.

Into this world came Chin Tiki. Two years in the making, Chin Tiki was the ne plus ultra of Polynesian restaurants. Inside, a bamboo bridge led over a waterfall-fed stream, conducting the prospective diner to a faux-village of thatched-roof booths. The second floor housed a spacious nightclub with imitation rock walls and a rattan-covered stage. Tiki totems skulked in corners and a kayak hung from the ceiling. The frequent stage shows presented swivel-hipped hula dancers and incandescent fire-breathers, bringing pop-Polynesia to the Midwest. Barbra Streisand dined there, so did Joe DiMaggio and Muhammad Ali.

But Chin Tiki opened the year of the Detroit riots, and the hermetic world of hipster lounge music and fruity drinks was like a sealed compartment on a sinking ship. So in 1980, as the downtown lights flickered and the residents fled for the suburbs, Mr. Chin bolted the doors and went home.

For over twenty years this pseudo-Polynesian eden stood silent and dark. Palm fronds gathered dust over a dry streambed as a menagerie of exotic drink glasses stood arrayed and waiting on their shelves.

One day a few years ago, a representative of a movie studio contacted Mr. Chin about using the slumbering Chin Tiki as a film location. Mr. Chin agreed, and for a short while, passersby were startled to see Chin Tiki all lit up and open again, with crowds going in and out of its front doors. It was as if the clock had been turned back.

Afterward, a thoughtful Mr. Chin considered whether the time to reopen might have finally come. Only time will tell.

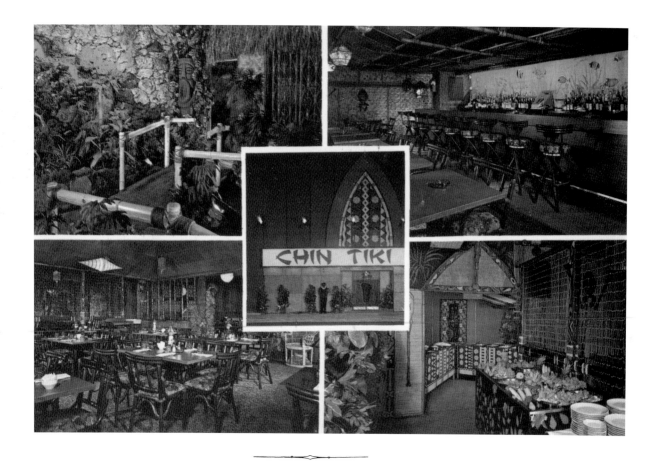

A postcard view of the shining new Chin Tiki, c. 1970.

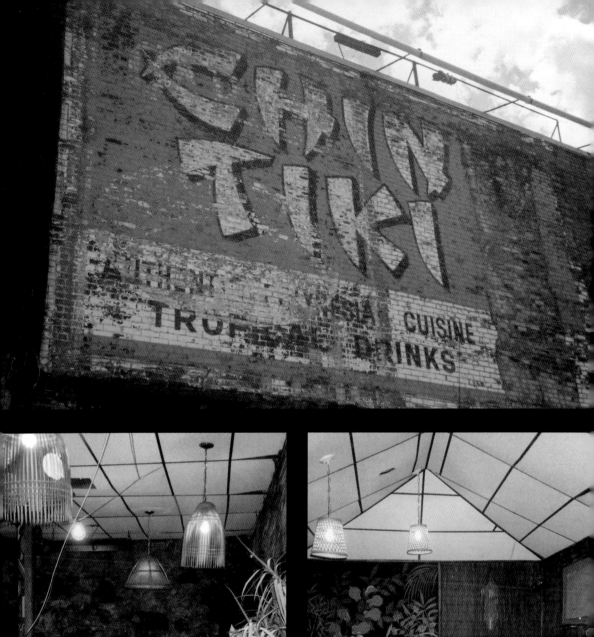

Chapter 4

Public Works

A great republic must care for its people. The founders knew this, and so even before the country was born, they began creating libraries and universities, public cemeteries and public parks, all in a continuing effort to improve the quality of life for its growing number of citizens.

So as villages became towns, and towns became cities, more services were added. Fresh water was piped in and sewage borne away. Sidewalks were laid down and garbage was picked up. Communities large and small flourished in the relative cleanliness and safety of their tax-dollar–nourished utopias.

From the earliest days, municipal structures were accorded the respect they deserved. Along with the church steeple, the town hall was usually the tallest building in town, often in the guise of a Greek temple, Romanesque redoubt, or Italian palazzo. The library too was deified, as was the post office, the courthouses, museums, aquariums, and even municipal waterworks. All came to reflect their nobility of purpose in the shape of the great lost architecture of the great lost civilizations.

That should have been a warning.

From the beginning of the century, through the pain and abandon of the World War and the Roaring Twenties, even surviving a brief flirtation with art-deco in the 1930s, ours was a great civilization and we boasted of it through our buildings. But during World War II, new construction all but ceased and when it resumed, it was under the influence of the stylistic purity of the European Bauhaus and the utilitarian construction methods adopted for factories and government buildings during the war.

Perhaps we were tired and disillusioned, or perhaps we were seduced by the speed and economy with which inauspicious buildings could be erected, or perhaps all of the old architects had died off, their T-squares and slide rules inherited by a younger, more cynical breed. Whatever happened, it spelled the end of the classical structures which made manifest our image of ourselves as a great republic. Public buildings became just another structure to be thrown up by the lowest bidder, often supplanting an aging holdout from a graceful earlier era. At best the new buildings might be clad in expanses of ornament-free marble or limestone. At worst they could resemble a concrete bunker, more reminiscent of Hitler's last retreat than even the cold calculus of the Bauhaus. Our public buildings have always acted as a mirror in which the countenance of our civilization is reflected. How must we see ourselves now?

But think back. Remember when citizens of even the smallest towns took pride in their community? When the people ennobled their institutions and the institutions ennobled their buildings? Remember a time when even the most prosaic of public necessities was considered worthy of beauty in execution? No? Well, let's take a little trip; jog the old memory. After all, your tax dollars paid for it. And it's the will of the people. So, let's be good citizens and cast our votes...

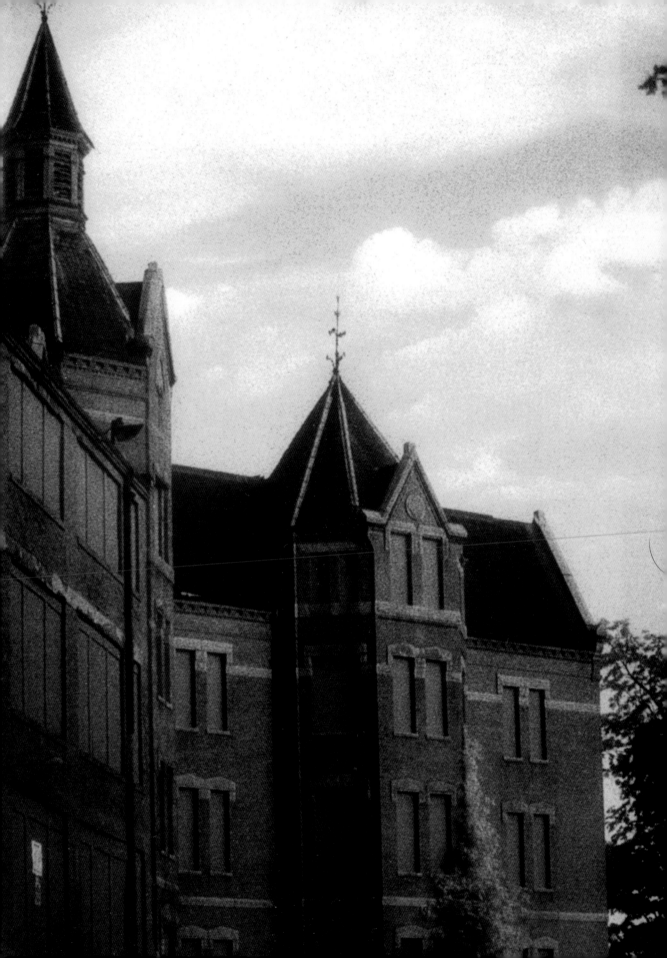

ɘ· THE DANVERS ·ɕ
STATE HOSPITAL

W hat could be more frightening than an abandoned Victorian lunatic asylum?
The Danvers State Hospital.

Built during the 1870s and operational until overcrowding and changes in the law forced its closure, this crumbling Massachusetts artifact already had a bad reputation by the time H. P. Lovecraft referred to it in several of his tales of the preternatural.

Although a model facility when constructed, the Danvers State Hospital gradually succumbed to all of the overcrowding and abuses typical of mental hospitals during an era which spawned talk of "snake pits." And as treatment deteriorated over the years, so too did the condition of the once-staid edifice. Eventually the building fell into leaking roof and peeling paint disrepair and the facility, which was designed to house two hundred patients, had crammed in two thousand. Danvers closed in 1990.

But even Lovecraft may have been unaware of the site's darker history: that over three hundred years ago the village of Danvers went by another name. And that the asylum was constructed on the very hilltop once occupied by the house of a fanatical judge who presided over the trial and execution of twenty people convicted of practicing witchcraft in the village below—a village so traumatized that years later it changed its name to Danvers—from Salem.

The Danvers State Hospital may have the worst karma of any abandoned site in the country.

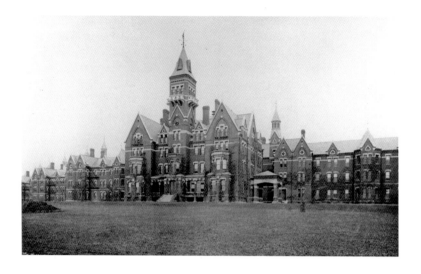

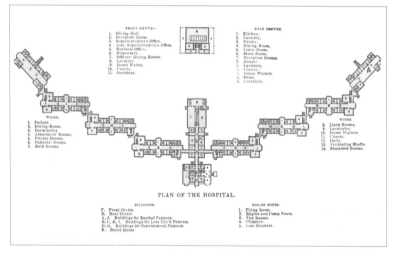

PLAN OF THE HOSPITAL.

Top: The Danvers State Hospital in its prime, c. 1893. Only a fraction of the immense structure is visible in this photo.

Bottom: A plan of the hospital reveals its organization. Designed along the principals espoused by Thomas Kirkbride in the mid-1800s, Danvers segregated patients of similar disposition in separate wings; the more violent being in those most distant and the least disturbed near the center.

Opposite

The brooding hulk of the administration building, c. 2000. The top of the tower was removed years ago.

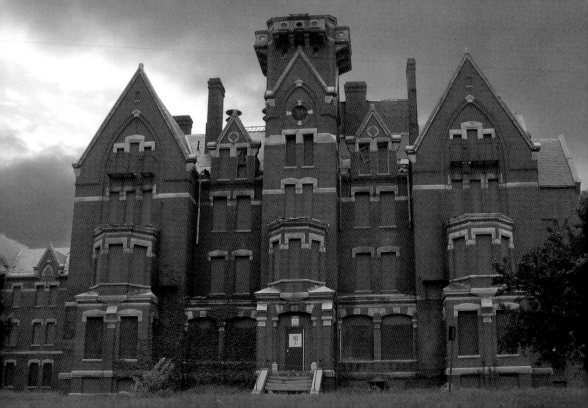

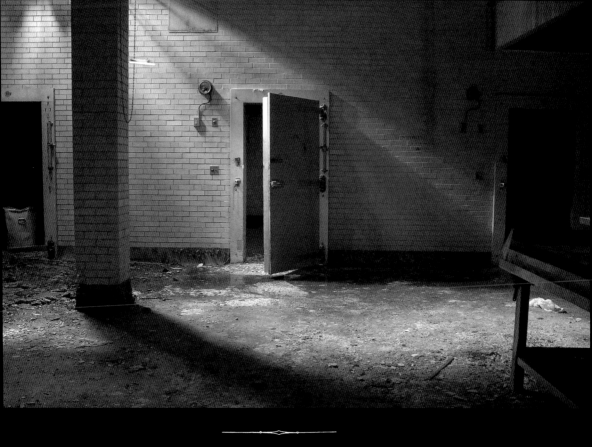

A walk-in cooler. What might be waiting within?

OPPOSITE
Top: Even sunlight cannot disperse the gloom within this patient's room.
Bottom: Inside the front entrance medical records are strewn across the floor.

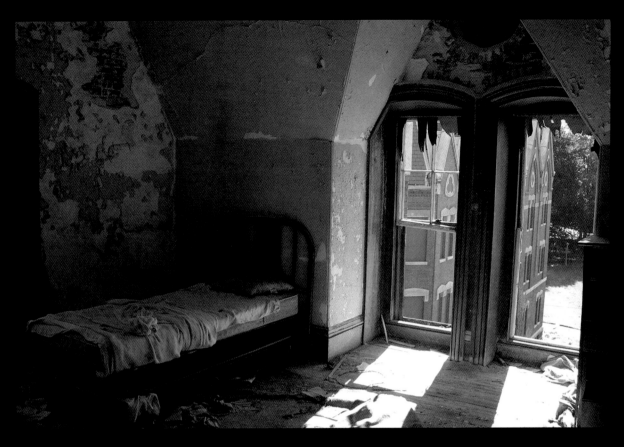

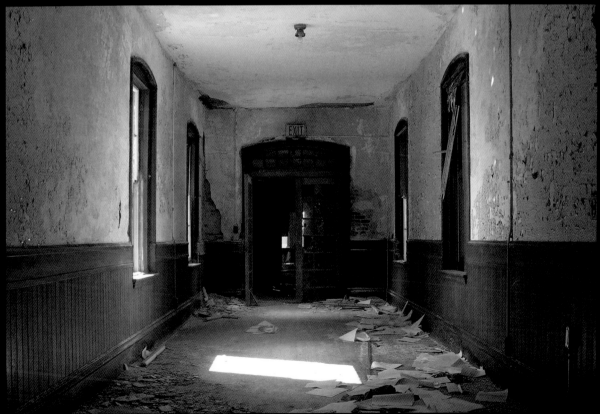

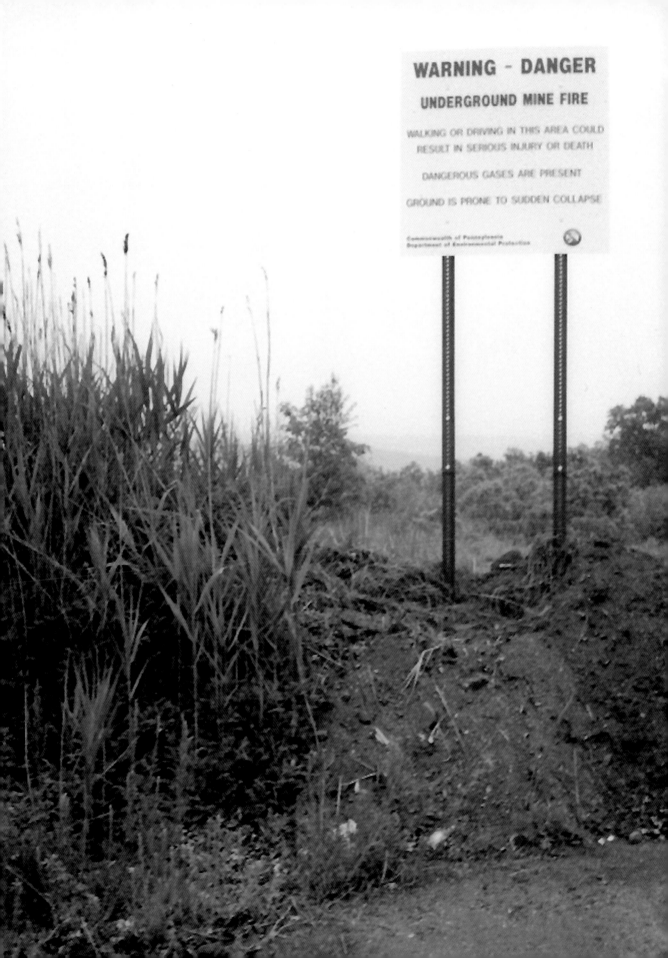

CENTRALIA, PENNSYLVANIA

It's as though the ground opened up and swallowed the town of Centralia, Pennsylvania. Literally. It did swallow one resident, but he, at least, was saved.

Centralia was not so lucky.

Once Centralia was a typical Pennsylvania mining town, its livelihood built on the coal seams which lay deep beneath its quiet streets. It had stores and a bank, a school and post office, five churches and seven saloons. And it had 1,400 residents until, in May of 1962, all of that changed.

A trash fire, set in an old mine pit used as a garbage dump, spread to an exposed coal seam, igniting it. Like a hidden fuse, slowly, inexorably, it began to burn. Before the residents were even aware of what was happening, their town was being incinerated from below, as the labyrinth of mine shafts, rich with Pennsylvania anthracite, turned into an invisible inferno.

Over the years, various government agencies made attempts to stop the ever-spreading conflagration, but with no success. Meanwhile, the mine fire continued to make itself known, as cracks belching sulfurous steam, and sometimes flames, continued to appear.

On Valentines Day, 1981, as twelve-year-old Todd Domboski walked across his grandmother's backyard, the ground opened up and swallowed him. The fire in the old mine shafts below had caused a subsidence—a collapse of the weakened soil—and as Todd frantically clutched at tree roots and struggled to save himself, the mine inhaled and exhaled around him, alternately sucking in combustion air and exhaling noxious, monoxide-rich steam. If not for the proximity of Todd's cousin, who heard his cries and pulled him to safety, he would have been lost. But even as Todd was pulled, muddy and dazed, from this Dantean nightmare, Centralia's fate was sealed.

In 1979 the gasoline had to be emptied from the buried gas tanks at Coddington's Service Station, as the ground's temperature continued to rise. Vegetables in home gardens burned to a crisp in the ground, and route 61 out of town had to be closed as the smoldering fissures continued to spread. In 1983 a voluntary program began the government buyout of houses, now too dangerous to live in. In 1991 evacuation was made mandatory.

Todd Domboski's family had already moved away.

By the late 1990s little remained of Centralia. Its buildings were nearly all demolished and its 1,400 residents dispersed. Only a few dozen remained—too stubborn or too much in denial to realize that the town they had loved was gone.

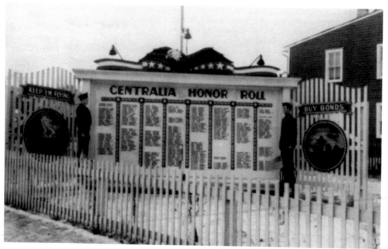

Small town life in Centralia: a parade, and a war memorial.

Opposite
Too late. A trash fire in 1962 started the hidden conflagration that would ultimately
consume Centralia. A later sign discourages similar behavior.

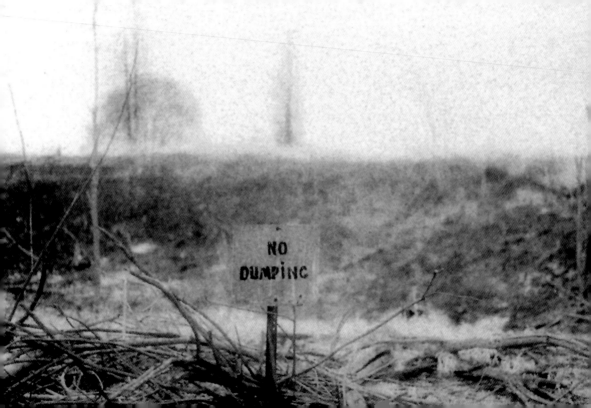

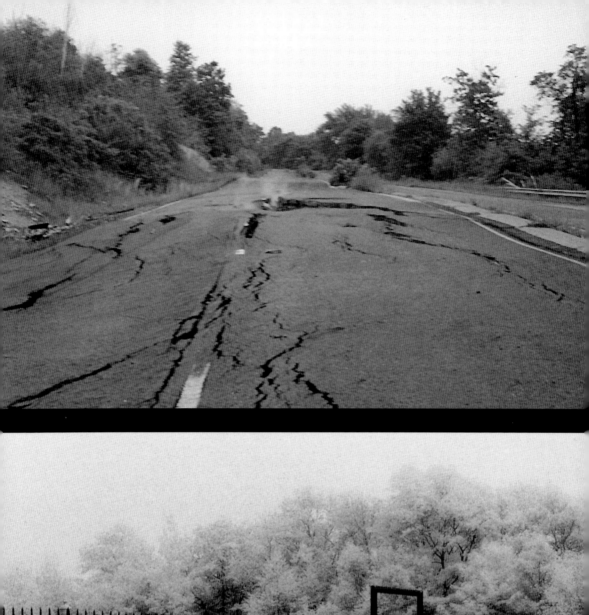

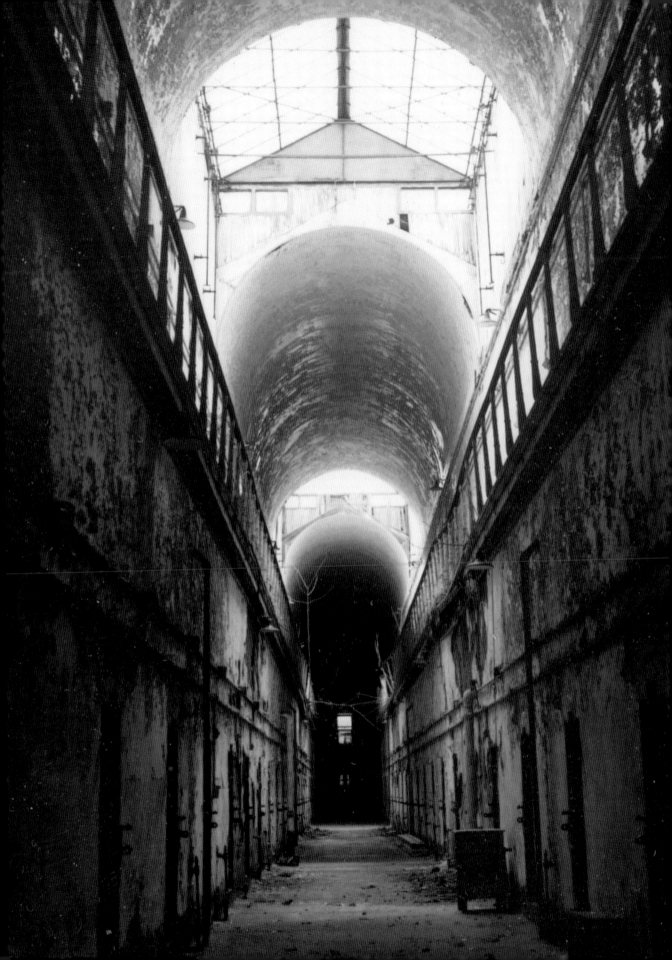

᠉᠊ EASTERN STATE PENITENTIARY ᠊᠊

In the bustling heart of Pennsylvania lies one square acre of stillness and neglect.

Massive stone walls, thirty feet high, and a rusting iron gate many times taller than a man, circumscribe and contain the silence. No traffic noise or children's cries penetrate the walls from without, as, in earlier times, the cries of men could not issue from within. Crenellated towers and narrow Gothic windows adorn this grim edifice. But unlike castles of old, this castle was intended to safeguard the innocent by containing its violence within.

This is Eastern State Penitentiary.

There are no guards now; no prisoners. Save the occasional adventurers, no one has spent the night in Eastern State in over thirty years.

Eastern State is old. In 1829, when it opened, it was the largest public building in the United States, and Revolutionary War veterans still tended the rolling farmlands surrounding the new penitentiary's site.

In accordance with the most modern theories of the time, Eastern State was intended to be a true "penitentiary," or place of penitence. To this end, prisoners were isolated in individual cells, unable to speak with, or even see, others. They were expected to contemplate their sins in isolation and silence.

Some went mad.

When Charles Dickens visited the prison in 1842 he decried the "slow and daily tampering with the mysteries of the brain" and proclaimed it "...immeasurably worse than any torture of the body."

Although the system was eventually abandoned as unworkable, the prison ultimately saw everything from education to torture employed in various attempts to maintain order and discharge its obligation to society.

The prison was essentially successful, but eventually Eastern State's dangerous location in the city that had grown to engulf it proved its downfall. In 1970, after 141 years of operation, its inmates were relocated to other facilities and its gates finally closed for the last time.

Eastern State Penitentiary is now a historic site and open to the public. It has more visitors at Halloween than at any other time of the year.

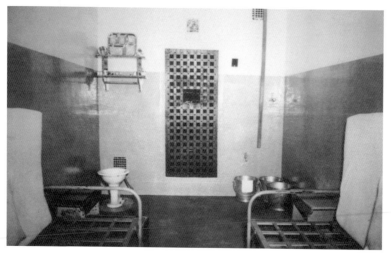

Top: An 1846 steel engraving of the new penitentiary. At the time of its construction, revolutionary war veterans still farmed the surrounding fields.

Bottom: The interior of one of the newer cells in the early part of the twentieth century.

Opposite

Top: Cellblocks 11, 2, and 10 as seen from the center of the prison in 1967. The center cellblock dates from the original construction, the others from before 1900.

Bottom: Cellblocks 7 and 6. Both were constructed with two levels of cells and are seen here in 1967.

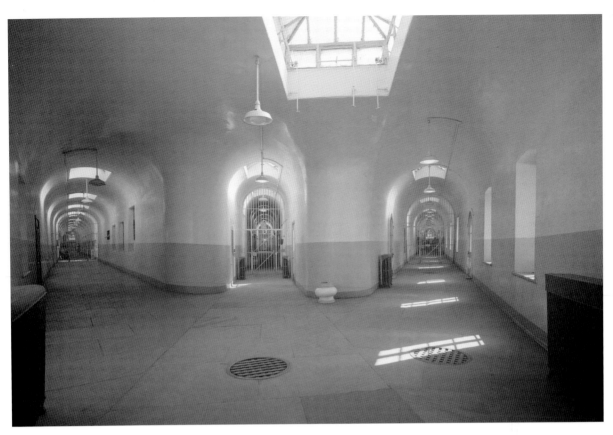

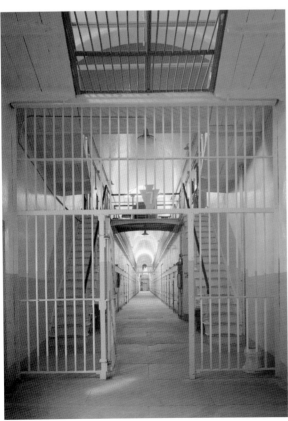
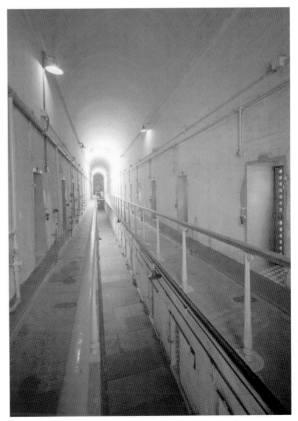

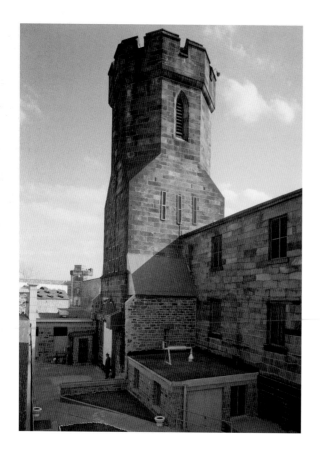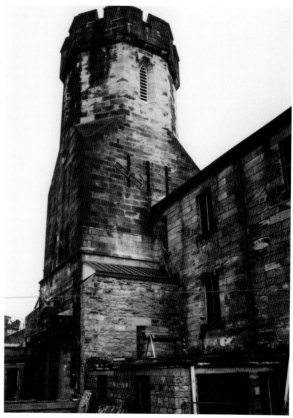

The front tower as seen from inside the prison in 1967 (left) and 2003 (right).

Opposite
The many textures and contours of this courtyard wall betray the changes and additions
made to the prison over the years.

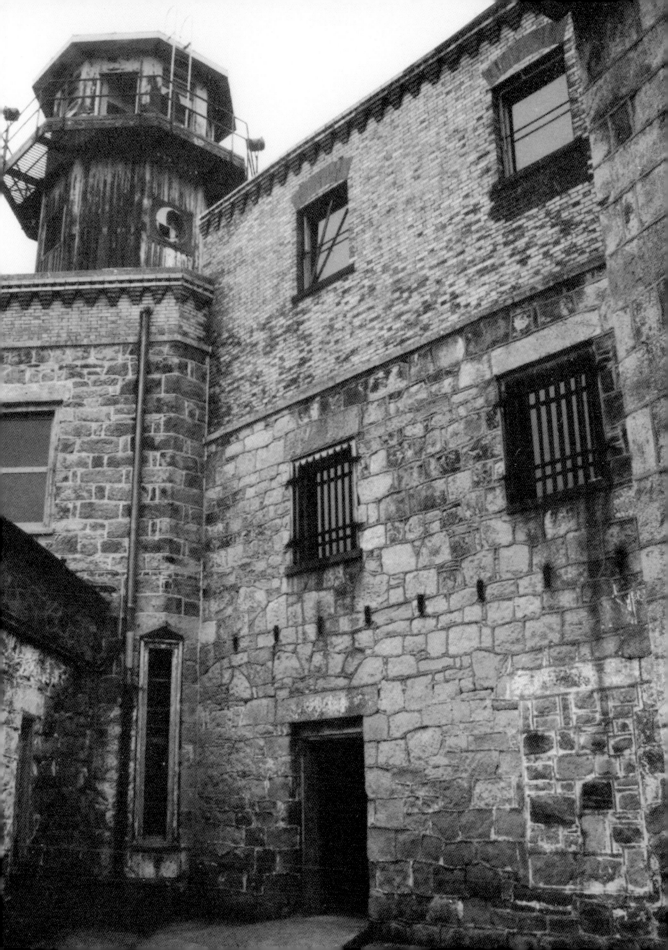

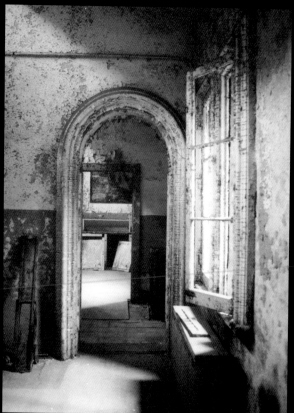

Left: At a junction of corridors, mirrors allowed guards to see around corners.
Right: Staff rooms exhibited the luxurious appointments typical of a building of stature—
now gone to seed.

Opposite
An original cell in 2003.

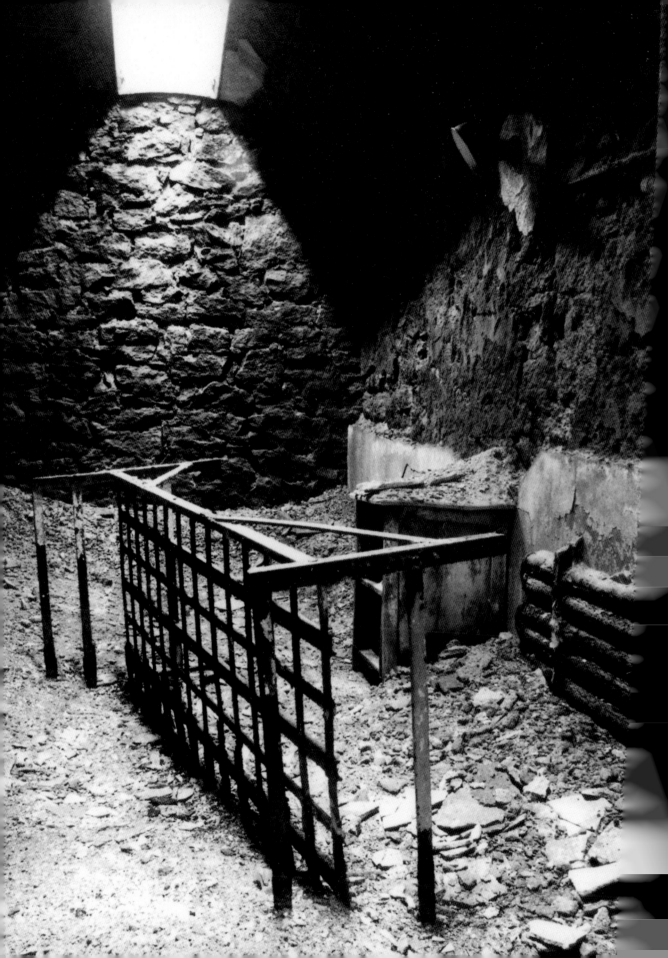

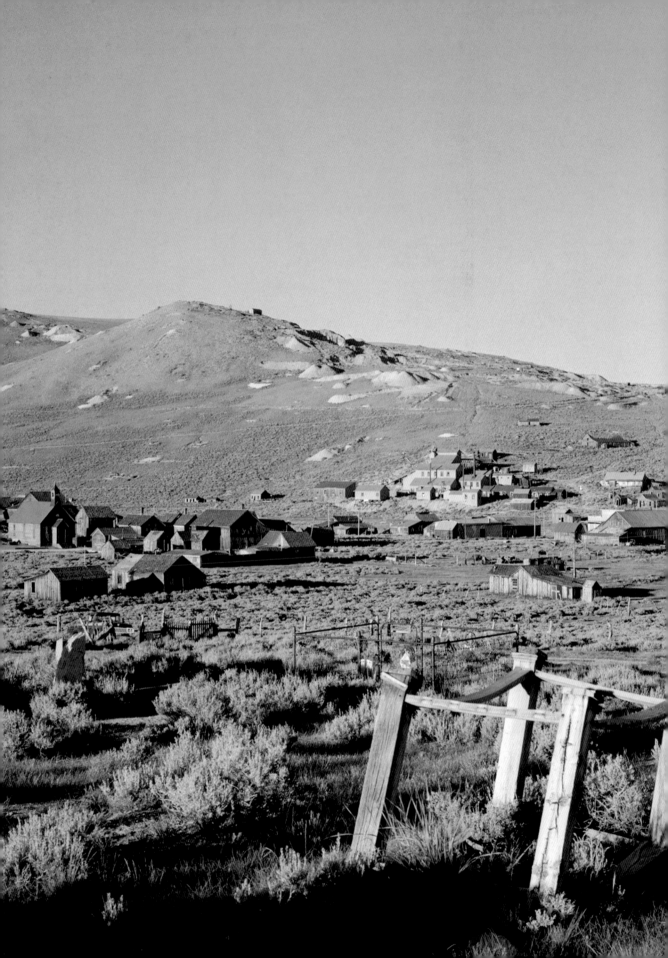

❧ BODIE, CALIFORNIA ❧

What is there about a ghost town that intrigues us so? It's just a bunch of old buildings. But a ghost town, more than almost any other abandoned site, exhibits evidence of its long-lost inhabitants wherever one looks. On every scale there are signs of the hand of man; from the arrangements of the buildings, to the furniture inside, to the bottles on the shelves, it is all too easy to picture those long-dead people going about their lives.

Perhaps the granddaddy of all ghost towns is Bodie, California.

Gold was first discovered in Bodie in 1859, but it wasn't until 1874 that the real growth began. Throughout its peak years, Bodie's mines produced over 100 million dollars in gold and silver. And with wealth came people, and with people came vice. At its peak, Bodie had a population of 10,000. The saloons prospered, as did houses of ill repute and even, in Bodie's Chinatown, opium dens. At one time Bodie boasted twelve breweries. In 1879 Bodie's Main Street was a mile long, lined with one- and two-story buildings, of which every other storefront was a saloon or gambling hall. Bodie's reputation for lawlessness was legend.

When the end came for Bodie, it was through a combination of factors. Mining was on the wane, as some of the mines began to play out. At the same time a series of fires decimated the town, first in 1892, then later and more seriously in 1932. A large portion of the downtown was destroyed in this fire, a blow from which the town never recovered. The coup de grace was the fire of 1946, in which an idle mine building that had just reopened caught fire and burned to the ground, effectively removing any reason for the population to remain.

In 1962 Bodie was designated a California state park. In an effort to preserve the town, it was decided to maintain it in a state of "arrested deterioration," a sort of architectural embalming, allowing it to survive relatively unchanged, into the indefinite future.

Green Street in Bodie as seen c. 1928.

Opposite
Top: Another view of Green Street, this time in 1962.
Bottom: The home of J. S. Cain, a wealthy lumber merchant, seen in 1962.

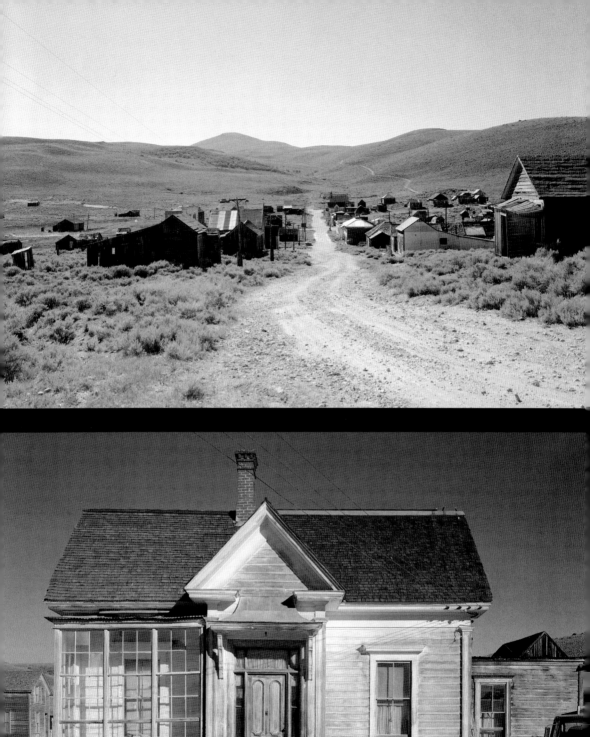

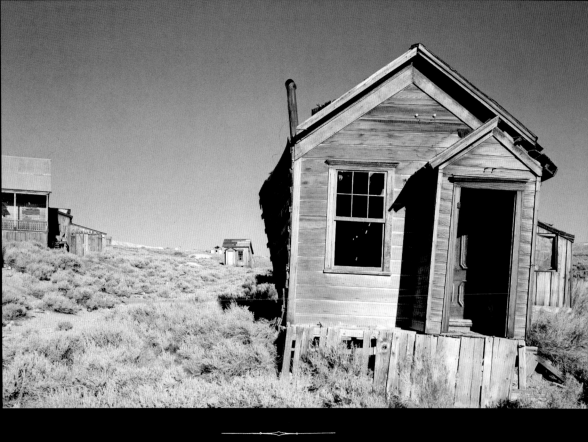

A typical miner's house, 1962.

OPPOSITE

TOP: The Methodist Church.

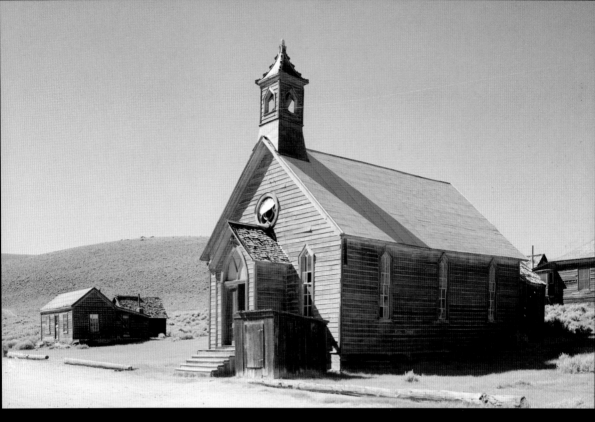

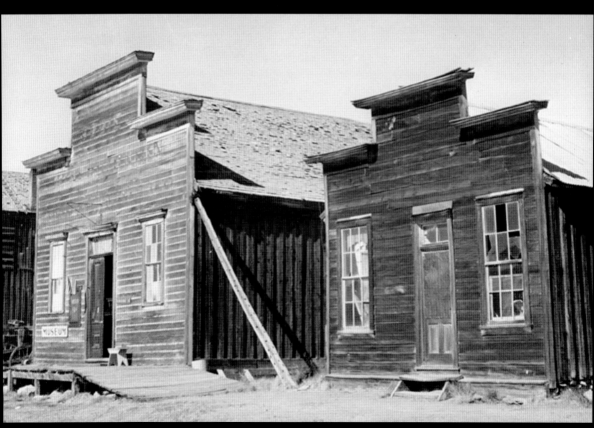

Chapter 5

⊰ HOME ⊱

Once upon a time, giants walked the earth. Giants not in stature, but in wealth. They were captains of industry, merchants, bankers; successful men of grandiose wants and bulging pockets, men who could conjure cities from swamps, fling railroads from coast to coast and smelt the iron and steel necessary to do this and more.

The latter half of the nineteenth century and the early part of the twentieth were a golden age for these men. There was little government interference in the affairs of business, no income taxes, and no anti-trust laws. Opportunities for accumulating wealth were unparalleled, and the wealthy grew fat.

But at the end of the day, even giants must rest their heads, and millionaires, like lesser mortals, desire the warmth of the hearth and comforts of home. So when it came time for these men to build homes for themselves, they did so with the same exuberance applied to their dealings in business. Mortals can reside in tiny houses, but giants require castles. Castles, palazzi, chateaus, and mansions.

And that is what they built. Architects were hired and builders sought. The architecture of the Old World was plundered, both figuratively and literally, for ideas and artifacts. Estates of previously unimagined size and lavishness appeared, at first on the outskirts of cities, then in more remote areas, as the weary wealthy sought pastoral relief. Great urban enclaves of wealth blossomed into tree-and-mansion-lined European-style boulevards. Summer houses, as much like cottages as the Queen Mary is like a houseboat, clustered along the north shore of Long Island, on the Hudson River, and at Newport, Rhode Island. Life was good. After all, there's no place like home.

There's a saying that the first generation makes the money, the second invests it and the third spends it. With the passage of time, the former *nouveau riche* found that they had become old money, and that the fine, elegant boulevards they had created on the edge of town were being swallowed up by the very cities that perpetuated their wealth. The wrecking ball swung, and swung again, and the graceful boulevards vanished like the dream they had been, replaced by office buildings and apartment blocks. The wealthy were forced to move further from the city's core, a move that put them once again on the outskirts of town and allowed them the elbow room to construct even more grandiose estates.

But in 1929 the world changed. The Depression came and greatly thinned the ranks of the rich. City houses were sold, and even country estates, not subject to urban pressures, were vacated as too expensive to staff and maintain by their *nouveau pauvres* owners. Many were left to fall into silent ruin. Gatsby's last party was over.

But wait! We can still go to the ball. Of course the ballroom windows may be broken and the draperies hanging in tatters, but better late than never, right? So let's take a walk up that weed-choked driveway…

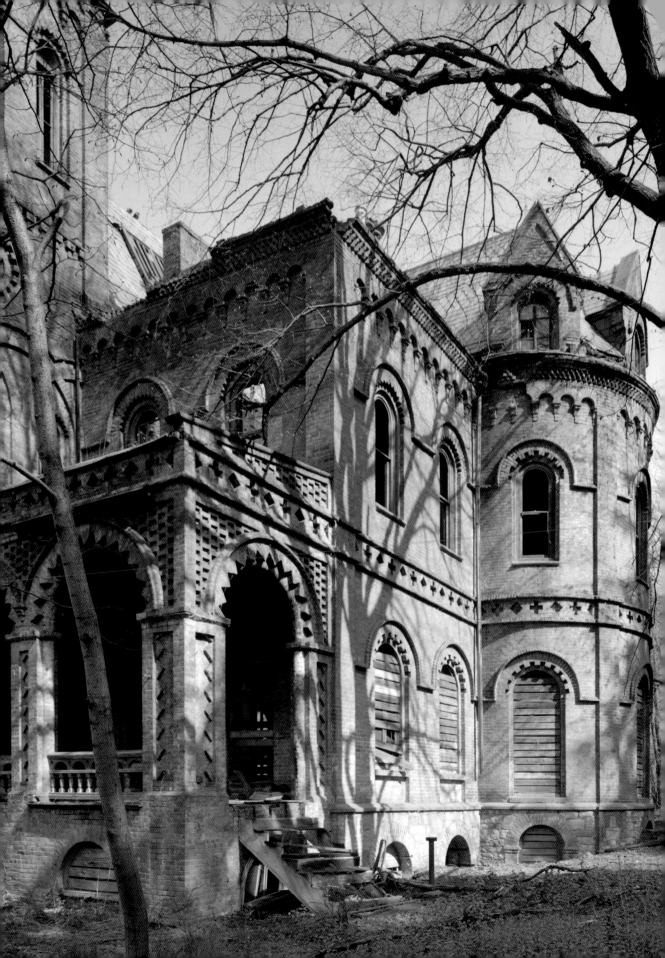

❧ WYNDCLIFFE ❧

RHINEBECK, NEW YORK

High on a hill overlooking New York's Hudson River Valley towers the crumbling ruin of a Norman-style villa once known as Wyndcliffe.

Uninhabited now for over half a century, Wyndcliffe was originally built in 1862 as a summer residence for Miss Elizabeth Schermerhorn Jones of New York City. A cousin to the wealthy Astors, Miss Jones was also the dour maiden aunt of poet Edith Wharton, who once observed "...a queer resemblance between the granite exterior of Aunt Elizabeth and her grimly comfortable home..."

Although praised by one critic of the time as "a very successful and distinctive house with much of the appearance of some of the smaller Scottish castles," Mrs. Wharton's memory of it, as related in her 1933 autobiography, was somewhat less glowing: "The effect of terror produced by the house at Rhinecliff was no doubt due to what seemed to me its intolerable ugliness."

What would she think of it now?

For the past half-century, no owner has chosen to live in Wyndcliffe. The reason is unclear. The house was left to itself as early as 1936 and stood vacant until it was briefly occupied by a bohemian group of "nudists" in the early 1950s. It was finally boarded up and closed for good in 1953. Although slated for demolition in 1961, its death sentence was somehow never carried out, leaving the already deteriorating house standing, but at the mercy of the elements. By the early 1970s water leaks had compromised the roof structure on the south side of the building until its heavy slate roof came crashing down, destroying the bedrooms and parlor below. In the years following, the other rooms on the south side also succumbed, until even the great entrance hall's floor collapsed into the basement.

And so it stands, towering on its hill while crumbling in upon itself. Wyndcliffe remains a monument both to wealth attained and greatness lost.

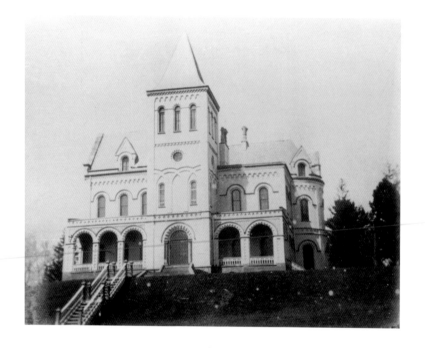

Perched atop its hill; the whitewashed glory of Wyndcliffe, c. 1880.

Opposite
A detail of the tower, c. 1975.

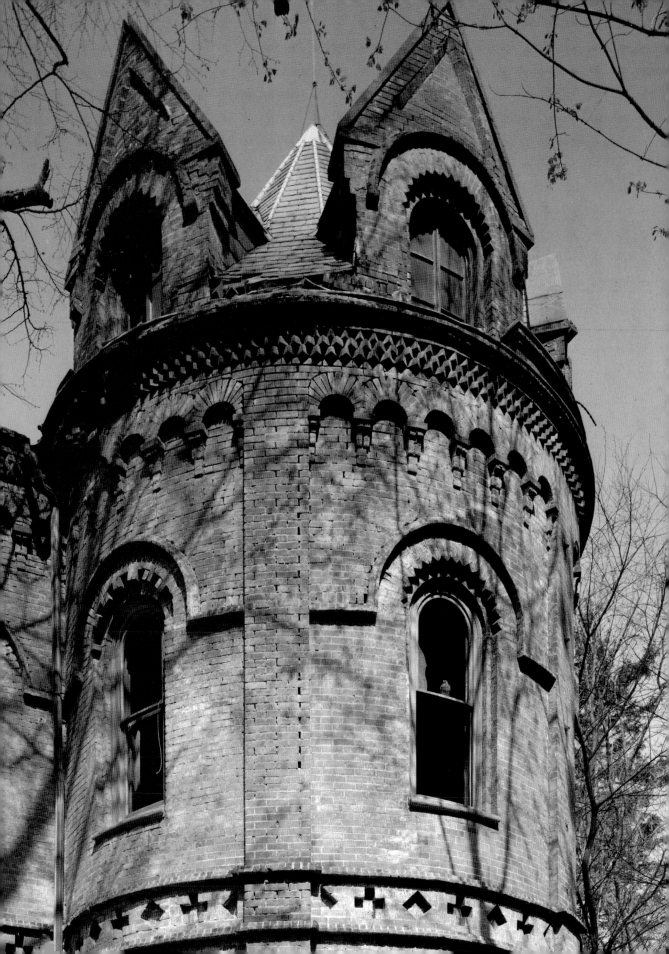

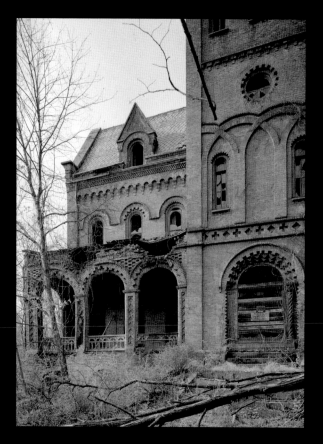
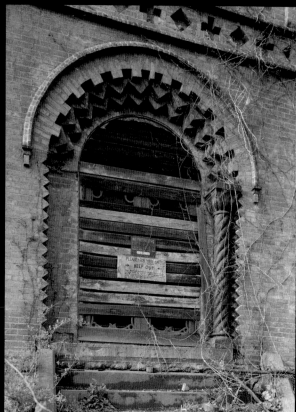

Left: The front of Wyndcliffe in 1975. The porch has since collapsed.

Right: A sign warns intruders away from Wyndcliffe's front door.

Opposite

The main hall was once illuminated by a Tiffany stained glass skylight, now long gone.

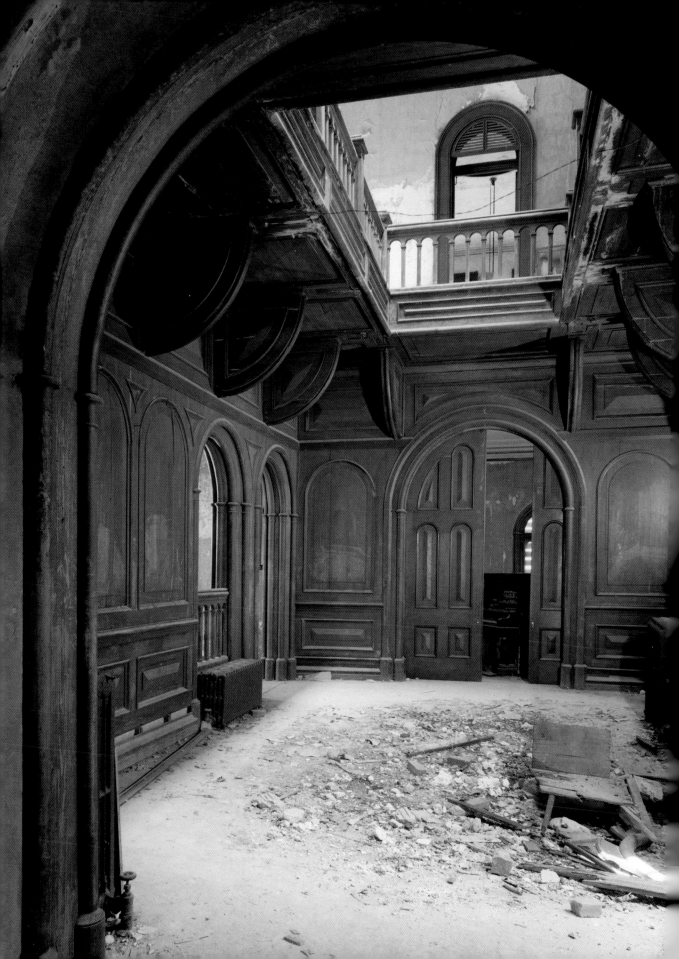

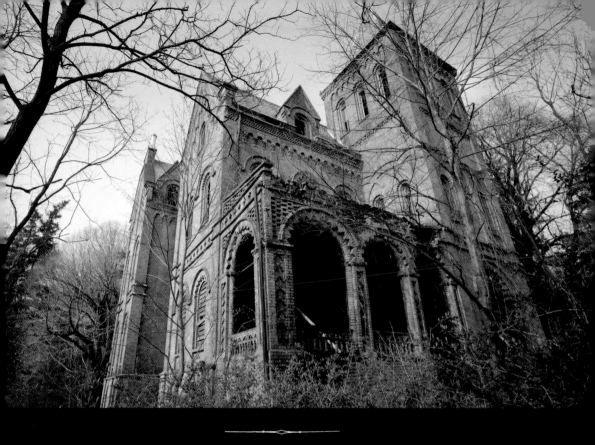

"And at length found myself, as the shades of evening drew on, within view of the melancholy House of Usher…" —Edgar Allen Poe

OPPOSITE

TOP: In the attic, an elaborately carved railing surrounds the stained glass in the ceiling of the hall below. A glass skylight illuminated it, and the attic, from above.

BOTTOM: The stair hall (left) and the library (right)

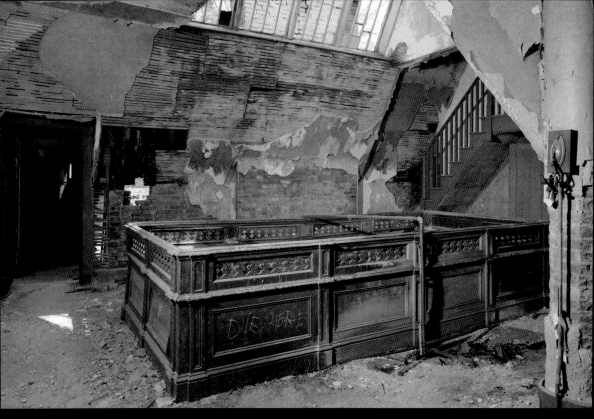

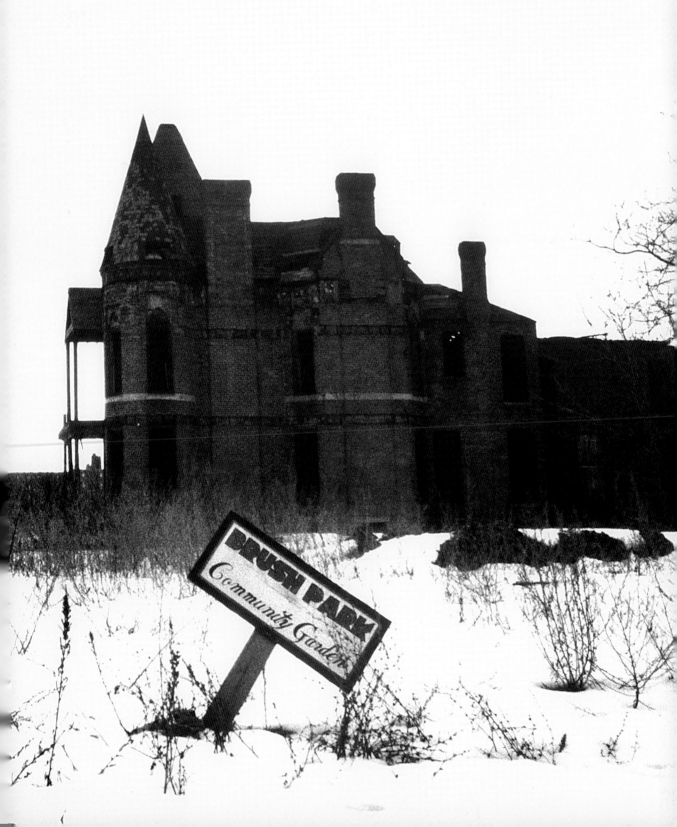

❧ Brush Park ❧

Picture a haunted house.

Equip it with the usual compliment of towers, turrets, gables, and shadowy vacant windows. Perhaps you'd like to board up a few for good measure. Now picture a whole street of them, all different, punctuated by the occasional vacant lot. Now imagine an entire neighborhood like this, hundreds of houses over a dozen blocks. A few show signs of habitation: glass in the window frames, a front door still on its hinges, but these are few and far between. Most are skeletal ruins, some with caved-in roofs or fire-scorched windowsills; all are mere shades of their former selves. It's a cemetery of domestic architecture.

It's called Brush Park.

But it wasn't always like this. In the 1880s Brush Park was a shining new outpost of affluence on the northern fringe of Detroit. Newly constructed mansions for the rich and richer graced spacious lots on tree-lined boulevards. Horses clopped down streets paved with sweet-smelling cedar blocks and children played on manicured lawns. It was all its residents could ask for.

But by the 1920s the city had grown. Commercial buildings began to replace the largest mansions on the adjacent avenue. Houses in Brush Park, vacated by the wealthy for newer homes in less urban neighborhoods, became boarding houses or were adapted for retail use.

As the years passed, Brush Park became increasingly squalid. Public housing was constructed a few blocks away, and the former mansions were vacated or turned to less savory uses. By the 1980s, only about one hundred of the original grand homes remained, and many of those were in rapid decline. Although interest in preservation was increasing, the City, which by now owned most of the derelict structures, was unwilling to sell them to interested individuals. It was rumored that a wholesale demolition with subsequent industrial development was more to the City's liking.

So for years the mansions just stood there, slowly falling into ruin, many of them now long past the point of no return.

Recently, condominiums have begun to sprout where mansions once bloomed. Although a few of the old houses are being saved, most will no doubt perish, taking with them the last vestiges of a simpler, more gracious, era.

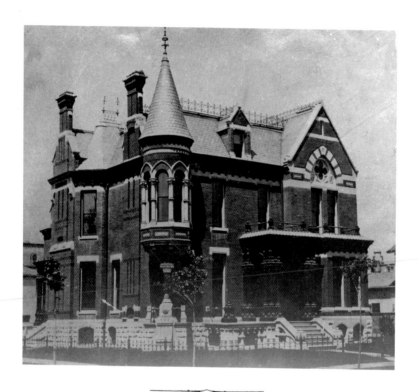

In 1876 architects Henry Brush and George Mason designed the gothic-flavored
fantasy that was the Ransom Gillis house. From its iron cresting and
quatrefoil window to its tile-inlaid turret, the Gillis house reveled in the prominence of
its corner lot. Photo c. 1876.

In 1992 (top), its porch gone, its neighborhood decimated, and its era vanished,
the Ransom Gillis house verges on collapse. By 2002 (bottom) the roof
has collapsed and the tile-inlaid turret is gone. The elaborate victorian mansion is all
but a memory.

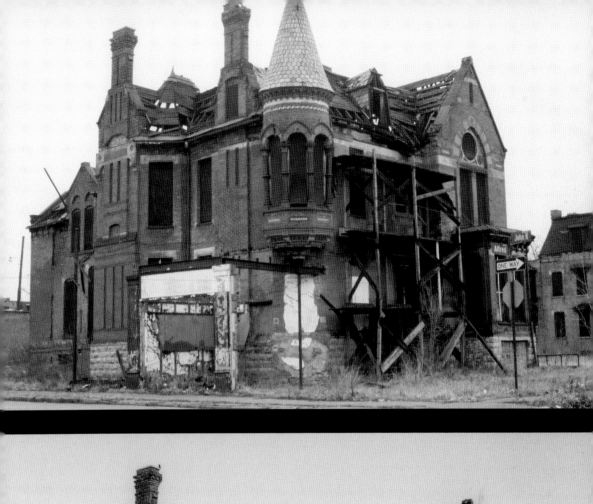

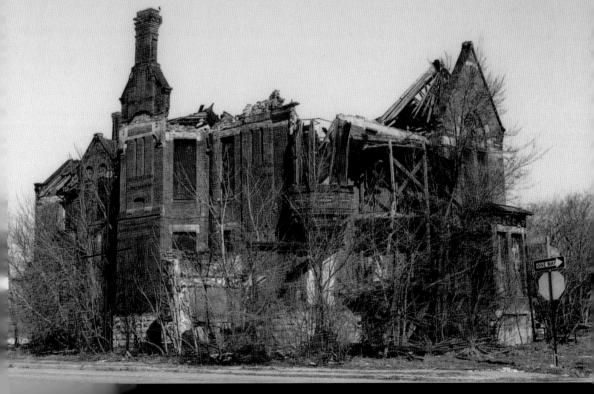

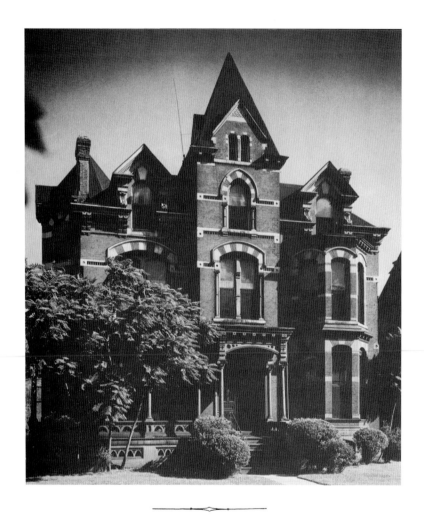

Lumber dealer Lucien Moore commissioned the construction of his home on Edmund
Place in 1885. Although essentially Gothic, the era's eclecticism allowed for such features as
dormer windows and renaissance detailing. Photo c. 1940

OPPOSITE
Deprived of the top of its tower and its fragile Gothic porch, the Moore house, as seen in
2001, is a sad shade of its former self.

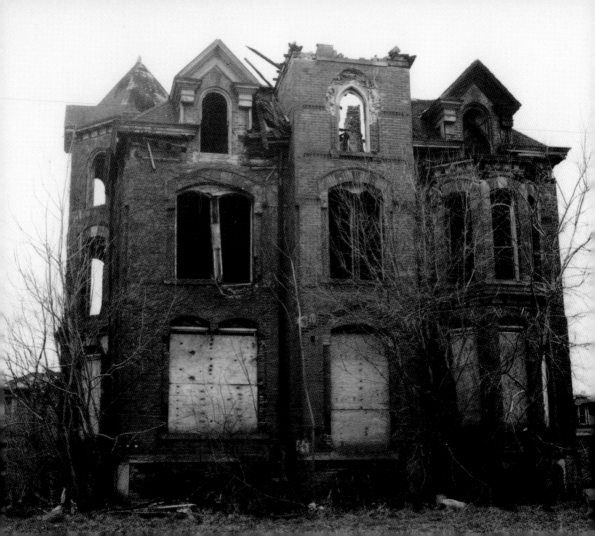

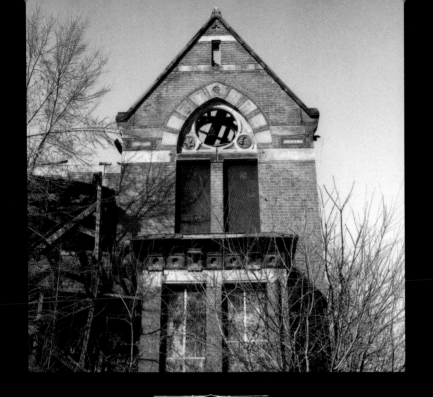

A gallery of neglect: urban decay in Brush Park.

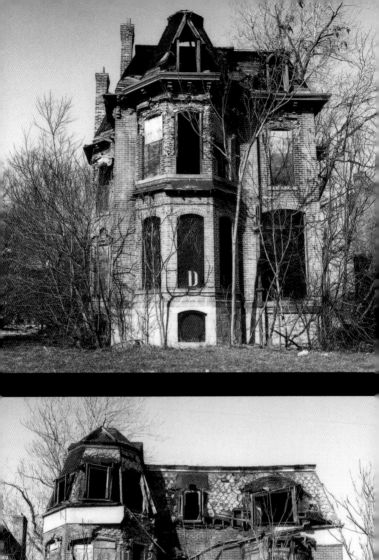

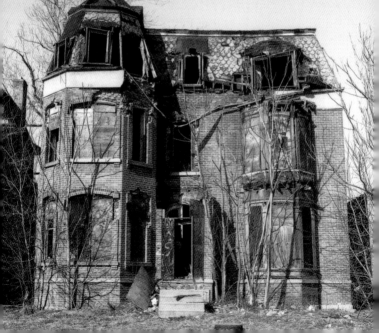

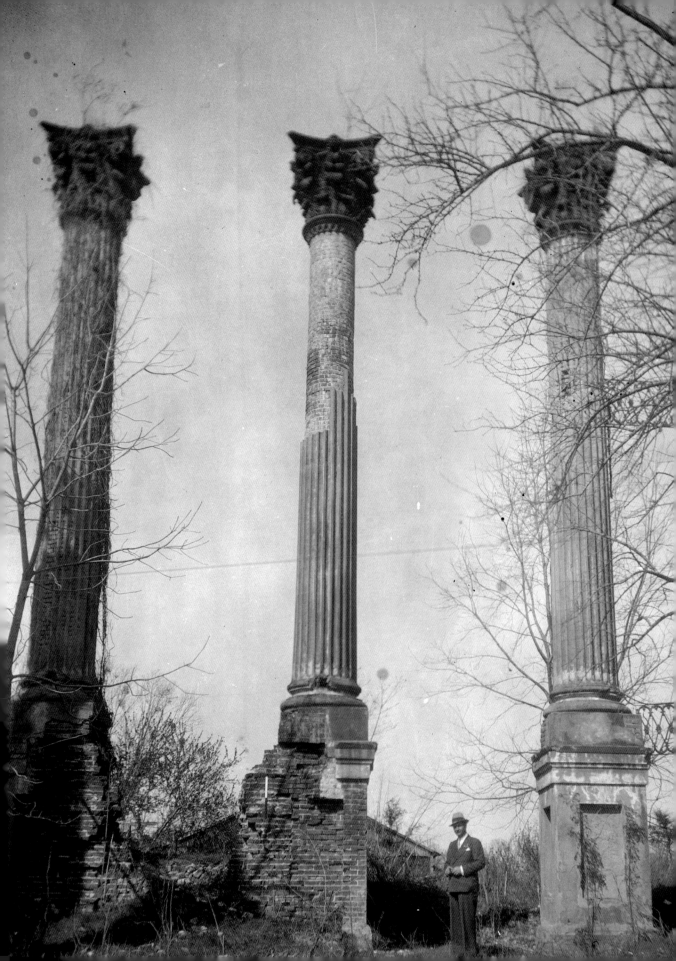

⊰ WINDSOR ⊱

PORT GIBSON, MISSISSIPPI

Of all the structures collected herein, this one has been a ruin the longest.

Windsor seemed ill-fated from its very beginning. Completed in 1861 by builder David Shroder for cotton plantation owner Smith Coffee Daniels II, Windsor was spectacular, even by the standards of southern plantation houses.

It was built for over $140,000 and contained twenty-five rooms of gracious appointment. Twenty-eight towering columns with elaborate cast-iron Corinthian capitals encircled the house, supporting the roof, which in turn covered two spacious galleries. An ornate wrought-iron staircase communicated to the upper floors and to an observation gallery on its roof. It was said that Mark Twain used to stand and regard the distant Mississippi from this perch while a guest at the house.

Sadly, Mr. Daniels was not able to enjoy his lavish home. He died a few weeks after its completion.

During the Civil War, Windsor was used by the Union forces as a hospital and observation post. It survived the war essentially intact, only to be destroyed by fire in 1891, the result of a party guest's mislaid cigar.

Little survived the fire. The elaborate wrought-iron staircase was salvaged and installed in nearby Alcorn State University. Twenty-three columns with their elaborate Corinthian capitals yet stand on the site, circumscribing and defining the void which was Windsor.

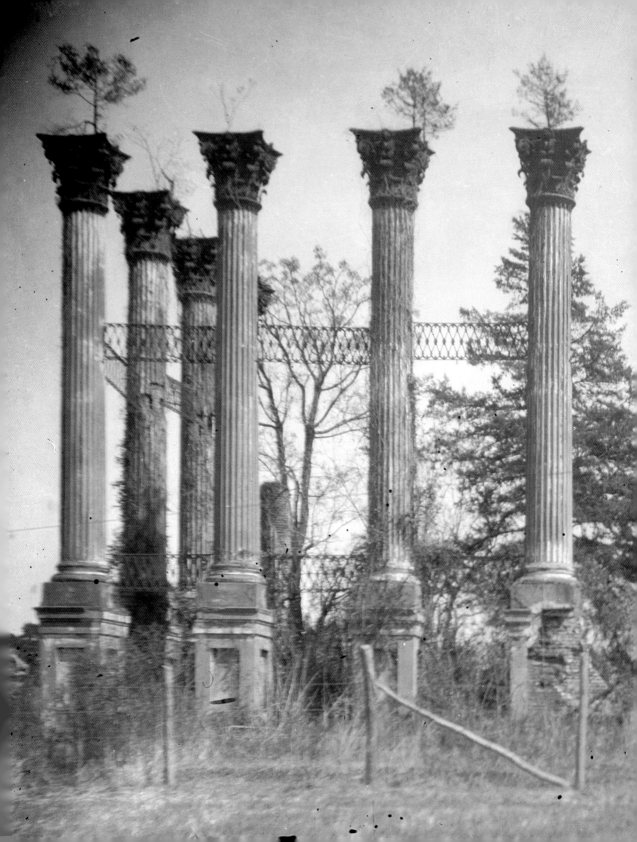

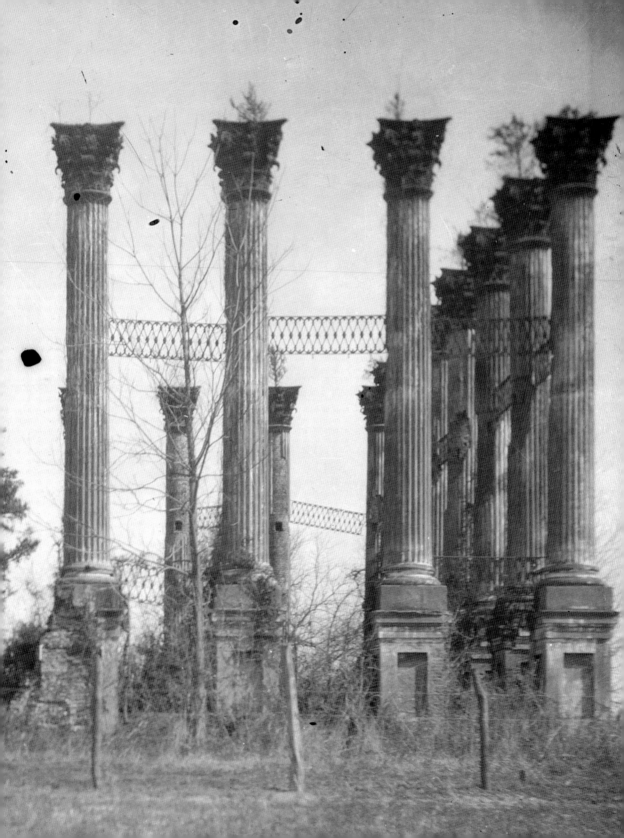

Chapter 6

AMUSEMENT

Many of the most popular entertainments in the first half of the twentieth century owe their popularity to the 1893 Chicago World's Fair. Theatre, certainly, had already existed, but not movies, which would eventually spring from Edison's Kinetiscope, exhibited at the fair. "Exotic" dancers, almost as unsavory as the movies, also made their American debut. The fair's Midway Plaisance was the original and namesake midway, from which thousands of pale imitations would later spring.

Bridge designer George Ferris's first and largest eponymous wheel made its debut in the Midway, as did early precursors of the water ride and theme park–style imitation German, Dutch, and Chinese villages serving regional cuisines.

So popular was the White City, as the fair became known, that barely were its gates locked before imitations sprang up around the country. One of the first, at Coney Island in Brooklyn, even commissioned the construction of a smaller, imitation Ferris Wheel. By 1910, over 2,000 amusement parks had sprouted, and by 1930 some cities had as many as six. Movie theaters followed a parallel course, moving from Kinetiscope to penny arcade to nickelodeon to movie palace during the same period.

Americans had money and free time, and opportunities for entertainment multiplied as never before. Amusement parks and movie palaces, dance halls and ballrooms, giant seaside resorts and miniature golf—all prospered. But while Valentino emoted and the Charleston was danced, the economy teetered on the brink. When it ultimately toppled, construction of new amusements came to a grinding halt.

Those recreations that survived limped through the Depression, but got a second wind during the war years as those at home clung fervently to familiar ways of relaxing. After the war, the influx of returning veterans and the subsequent baby boom created new demands for entertainment, and for a time many of the old public recreations flourished once again. But before long the advent of television and air conditioning made it easier to stay home on those hot summer days and nights.

By the 1970s, barely one hundred of the 2,000 wooden roller coasters that existed in the 1920s remained. The others were abandoned or demolished. Of the once ubiquitous movie palaces, only a handful operated. The others, if they still stood, were closed, their marquees dark and their velvet draperies covered in dust. And cars no longer tarried in angled repose before endless beach parties and rubber-suited monsters projected on billboard-sized drive-in screens. The season, after all, was over.

Still, on those warm summer nights, can't you hear the clacking of the rollercoaster climbing to its precarious perch? Don't you long for the twinkling lights of the midway or the dark, popcorn-scented and chandelier-illumined movie palace? Well, come along! The sun's setting fast. Pay no attention to that "closed for the season" sign— there's always time for fun! No tickets required! No lines to stand in! Step right up…

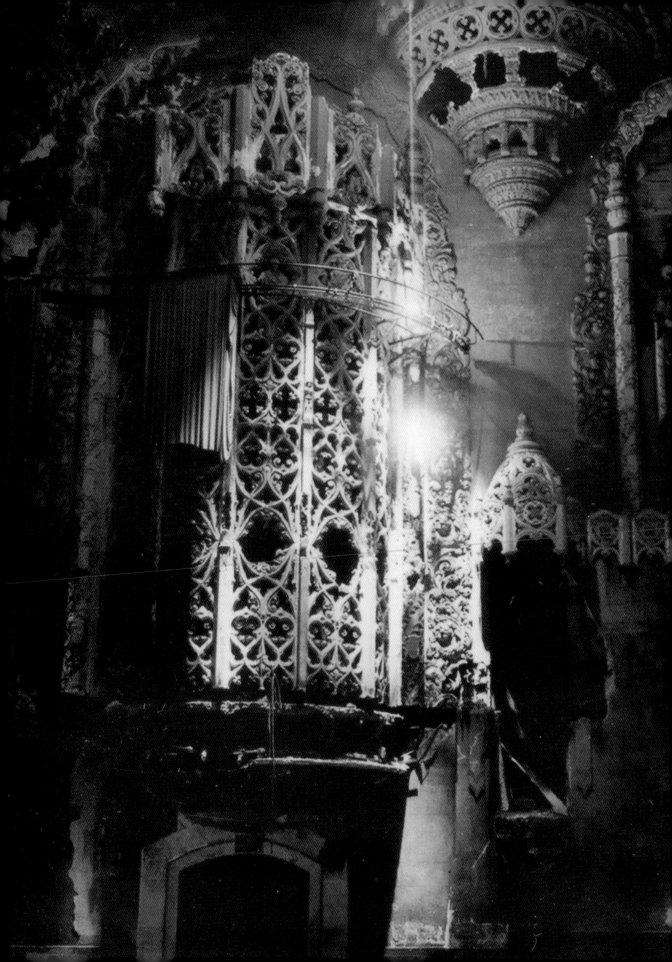

The United Artists Theatre

In the fevered days of the late 1920s, the construction of theatres reached its peak. In quantity, size, and elaborateness they surpassed anything that had come before, and have remained unsurpassed since.

One of the most unusual styles of décor employed was in the three theatres commissioned by the United Artists chain and designed by Detroit architect C. Howard Crane.

Eschewing any of the tried-and-true historical styles, Crane chose to design the United Artists theatres in a Spanish Gothic motif, invoking and combining the massive stone walls of a monastery with the delicate churrigueresque detailing of a Spanish mission.

At its opening in February of 1928, the public marveled at the theatre's mirrored octagonal lobby, its lush star-patterned carpeting, and elaborate auditorium, in which huge, colorfully back-lighted grilles flanked the proscenium and perforated the ceiling's center, and where hung chandeliers fashioned of wrought iron and stained glass.

The press lauded the effect, and described how "...the intricately carved wall corbels and the tracery screens of the side walls and proscenium give an indescribable air of an ancient edifice." The public loved it.

So for decades the theatre prospered, hosting the local premiere of Gone with the Wind in 1940 and, in 1956, as the first theatre in the state to show 70mm films. But despite its successes, time and economics took their toll, and, after decreasing attendance, misguided remodelings, and a flirtation with skin-flicks and exploitation films, in 1973 it closed.

In one last flash of its former glory, the United Artists was used by the Detroit Symphony Orchestra for a series of live recordings between 1978 and 1983, until the still deteriorating building was unusable, even as an empty—if acoustically superior—room.

For the more than twenty years since, the United Artists Theatre has stood empty save for the occasional vandals, derelicts, and thieves stealing and defacing its ornamentation and gradually reducing it to an even sadder shadow of its former greatness.

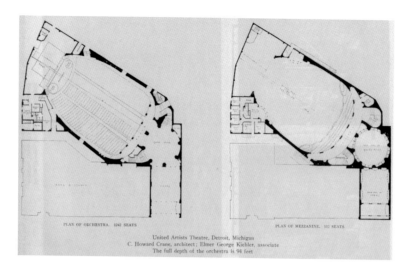

PLAN OF ORCHESTRA. 1242 SEATS PLAN OF MEZZANINE. 132 SEATS

United Artists Theatre, Detroit, Michigan
C. Howard Crane, architect; Elmer George Kiehler, associate
The full depth of the orchestra is 94 feet

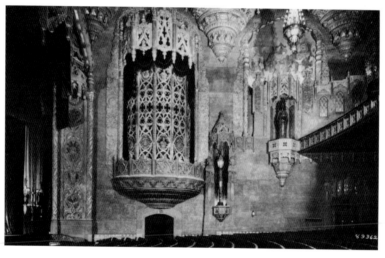

Top: The theatre and its office building occupied an irregular lot. To compensate,
architect Crane used the octagonal lobby to place the auditorium on an axis
angled relative to its entrance.
Bottom: The right auditorium side wall as seen before the theatre's opening in 1928.

Opposite
An architect's rendering of the Spanish Gothic interior.

155

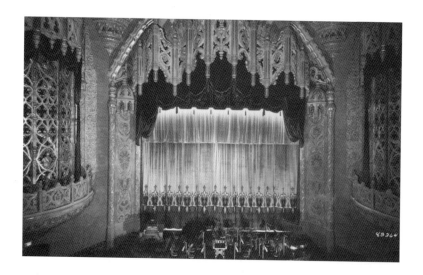

1928 views of the stage and the mezzanine foyer.

Opposite
The stage is a crumbling ruin and the foyer almost unrecognizable in these
photos taken in 2000.

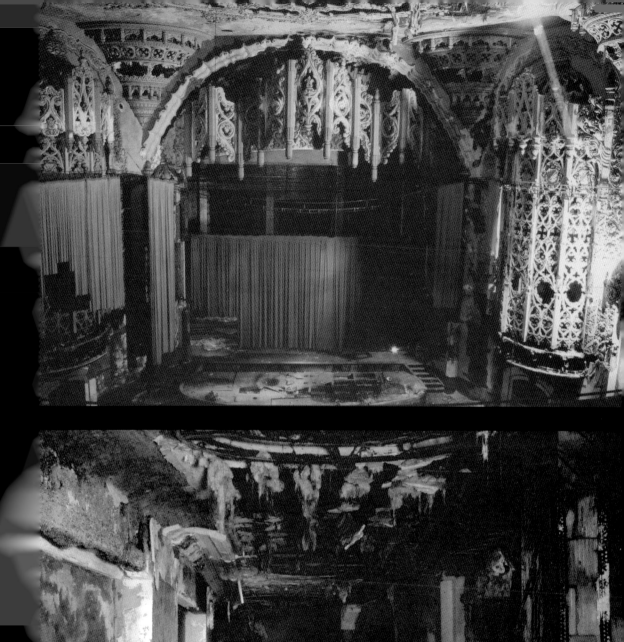
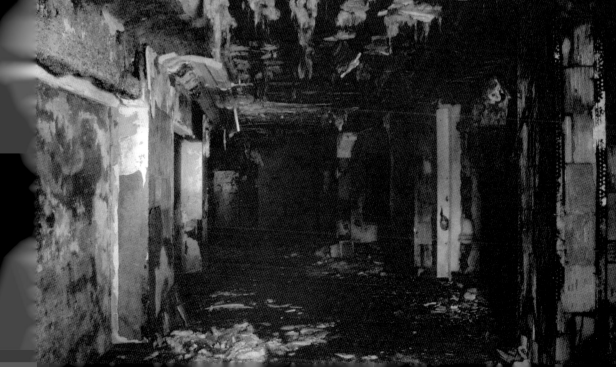

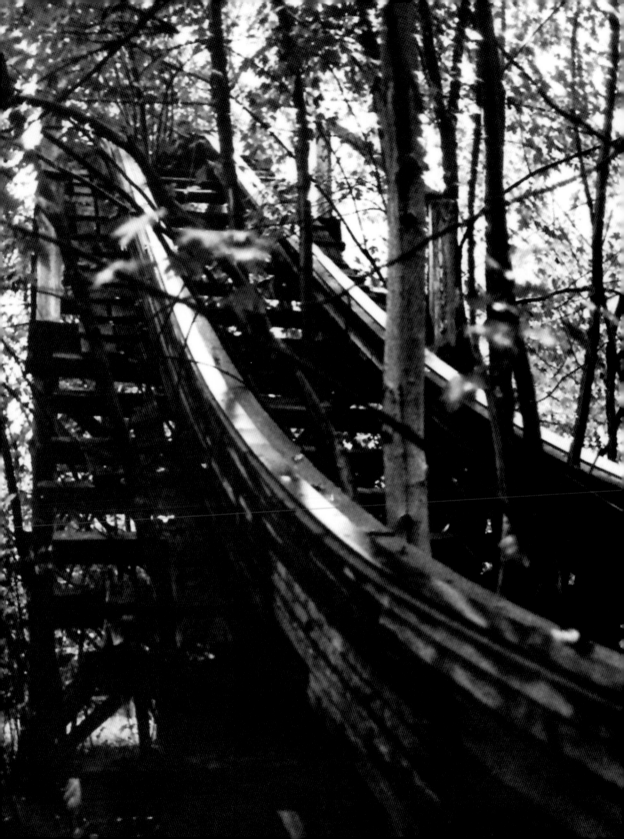

CHIPPEWA LAKE PARK

MEDINA, OHIO

Before the turn of the last century, when summers were long and warm, and air-conditioning was unheard of, people sought the cool breezes and restful atmosphere of lakeside resorts.

One such resort began around 1875 on the shore of Chippewa Lake, near Cleveland, Ohio, when a druggist named E. E. Andrews built a restaurant, dancehall, hotel, and docks, and opened them for summer business.

From its inception, Chippewa Lake Park was a great success. People came to picnic, swim, dine, and generally relax in the cool lakeside air. James A. Garfield spoke at a Republican picnic, and the trio of Thomas Edison, Henry Ford, and Harvey Firestone came to remove themselves from the burden of fame and wealth.

During the 1920s, Chippewa Lake Park began to change from a lakeside campground to a bona fide amusement park, with the addition in 1924 of a rollercoaster named The Big Dipper, and in 1927, a carousel built by the Allan Herschell Company. During this era such luminaries as silent film stars Dorothy and Lillian Gish came to camp and frolic in the cool, clear waters.

More rides and attractions were added in the 1930s and '40s as the park continued to prosper. There was a miniature railroad, a shooting gallery, Dodgem cars, a Ferris Wheel, Tumble Bug, and a penny arcade. The park was kept full with frequent corporate and school picnics, often consisting of thousands of guests. Big band concerts were also a popular attraction and were usually housed in the park's ballroom, which had a capacity of 4,500 guests. In 1937 Lawrence Welk, whose career was just starting, did his first live radio broadcast from the ballroom.

Through the 1960s the park prospered. Families would come to spend the day swimming, picnicking, riding the Ferris Wheel, and playing games in the arcade. Laughter and the delighted squeals of children echoed across the lake and, as night fell, mingled with the music of the glittering mirrored stampede that was the carousel and the clattering ascent of the Christmas Tree–lighted rollercoaster.

Those who saw it remember it as a golden time.

In 1969, when the park was ninety-one years old, Parker and Janet Beach, owners for the previous thirty-two years, decided to sell Chippewa Lake Park and enjoy a well-earned retirement. They had taken good care of the park, and it had returned the favor.

Sell it they did, to a company out of Cleveland called Continental Business Enterprises—in retrospect, an ominously ambiguous name. The company expressed its desire to invest "in the recreation field," saying that it constituted "one of the major growth areas for investment today."

On the park's one hundredth anniversary, November 11, 1978, its closing was announced. Various reasons were given—the recession, high maintenance costs, difficult competition—but no mention of poor management.

After the park closed, many of the rides were sold and carted away—but not all of them. For reasons that are vague, many attractions stayed behind.

Perhaps they could not bear to leave.

So as the years went by, and the asphalt sprouted cracks, then weeds, then trees, the Big Dipper continued to look down upon it all. The Ferris Wheel and Flying Cages stood aloof, at first waiting for a new season to begin, then later, growing senile in their dotage. The Tumble Bug, one of only five on Earth, tumbles no more, but quietly rusts. While the Fishpond, Burger Factory, and Frozen Whip stands cover their eyes and sleep.

BELOW AND OPPOSITE
As is often the case, the rollercoaster was Chippewa Lake's most popular ride.

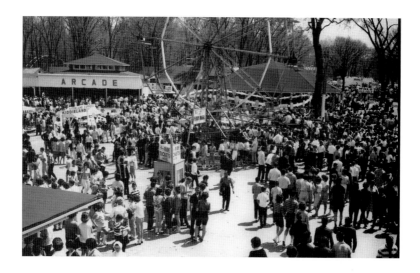

Top: In its prime, thousands would crowd the midway on a summer afternoon.
Bottom: Families loved the Tumble Bug. Built in 1927 by the Traver Engineering Company,
it was one of a few dozen ever constructed.

Opposite

Top: The midway's a jungle and the Ferris Wheel and arbor after years of neglect.
Bottom: The Tumble Bug, one of only five in existence, stands corroded and forgotten.

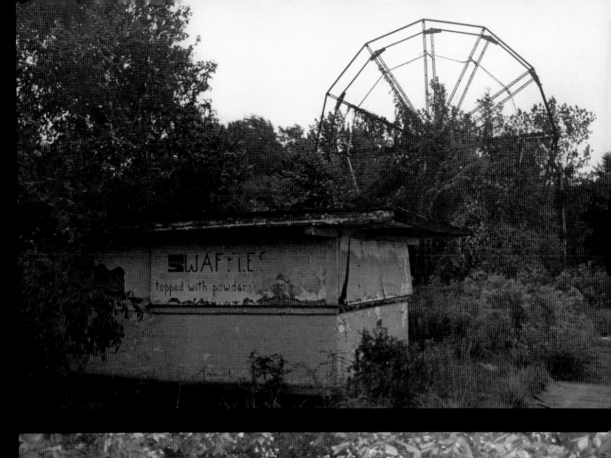

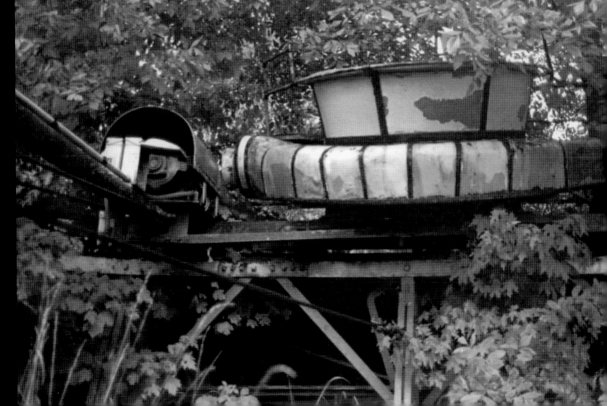

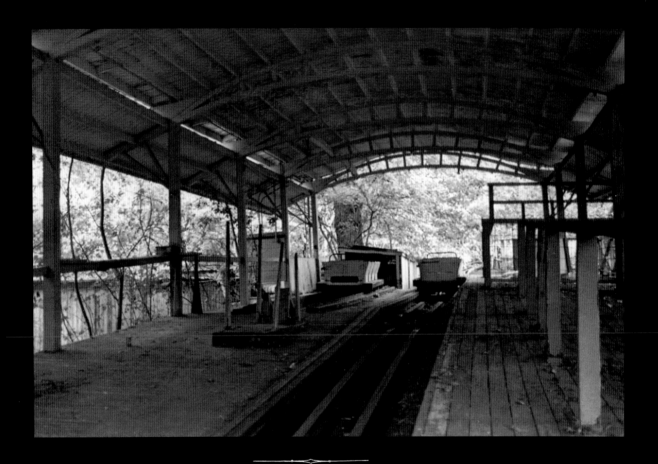

A rollercoaster car stands at the loading platform, waiting for riders
now long overdue, c. 1988.

OPPOSITE
TOP: As if in hiding, a lone car lurks in its tunnel. Even this cannot save it from the elements.
BOTTOM: The party's over. Chippewa Lake's 1923 dance hall stands vacant a decade
after the last party's end.

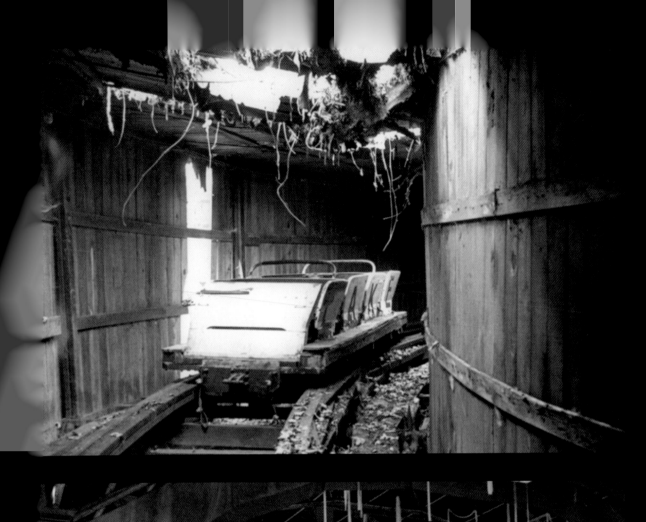

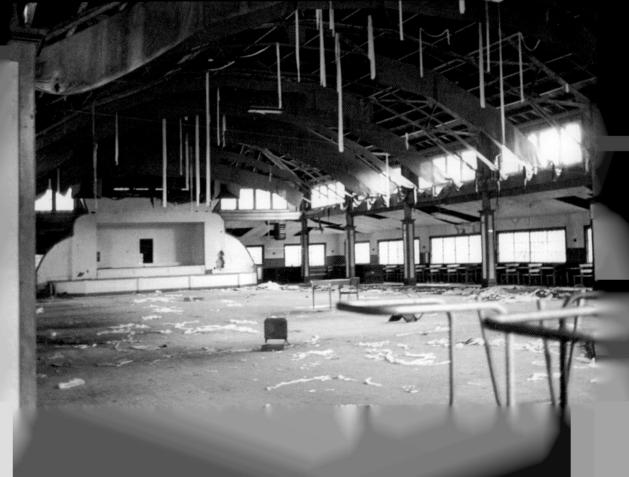

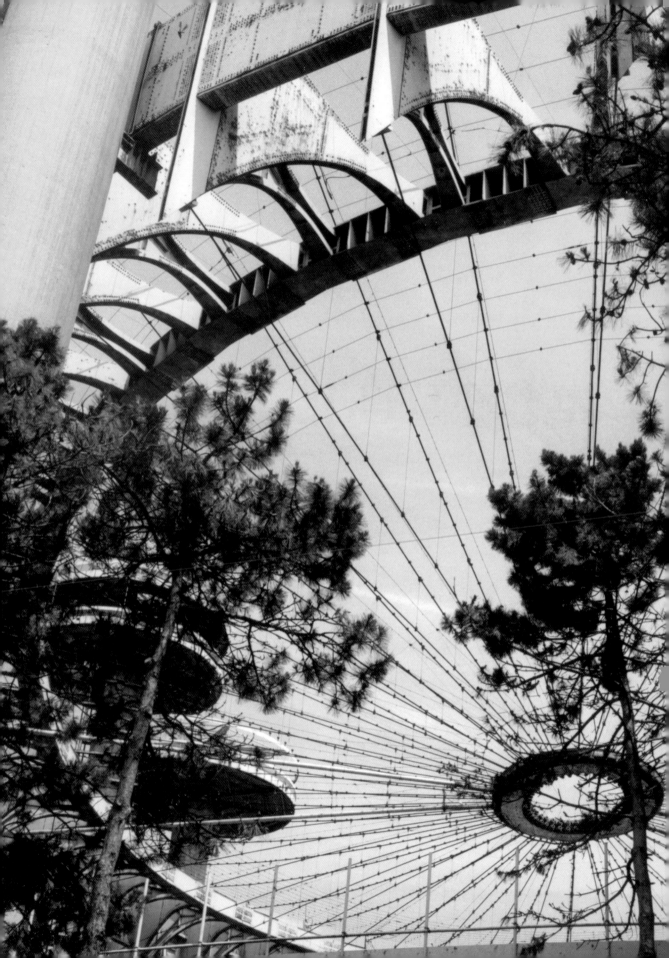

❧ THE NEW YORK STATE ❧ PAVILION

QUEENS, NEW YORK

The pavilion to be built on this site will stand as testimony to other efforts, hand-in-hand with fair officials and industry. The structure's nobility and grace will testify to the art of its famous architect, Philip Johnson, and to the skill and hard work of the men who will erect it.

—Governor Nelson D. Rockefeller
Remarks made at Groundbreaking for the New York State Pavilion, October 9, 1962

Designed as a "county fair of the future," Philip Johnson's New York State Pavilion for the 1964/65 World's Fair would prove to be one of its architectural highlights, and one of the few structures deemed worthy of preservation after the fair's close.

The pavilion consisted of three principal and interrelated structures: the Tent of Tomorrow, the Theaterama, and a cluster of three observation towers, the tallest of which, at 226 feet, was the highest point on the fairgrounds.

The Tent of Tomorrow was a spectacular elliptical open-air plaza, circumscribed by one-hundred-foot concrete columns supporting a dazzling translucent, multicolored plastic-paneled roof. Sunlight pouring through these panels to the floor far below illuminated a unique map of New York State. Executed in terrazzo, and over 160 feet wide, it was accurate down to the last town and highway and weighed 114 tons.

Next door was the Theaterama, a circular theater in which 360-degree movies proclaiming the wonders of New York State were shown in dizzying, panoramic splendor.

Throughout the fair the pavilion was a resounding success, popular with the public, lauded by critics. Crowds thronged. Events were held. Sunlight glinted off the parti-colored roof as elevators slid up and down like futuristic ladybugs, frantically climbing and losing traction on a giant flower stem. The future was magic.

But a fair, even a World's Fair, is a temporary thing, and at its end the buildings and exhibits and displays are dismantled and hauled away. Would this too be the fate of The Fair of Tomorrow?

No! The design was too perfect, the architect too famous. It had to be saved! After all, it was New York State! Think of the uses to which it could be put, in the great park that was to take the place of the great fair!

And so it was saved.

But no use was ever found for Philip Johnson's County Fair of Tomorrow. Except for a brief career as a roller rink in the early 1970s—a career cut short when the aging

roof panels began to fall—the great pavilion has stood empty ever since. It seemed that tomorrow wanted no part of it.

And so it stands now, with its rainbow roof panels removed and its elevators frozen in mid-flight; an empty promise of a future that never materialized. And far below an inaccessible observation tower—the tallest point at a nonexistent fair—sprawls a terrazzo facsimile of New York State, circa 1964—cracked and frozen in the past.

"In a way, the ruin is even more haunting than the original structure."
—Philip Johnson, 2002

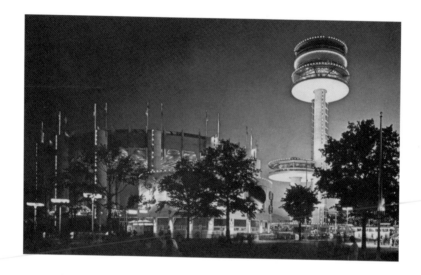

A night view of the pavilion, busy and glowing, during the World's Fair in 1965.

OPPOSITE
Even rusting, and denuded of its glowing colored panels, the elegant geometry of the pavilion is evident.

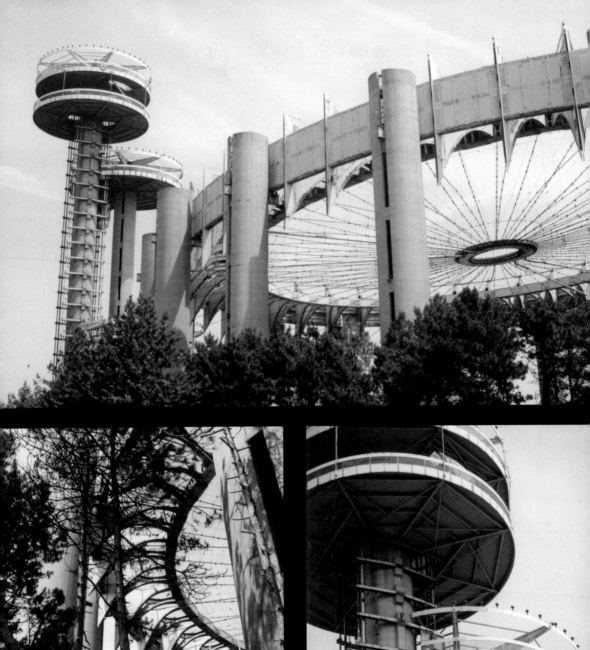
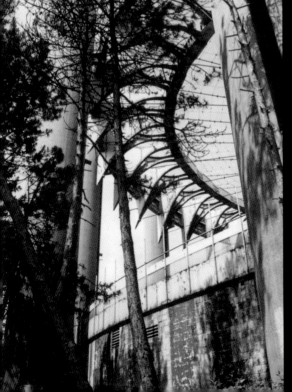
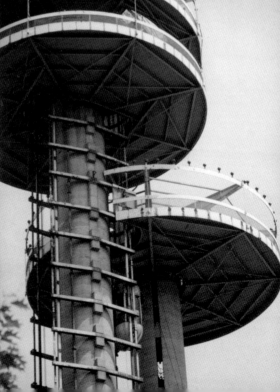

Chapter 7

·)· REINCARNATION ·(·

Once upon a time, buildings were both functional and beautiful. Functionality was born of necessity, and beauty out of longing for respite from an imperfect world.

Our predecessors understood proportion and scale, when to embellish and what to leave plain; how to mix and match heights and details and colors and textures to achieve effects of grandeur and intimacy; how to break up an otherwise featureless surface with just enough ornament to relieve boredom or, with a bit more, to add excitement. Imaginary lines crossed and intersected along a building's elevation, and at their nodes and angles sprang arches and entablatures, cornices and fenestration—an orchestration of invisible order and hidden design. And our eyes and hearts delighted in these not-always-consciously perceived interplays of order and chaos, stone and clay, copper and glass. And when we gazed upon their humanity we were refreshed.

And within the larger buildings, hidden beneath their skins of brick and terra cotta and stone, lay iron skeletons, their joints fixed with white-hot rivets. And within those stood great blustering ventilation fans, their purifying breath providing comfort and health to their frail human masters; and speeding elevators, allowing those same fragile beings the brief miracle of flight to lofty eminences of their own devising. All of the myriad pumps and motors, tanks, and veins of iron and brass; all the workings, from the cockles of its cast iron radiators to its copper pate, built to last indefinitely. Form following function following form, in a round robin of practicality and delight.

But then we got smart. Beauty was renamed simplicity, and the rich textures of stone and brick were replaced with great beige slabs of sameness. Proportion was an encumbrance and decoration bourgeois. Screws replaced rivets, drywall supplanted plaster, and the clockwork innards became ten times more complex but lasted a fraction as long. Finally, a few individuals, sunlight- and fresh air–deprived in their hermetically sealed offices and windowless cubicles, sick of theory posing as architecture and longing for humanity's warmth, had had enough.

And so a few old buildings were saved. Not many, but some. Because a few of the lemmings saw the precipice and wanted no part of it. They thought they'd rather have a drink with a few friends or read a good book and enjoy the fresh air, than join the great march to oblivion.

So which to choose? What path to take? Continuity or novelty? Warmth or sterility? Anonymity or humanity? Oblivion or...

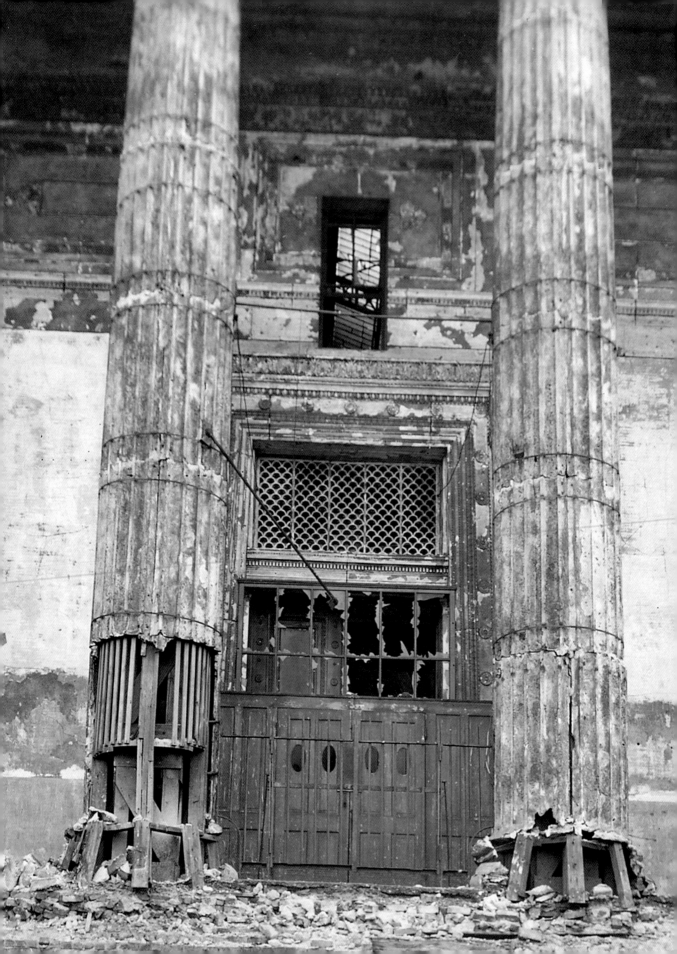

❧ The Palace of Fine Arts ❧

Chicago, IL

One of the greatest stories of survival is that of the Palace of Fine Arts.

Designed by Charles B. Atwood for the 1893 Colombian Exposition, its original purpose was to house exhibits of fine art from around the world. The building's design was classical Greek, but adapted to the needs of a modern museum. Covering four acres, it was one of the original "great buildings" at the fair, and housed so many paintings that it was said that spending only one minute admiring each one would require twenty-six days! Although the shining "White City" that was the fair seemed to be built for the ages, it was, like all fairs, essentially a sham. Almost without exception the largest structures were constructed of a plaster compound called "staff," made to resemble stone, and affixed to a wooden frame. It was more movie set than city.

The exception was the Art Palace. Because of the value of its contents, and the ever-present danger of fire, the Art Palace was made of brick. So when the fair closed and was dismantled, the Palace of Fine Arts was retained to house the nascent Field Museum, which contained many former fair exhibits. But in 1920 a new permanent home for the Field Museum was constructed in Grant Park, abandoning Atwood's building to the elements. Slowly its columns and friezes began to erode and melt away, exposing the naked brick beneath.

But people missed the great fair, and thirty years later the Palace of Fine Arts was the last crumbling vestige of the White City's grandeur—a reminder of the glory that had once been. And they wanted it back. Enter Julius Rosenwald.

Rosenwald, chairman of Sears, Roebuck and Company, proposed construction of a science museum such as he had seen in Germany years earlier, in the old Palace. After receiving wide popular support for the idea, in 1926 the South Park District passed a $5 million bond issue to restore the building, provided that, externally, it look just as it had in 1893. The restoration architects were to be Graham, Anderson, Probst and White—the progenitor company of the original designers.

The reconstruction took years. The building was almost completely dismantled and recreated in limestone, exactly mimicking the old staff and brick (which had been mimicking stone). Finally it was as permanent as it was meant to appear.

Since 1940, The Museum of Science and Industry, as it became known, has continued the building's original purpose of educating and entertaining the public. Now it serves again as a national destination, and a tribute to the artistry of its creators.

Two views of the Art Palace during the 1893 World's Fair. The south entrance, which faced the fairgrounds, was originally the main entrance and was approached by boat.

Opposite

Top: The sad remains of the Art Palace in October, 1929. No fairgoer has boated to its grand entrance for over thirty years.

Bottom: The entrance to the West Court, July, 1929.

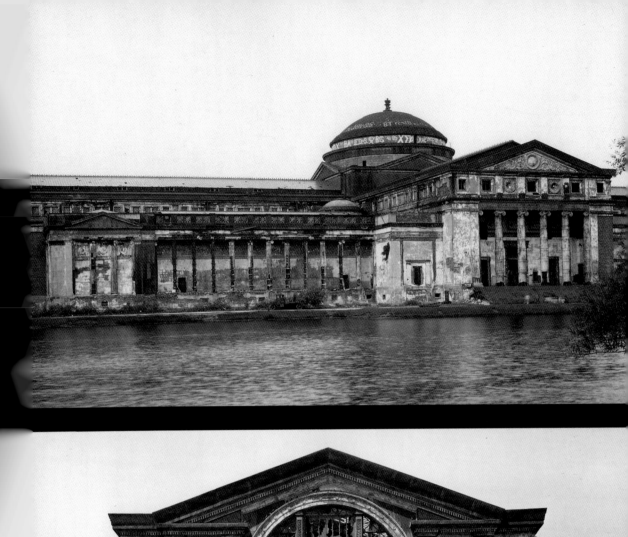

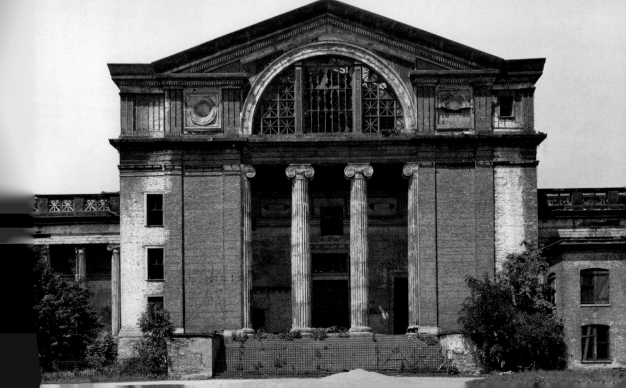

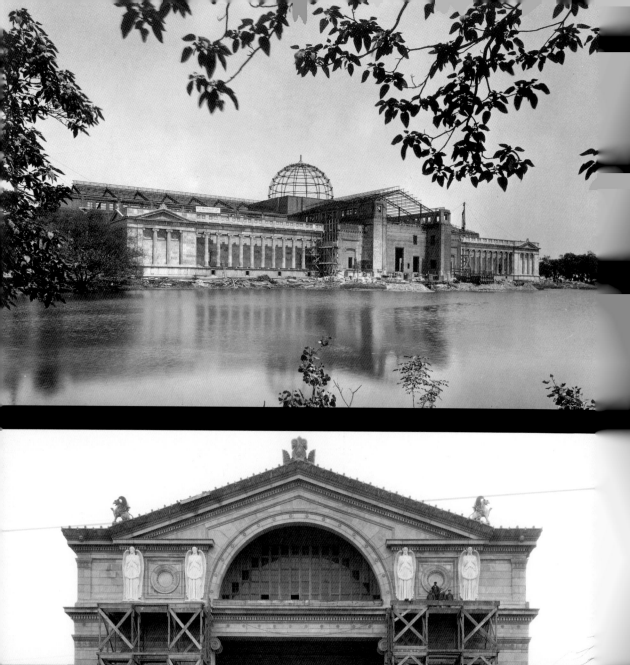
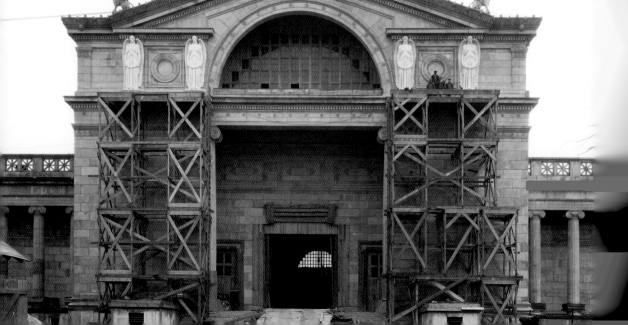

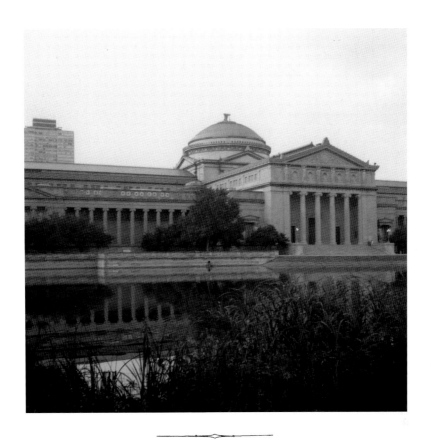

The Museum of Science and Industry, 2003.

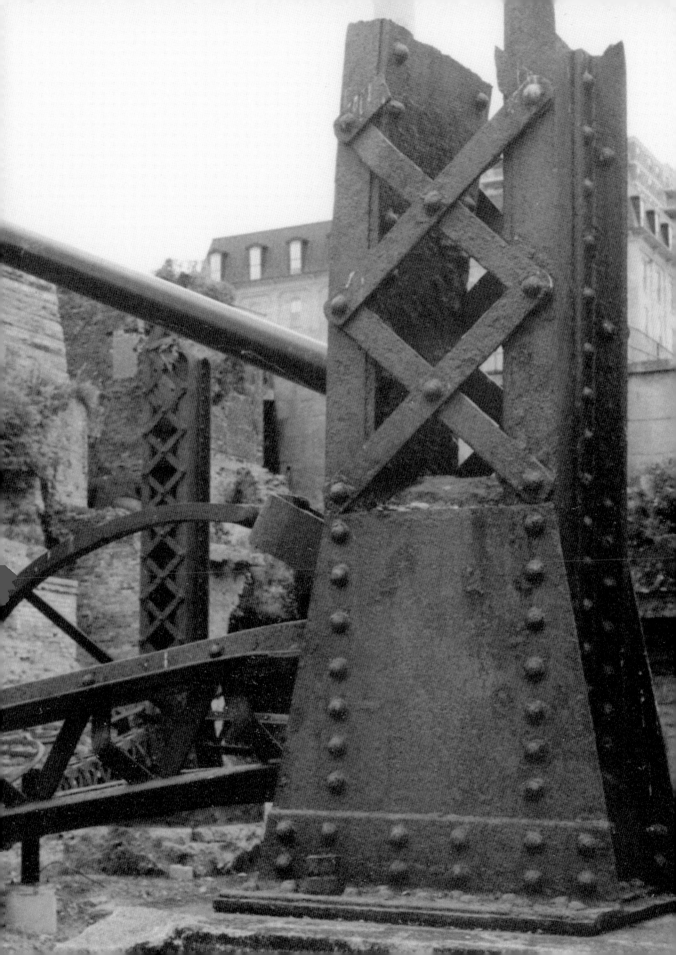

THE MINNEAPOLIS STONE ARCH BRIDGE

MINNEAPOLIS, MINNESOTA

Crossing the Mississippi river at Minneapolis is a graceful granite and limestone bridge.

The 2,100-foot-long stone arch bridge was designed by Colonel Charles C. Smith and constructed over a two year period using more than 100,000 tons of stone brought from Wisconsin, Iowa, and Sauk Rapids, Minnesota.

The bridge was built as a collaboration between the City of Minneapolis and railroad magnate James J. Hill, and was intended to expedite transport of freight and passengers between the Twin Cities. It is the only stone arch bridge to cross the Mississippi, and the oldest mainline railroad bridge in the northern Midwest.

Its graceful curve was originally necessary to allow an approach to the now-demolished Union Railway Depot, on the Minneapolis side of the river. For eighty-five years it safely conducted trains across the river, until its abandonment in 1978.

Rather than destroy the aging bridge, it was decided to restore it as a part of a downtown heritage trail project. Restoration began in 1993, and now the bridge has a second life as a beautiful bicycle and pedestrian path affording breathtaking views of the St. Anthony Falls, the shipping lock, and Mill Ruins Park.

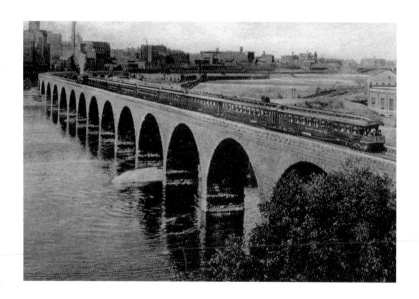

The Oriental Limited crosses the bridge heading toward Minneapolis, sometime after its completion in 1883.

Opposite
Top: The bridge as it appears today, adapted for use as a pedestrian walk across the scenic river.
Bottom: Beside the bridge, in what was once a thriving industrial milling district, ruins in the aptly named Mill Ruins Park. 2003.

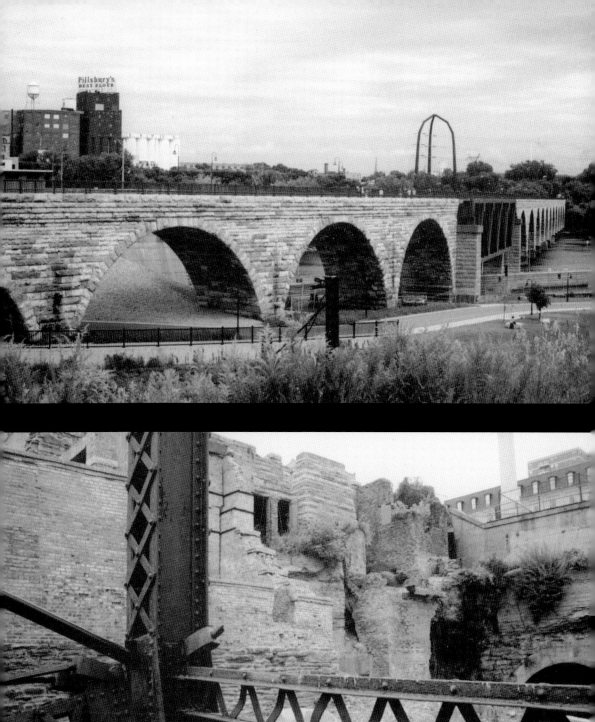

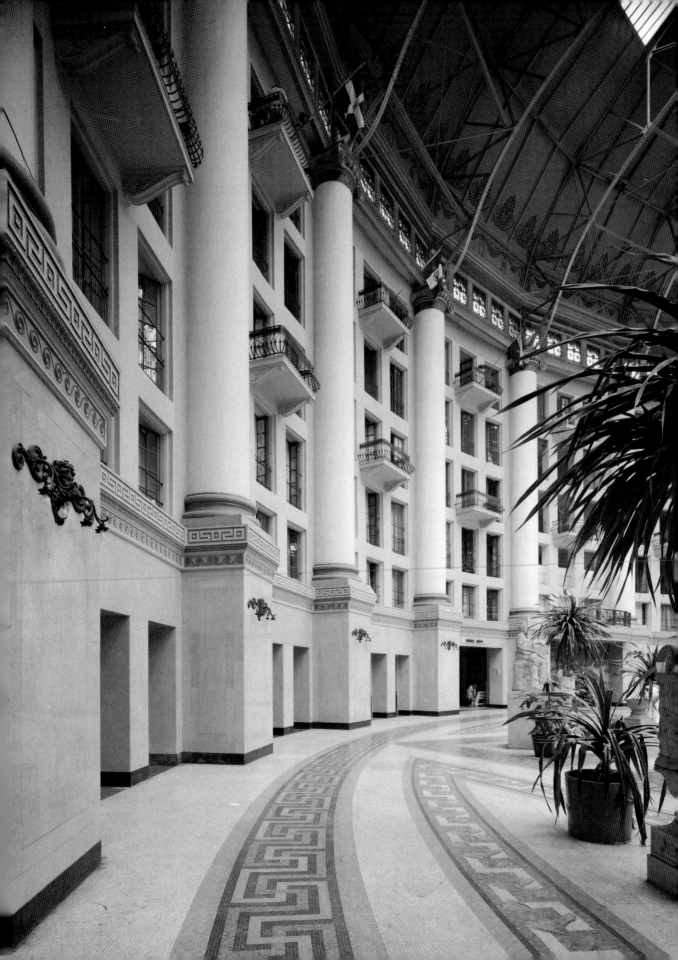

THE WEST BADEN
SPRINGS HOTEL

WEST BADEN SPRINGS, INDIANA

Before news of the stock market crash clattered from the stock ticker in the brokerage of the West Baden Springs Hotel, the hotel had been enjoying a banner year. Four days later, it was all but empty.

The West Baden Springs Hotel opened in 1902—constructed on the remains of a previous, fire-ravaged hostelry. The popularity of the earlier establishment was based on that of the local mineral springs, and dictated that the new hotel be even larger and more elaborate.

Lee W. Sinclair, the hotel's owner, wanted a hotel to equal the great European spas (thus the corruption of the name Wiesbaden), and so decreed the construction of what would become the West Baden Springs Hotel.

The finished hotel contained seven hundred rooms arranged around a spectacular domed atrium (the largest in the world for the next sixty years) two hundred feet in diameter, under which birds fluttered, and within which a giant art nouveau fireplace burned man-sized logs on cool evenings.

In addition to the atrium, the hotel contained the mineral baths, a barbershop, a bank, and other stores. Elsewhere on the property were to be found golf, horseback riding, baseball, bowling, hiking, and billiards. There was really no reason to go anywhere else.

But the 1929 crash signaled the end of an era for the hotel. With patronage reduced to a tiny fraction of its pre-Depression heights, and most of its rooms empty, in 1932 the hotel closed. In 1934 the Jesuits purchased it for one dollar.

For thirty years it operated as a Jesuit seminary before changing hands again—this time becoming the campus of a private college. Again it continued on in its new guise, until it again closed in 1983.

In 1987 the hotel was designated a national historic landmark. Despite this, deterioration continued until, in 1991, ice and water from a damaged roof drain caused the collapse of a portion of an outside wall.

For the last twenty years, sporadic repairs have been made in an effort to stabilize the structure while constant fundraising and paid tours have been conducted in an effort to finance its restoration, as groups of volunteers have worked to save this spectacular survivor of an earlier, more graceful, era.

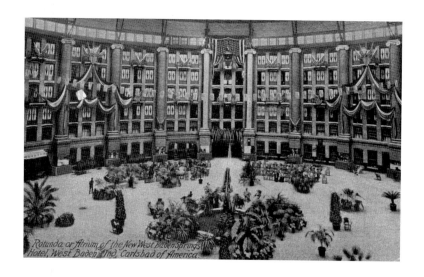

Top: Postcard view of the West Baden Springs Hotel, c. 1909.

Bottom: A detail of the mosaic floor in the rotunda.

Opposite

Top: In this 1974 view the atrium looks much as it did in the early decades of the century.

Bottom: The giant art nouveau fireplace is designed to accommodate logs much bigger than a man.

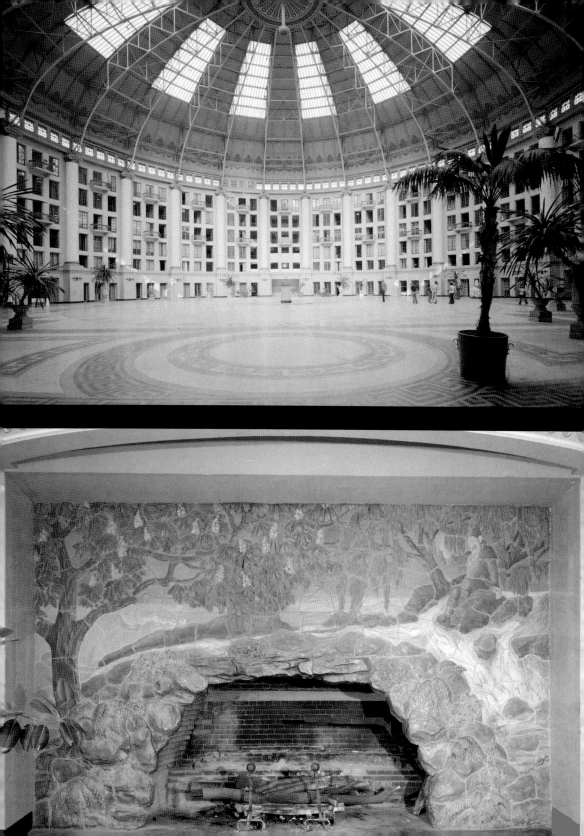

Chapter 8

Epitaphs

When we build, let us think that we build forever. Let it not be for present delight nor for present use alone. Let it be such work a s our descendants will thank us for; and let us think, as we lay stone on stone, that a time is to come when these stones will be held sacred because our hands have touched them, and that men will say, as they look upon the labor and wrought substance of them, "See! This our father did for us."

—John Ruskin

An abandoned building waits. It waits in silence and stillness, punctuated only by wind and rain, the falling autumn leaves and the gentle layering of winter snows upon its roof.

Long may it stand, silently enclosing the echoes of its life, of its residents, those beings who built it, imbued it with vitality and purpose and then, like a soul escaping an aged body, fled.

Years may pass as the building slowly decays. First goes the glass—brittle and tempting—easy prey for a well-aimed projectile or wind-blown branch. Then the wood, rotting where touched by rain and insects and sun. Perhaps a bit of cracked slate or corroded copper flashing falls away, and a tiny opening appears. A small thing—but the building's fate is sealed. For the sagging roof is the last defense against the implacable elements. And once the roof leaks the plaster falls. Then the weakened roof fails, followed by the overloaded floors. Then brick walls, no longer strengthened by the displaced timbers, their mortar weakened, topple inward. And what was once a church or a home or bank or hospital, is rubble... and memories.

Even the most worthy, the most elegant, significant, irreplaceable icons of our civilization are often left to perish by slow, lingering decay. Although the swifter coup de grace of a wrecking ball or explosives may be more spectacular, perhaps a building's agonizing, drawn-out demise serves better to remind us what poor stewards of our legacy we have been. And how, next time, we might do better.

So without further adieu, we present, appearing here for the very last time, ruins that are no more. Cenotaphs in the shapes of buildings. Last words said over fallen comrades...

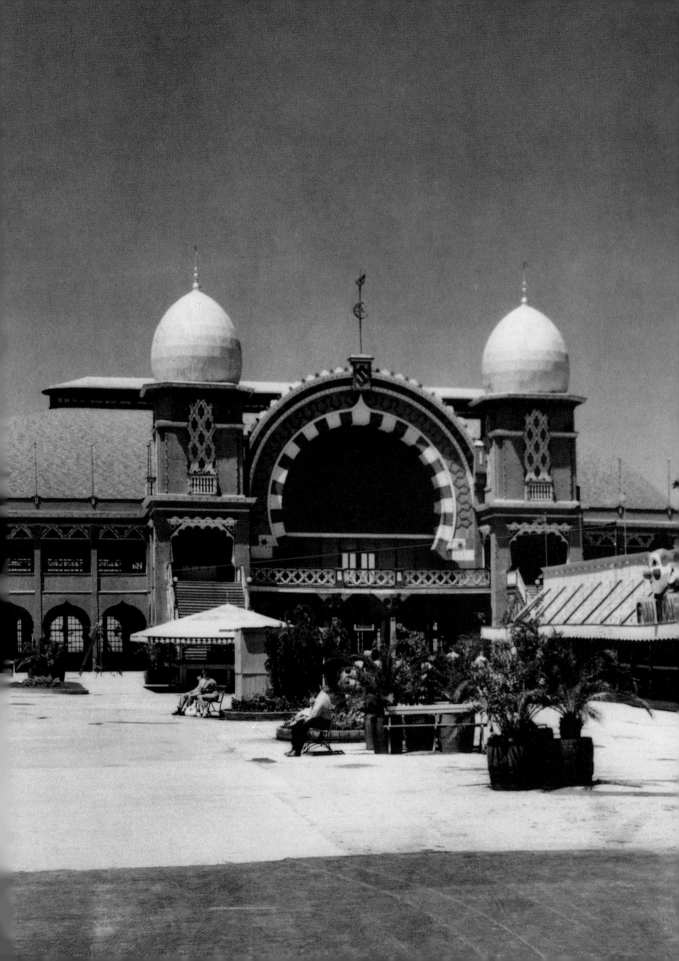

⊱ SALTAIR ⊰

Perched on Utah's Great Salt Lake once stood the impossible Moorish fantasy that was Saltair.

Part bathing pier, part dance hall, part amusement park, Saltair was built by the Mormon Church in 1893 as a place of wholesome recreation for the faithful. It provided saltwater bathing, dining, live music, carnival rides and even, after the pier was sold to a private operating company, gambling.

For decades Saltair prospered as the largest amusement complex west of the Mississippi. Its dance hall was a major venue for the likes of Glen Miller, Paul Whiteman, and Gene Krupa. Once it burned down to the water line, but was almost immediately rebuilt on an even grander scale; such was its popularity.

But while fire could not destroy it, water—or indeed the lack thereof—would prove its downfall.

By the 1950s changes in the level of the Great Salt Lake had left the pavilion high and dry, hundreds of feet from the receding water. In 1955 a series of small fires destroyed portions of the complex, and in 1957 a freak windstorm destroyed its Giant Racer rollercoaster. Saltair's days were numbered, and in 1958, after a financially disastrous season, the pier closed for the last time.

After sixty-four years of laughter and music, the cavernous ballroom stood empty. Streamers still hung from its rafters, souvenirs of the final performance, while the empty bandstand held court over a vast silence.

For years Saltair stood aloof at the end of its six-hundred-foot-long causeway, minarets and domes darkly mysterious silhouetted against the moon and the Great Salt Lake. In 1961, industrial film director Herk Harvey happened upon the ruin and was inspired to make it the centerpiece of his now cult-classic horror film Carnival of Souls. It was to be Saltair's last starring role.

In 1970 a fire destroyed all that remained of the great pavilion, right down to its salt-encrusted pilings.

This time it was not rebuilt.

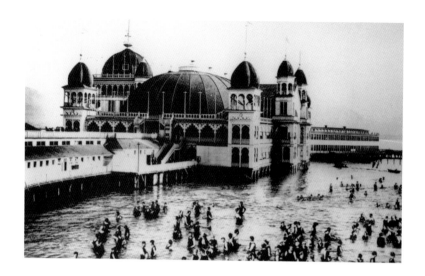

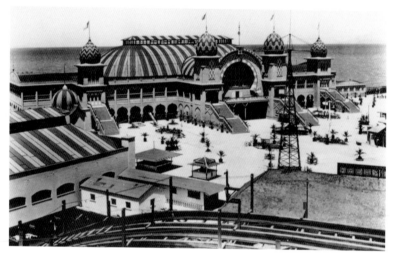

Saltair, before the fire (top) and rebuilt (bottom).

Opposite
Top: One of the two sprawling bathing piers which extended from either side of the center pavilion, c. 1900.
Bottom: The cavernous ballroom, decorated for one of its last shows, c. 1955.

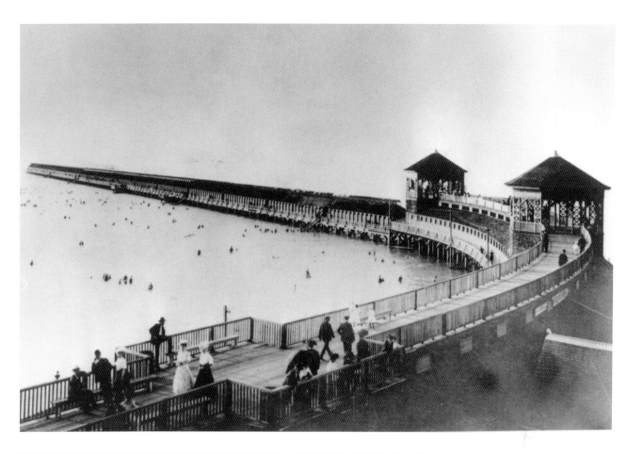

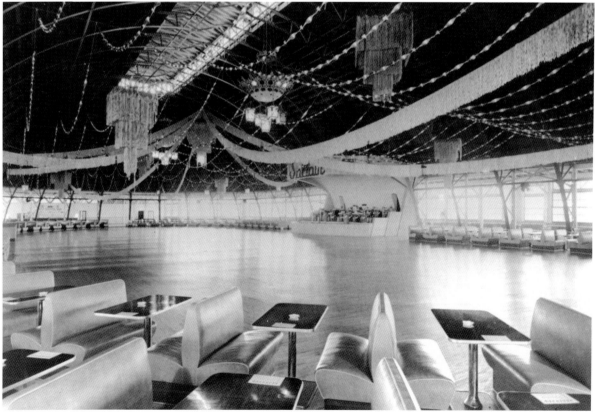

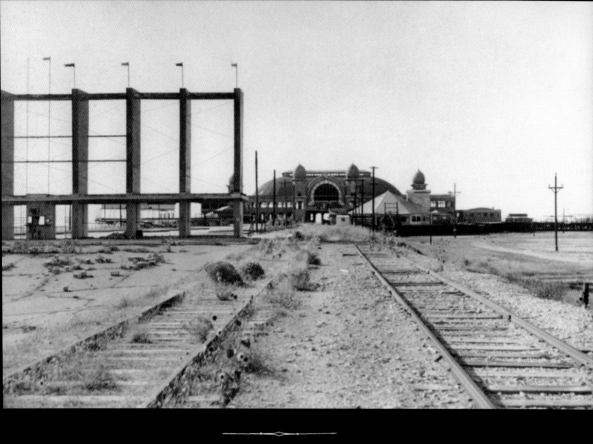

Isolated at the end of its six hundred–foot causeway, Saltair stands
derelict and alone, c. 1965.

OPPOSITE
The lakeshore has turned to mud, the pier is in ruins and no band will ever play the
great ballroom again.

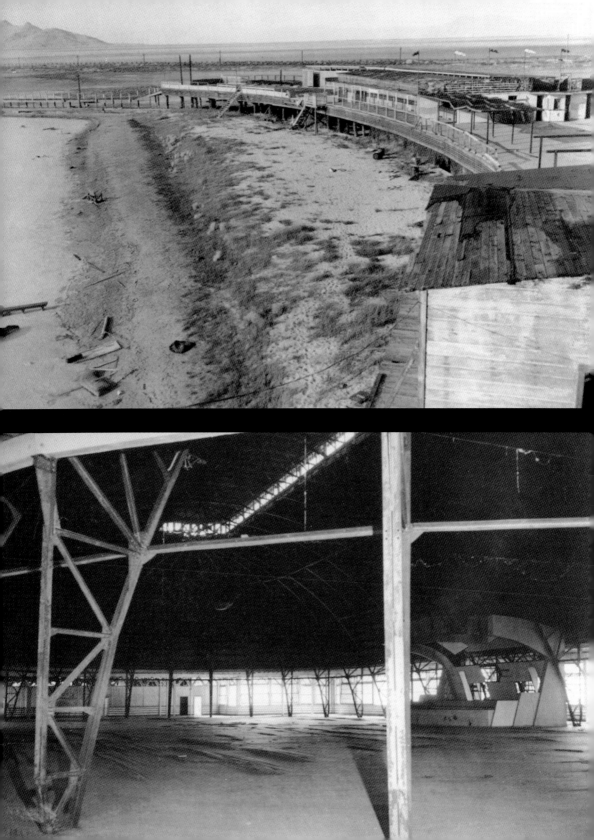

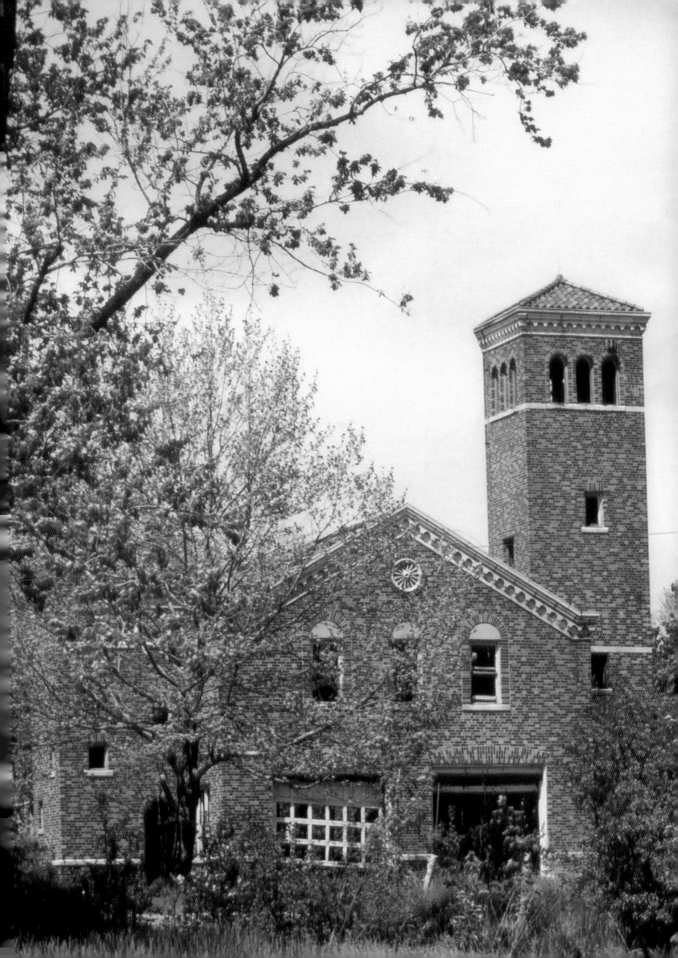

❧ THE WAYNE COUNTY ❧ TRAINING SCHOOL

WAYNE, MICHIGAN

In 1926 the Wayne County Training School for Feeble Minded Children accepted its first residents into its care. The school was constructed to house and train mentally impaired children between the ages of six and eighteen years. The goal being to "...make good citizens and useful men and women out of a class of unfortunates that has hitherto been a menace to society and a detriment to progress..."

Despite the harsh tone of the stated objective, the school really was as pleasant and comfortable as could be imagined—even today. It was designed on the "cottage" principal, where a series of cottagelike residences and dormitories were distributed about a beautiful rural setting. Along with the residences were intermingled treatment, training, administrative, and recreation buildings and facilities. In 1930, upon the completion of what would ultimately be the finished complex, there were thirty-eight buildings, including eighteen dormitories, four classroom buildings, a gymnasium, swimming pool, powerhouse, fire station, and laundry, all located among gently rolling, wooded hills and connected by lighted sidewalks (and underground steam tunnels). At its peak the facility housed over seven hundred residents and staff.

Although designed for as many as eight hundred, and with enough acreage for virtually unlimited expansion, the school's population would soon begin to decline, as other facilities opened around the state. Later trends in treatment also conspired against this pastoral paradise, as the accepted treatment methods tended more toward education than training for trades.

However lovely and humane, the Wayne County Training School closed in 1974. Although a maintenance staff was kept on until 1978, the prohibitive cost of utilities and maintenance for the vast complex conspired against it, and they too were dismissed. The facility was now abandoned.

The property, with its homes, basketball courts, firehouse, and power plant, stood forlorn for years, the grass growing tall and the ubiquitous lilac bushes reaching high above the cottage roofs. In 1997 a local teen fell to his death from the roof of an abandoned building on an adjacent property, and the government was forced to act.

After several failed attempts to find a use for the nine hundred–acre facility, it was demolished in the late 1990s. Condominiums are now sprouting on the fallow ground where once this humanitarian enterprise stood.

Although closed and technically off-limits for many years, the parklike grounds were often used by locals for picnics and softball.

OPPOSITE

TOP: Only the shell of this director's residence remains. Unlike most of the buildings, this one was not Italianate but Gothic in design.

BOTTOM: One of the many larger buildings in the complex, which likely contained classrooms

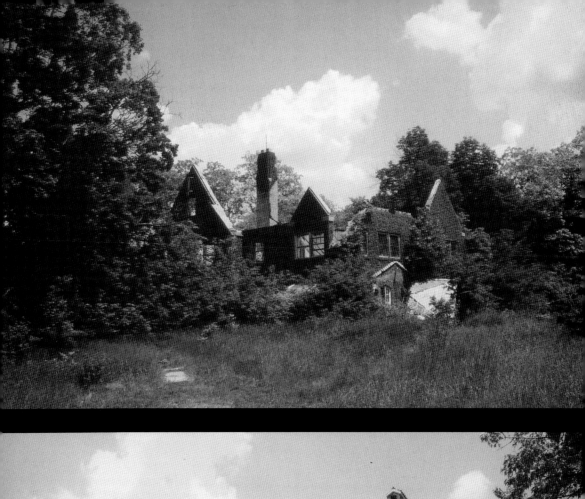

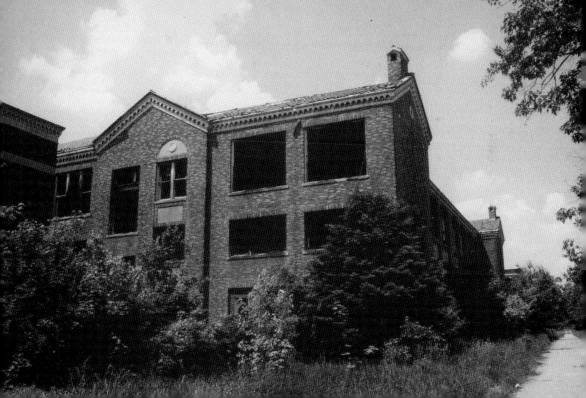

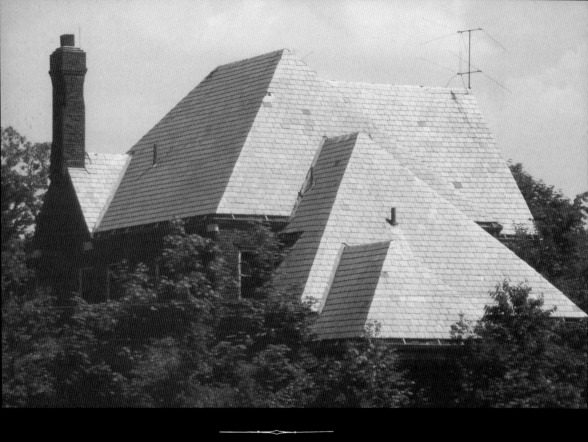

Vast expanses of slate cover a staff residence, now hidden in the undergrowth.

OPPOSITE
Two views of the Powerhouse. Massive steam engines once housed here produced power for the complex.

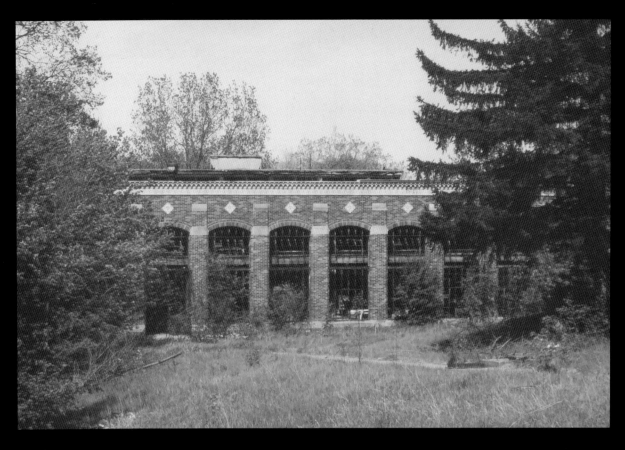

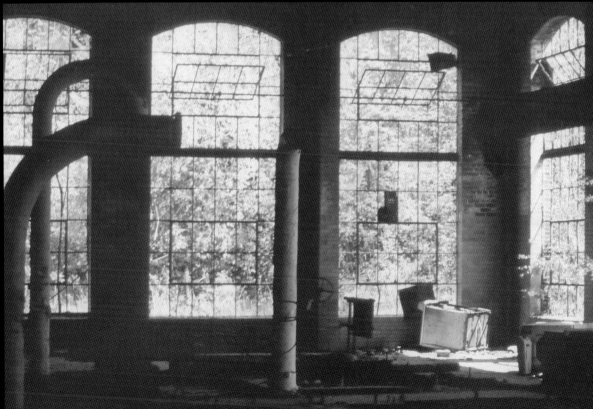

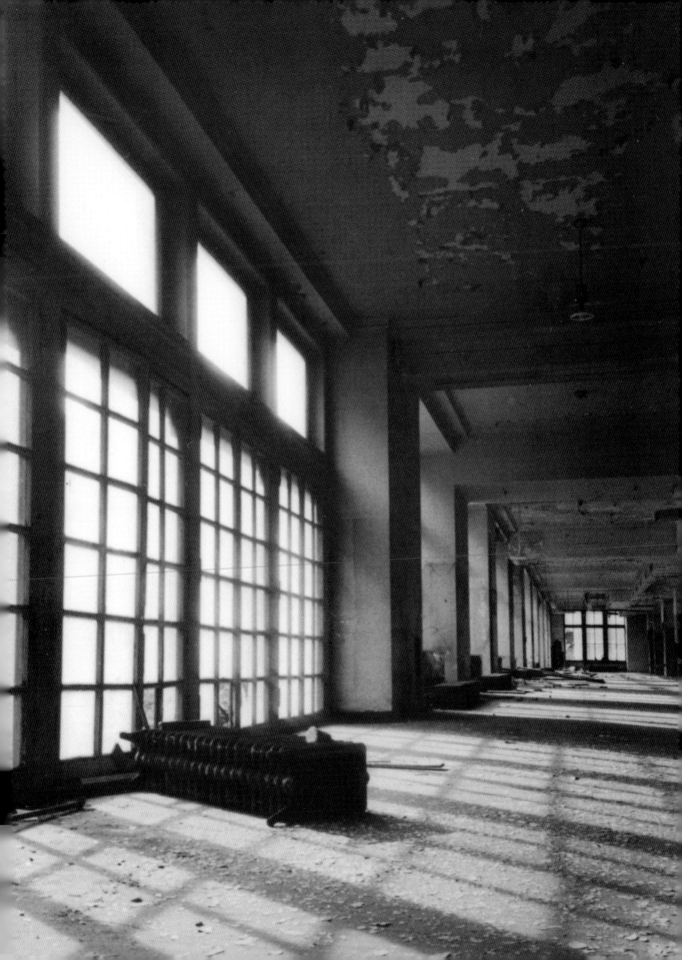

❧ HUDSON'S ❧

DETROIT, MICHIGAN

There are not enough superlatives to describe the J. L. Hudson department store.

Known to the locals as Hudson's, the building began life modestly enough in 1891 as an eight-story full-line department store—a relatively new concept at the time—but by the late 1920s it had grown to occupy nearly an entire city block.

Larger than any department store in the country except Macy's in New York, Hudson's comprised 2.2 million square feet over thirty-two levels. From the top of its four-hundred-foot-tall tower to the floor of its fourth basement, Hudson's contained over forty-nine acres of every service that one could desire.

Its distinctions were many. Hudson's was the first air-conditioned department store. Upon its completion in 1928 it contained more elevators under one roof than any other building on earth: seventy-six (and forty-eight escalators!). It had over seven hundred fitting rooms and the world's largest beauty salon. It had eighteen entrances, one hundred display windows, and the largest telephone switchboard in the country, after the Pentagon. It was astounding.

But by the 1960s things began to change. Populations fled the cities for the new suburbs, and convenient local shopping malls sprouted like weeds. Riots and increasing urban blight accelerated the flight from the cities, and one by one, businesses began to close. During the 1970s Hudson's began to falter, as business and profits suffered, and by the early 1980s they were the last major retailer in the now barren downtown landscape, a lone giant struggling to survive.

At the end of the 1982 holiday season, after doing business in the same location for over ninety years, Hudson's closed its doors for the last time.

For another sixteen years the building stood empty, except for vagrants and memories, a victim of scrappers and politicians, until October 24th, 1998. On that date, at 5:45 pm, Hudson's became the largest building in history to be imploded with explosives—a final superlative, drawing to a close the history of a great department store and a remarkable building.

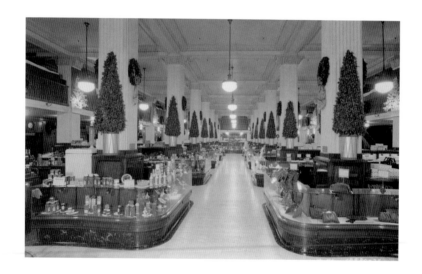

Christmas time on the main floor, c. 1940

OPPOSITE
TOP: The huge building contained over two million square feet of retail space
and occupied an entire city block. The four-hundred-foot-high tower contained a carillon
which chimed the hours.
BOTTOM: One of the many elevator machine rooms, c. 1927. The motors and generators
were maintained in pristine condition.

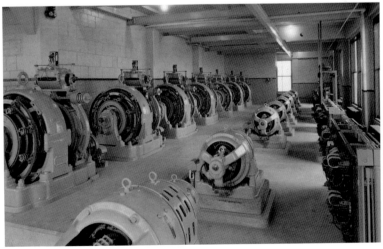

The elevators and their machinery are no longer operable, 1997.

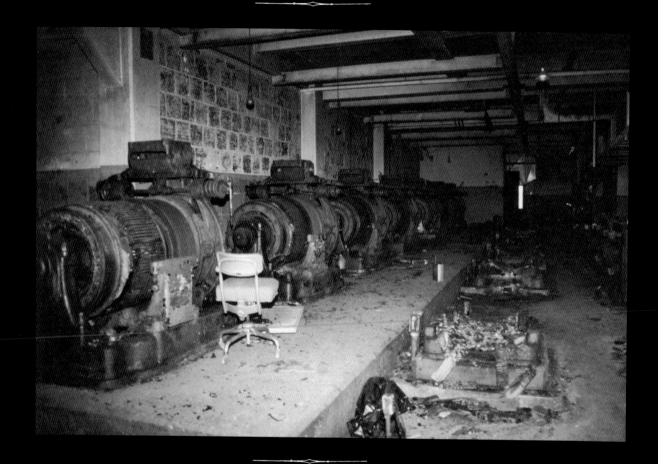

OPPOSITE
No customers linger by the windows looking out at the city far below (top), and no employees
dine in the cafeteria (bottom).

OVERLEAF
LEFT: No footfalls echo in the empty staircases.
RIGHT: In a few seconds the second-largest department store in America is reduced to rubble.

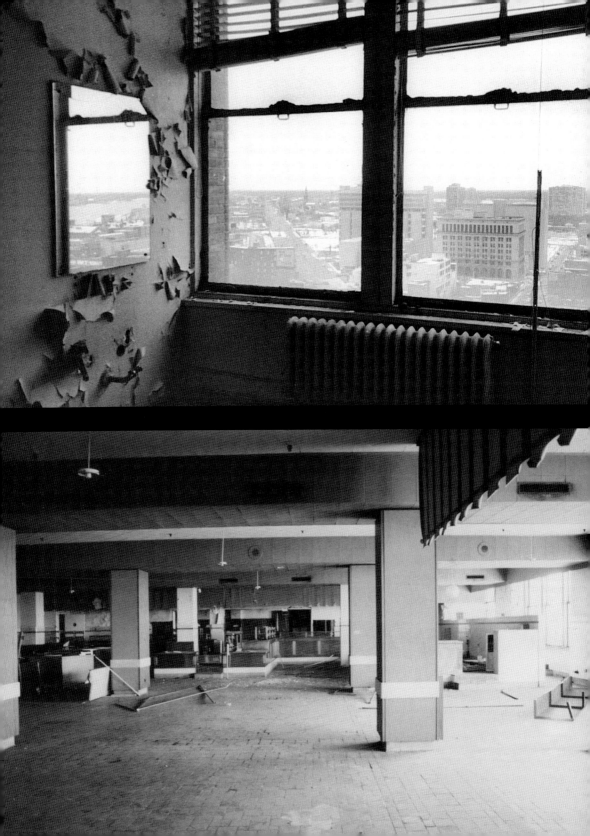

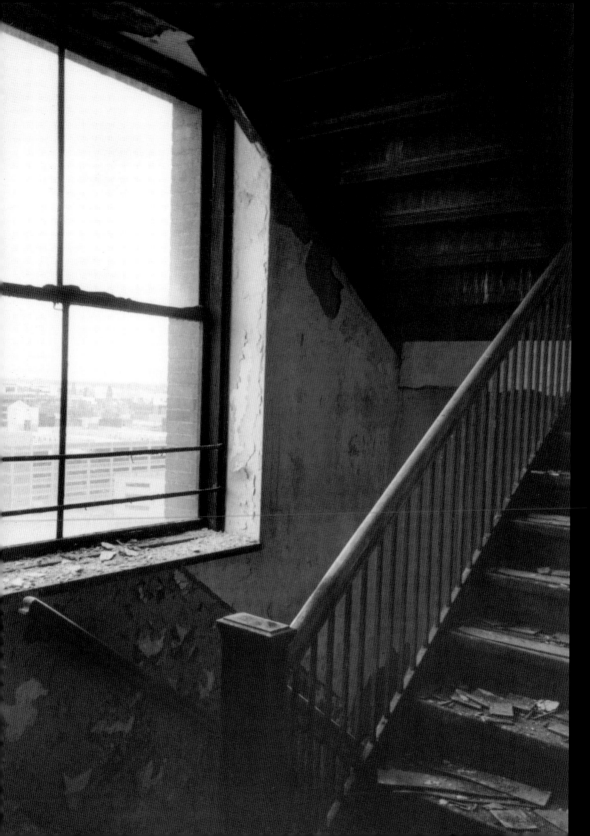

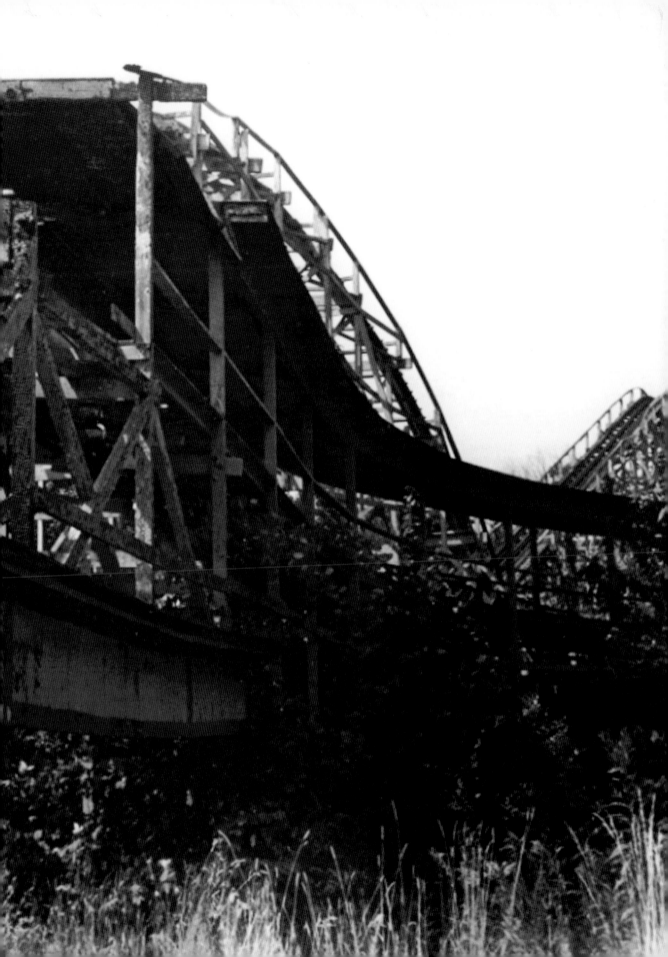

❯❙ Idora Park ❙❮

For eighty-five years, laughter, music, and squeals of delight permeated the summer air of an otherwise quiet neighborhood on the south side of Youngstown, Ohio. Residents, rather than being outraged, counted themselves as fortunate—for they lived next to Idora Park.

Idora Park was started in 1899 as a "trolley park." Built on the outer fringe of town, it was created not just as a recreational destination, but as a way for the streetcar company to increase its otherwise fallow weekend business. Originally not much more than a dance hall and theater, Idora soon added a rollercoaster, carousel, and swimming pool. There were picnics in the grass, musical comedies in the theater, and concerts in the dance hall. In the early days John L. Sullivan fought there and John Phillip Sousa's band played. Later, over a hundred bands and orchestras including the Dorseys, Cab Calloway, Guy Lombardo, and Benny Goodman would play in the by-then famous ballroom.

By the 1940s Idora had become a major regional attraction, boasting two major roller coasters, a Ferris Wheel, dodgem cars, a water ride, miniature railroad, kiddieland, penny arcade, roller-skating rink, and more. A hungry visitor could indulge in Idora's famous "candy floss" or French fries, along with other more substantial fare, or one could partake of games of skill and chance along its midway.

But by the 1970s high gas prices, air conditioning, and television conspired to diminish Idora's attendance, and in the 1980s the park went up for sale. Limping along with reduced profits and high maintenance costs, the park was only barely sustainable, until, just before opening in the spring of 1984, a welder's torch ignited a fire which destroyed several major rides, including one of the rollercoasters. Although it struggled through the 1984 season, the park closed for the last time at summer's end.

Idora, the best amusement park between Cleveland and Pittsburgh, stood silent and forlorn for almost twenty years. Eventually a church group purchased the property, announcing plans for a "City of God." The remains of the park were, without fanfare, bulldozed. To date, nothing has been built on the site.

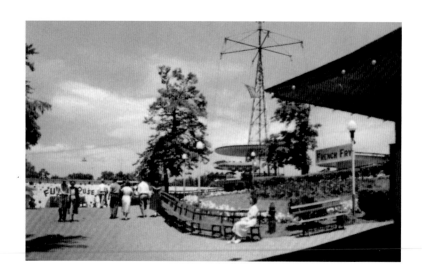

For many years Idora Park flourished as one of the favorite amusement parks in the region.

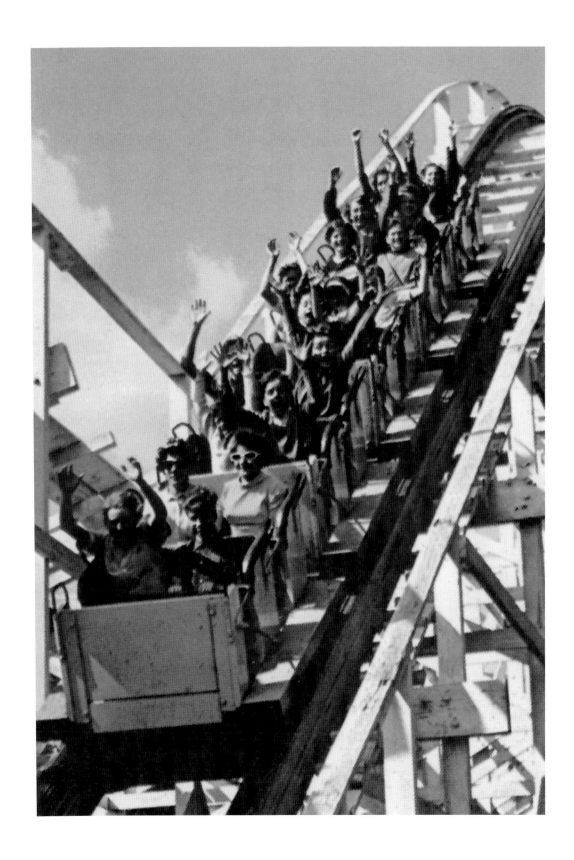

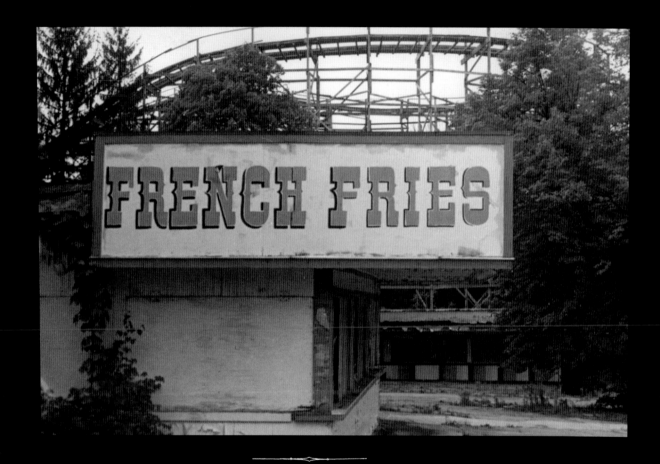

The aroma of Idora's famous fries no longer wafts through the midway.

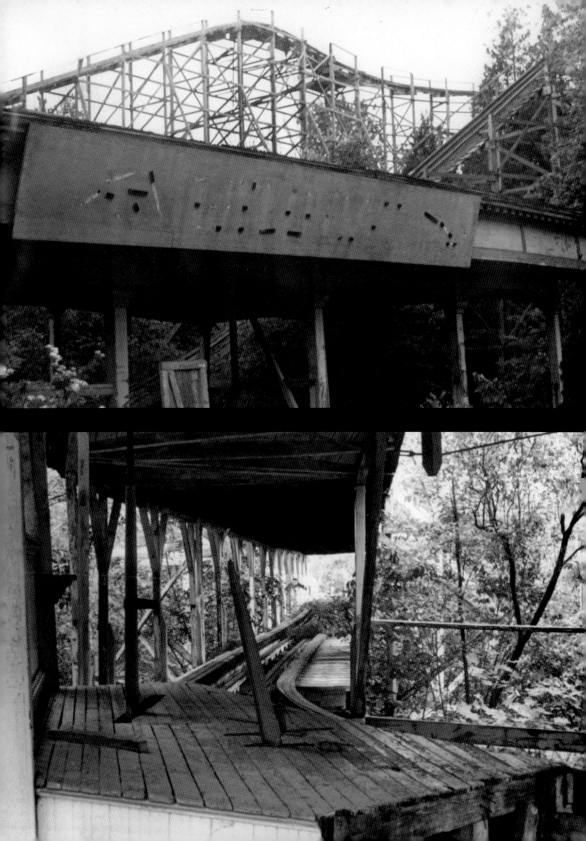

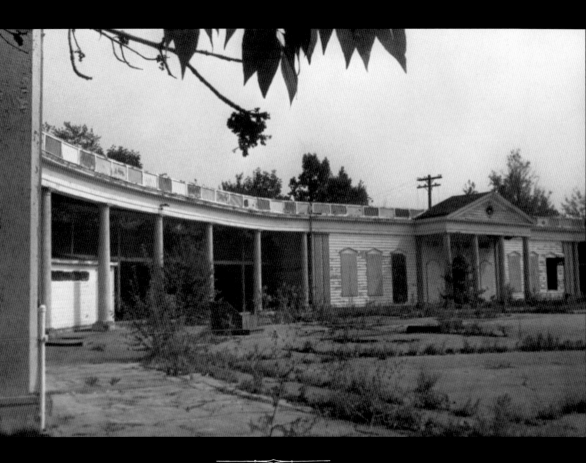

The encircling colonnades of the bath house once embraced the oval swimming pool.
In later years a safer kiddieland replaced the pool.

OPPOSITE
TOP: The remains of the lower midway in the late 1980s. The carousel pavilion is on the left
and the arcade is on the right.
BOTTOM: Although constructed in 1910, the ballroom underwent extensive renovation in 1956.
Even though the park had been closed for several years by the time of
this photo, not only was the ballroom remarkably intact, but it still had electric power.

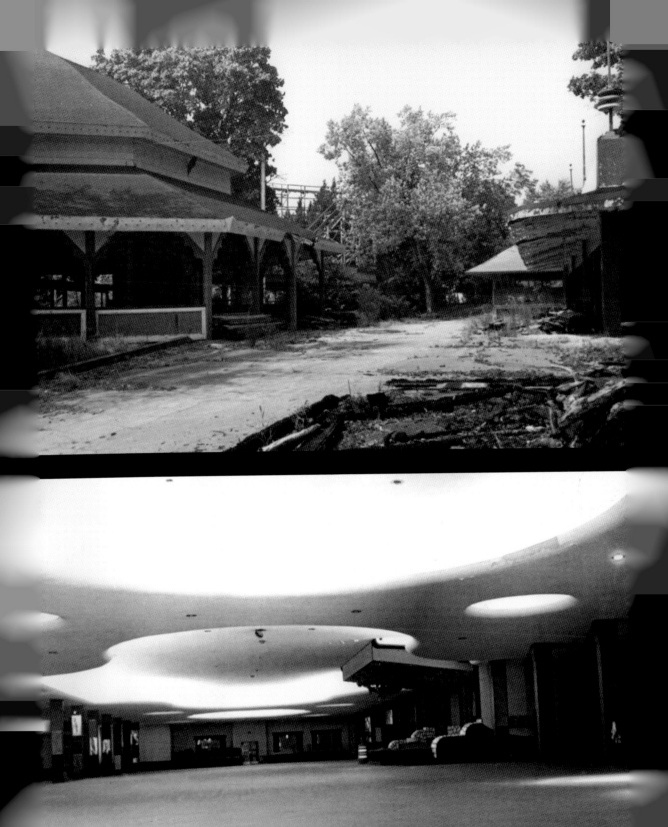

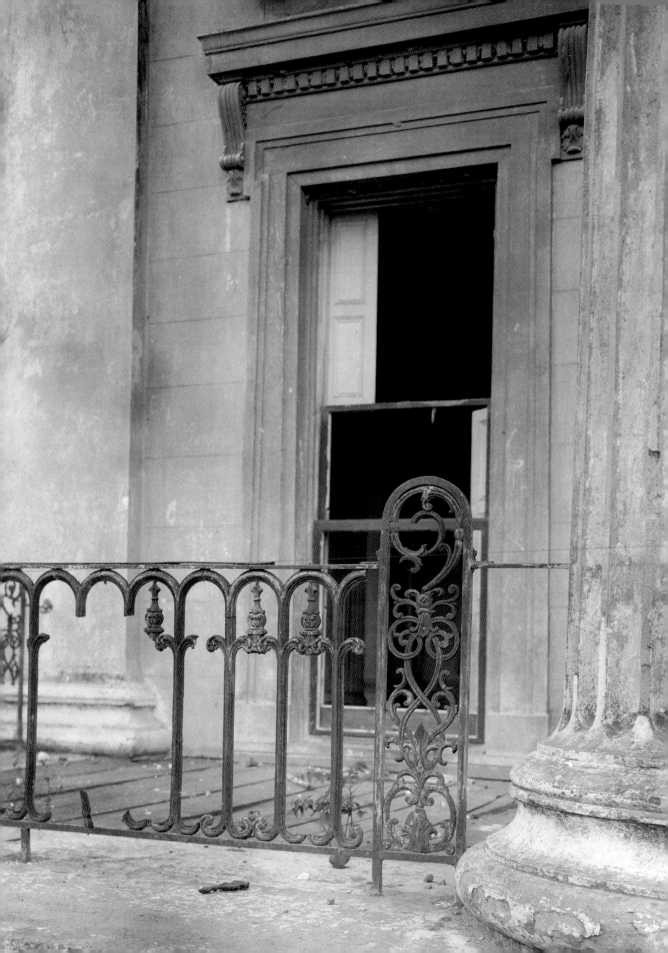

❧ BELLE GROVE ☙

Louisiana: land of bayous and Spanish moss, Mardi Gras and voodoo... and ghosts. This particular Mississippi ghost has long since evaporated, but for years its spectral form haunted Iberville parish.

Belle Grove plantation house was built in 1857 by John Andrews, a Virginian who had come to Louisiana twenty-seven years earlier. Although pictured here in its dotage, Belle Grove, in its prime, was palatial. With seventy-five rooms it was one of the largest antebellum homes in the south. Its rose-tinted stucco exterior was treated to resemble stone, and real marble steps ascended to its entrance portico. Thirty-foot Corinthian columns supported a classical Greek pediment, while inside, an ornate circular staircase curved sinuously up to the second floor. The architecture of Belle Grove was, however, unique, in that it combined classical motifs with Victorian composition and sprouted an unlikely assortment of asymmetrical bays and wings in addition to its classical principal facades.

Although fashionable and prosperous for nearly fifty years, the dissolution of the plantation system by the early decades of the twentieth century precipitated the decline of Belle Grove.

In 1925 an auction was held to dispose of the mansion's furniture and fixtures. Even the black marble fireplace mantels were tagged, sold, and removed, leaving Belle Grove literally a shell of its former self.

For years it stood as a slowly decaying vestige of the antebellum south until it eventually succumbed to fire, water, and time. It was razed in the 1940s.

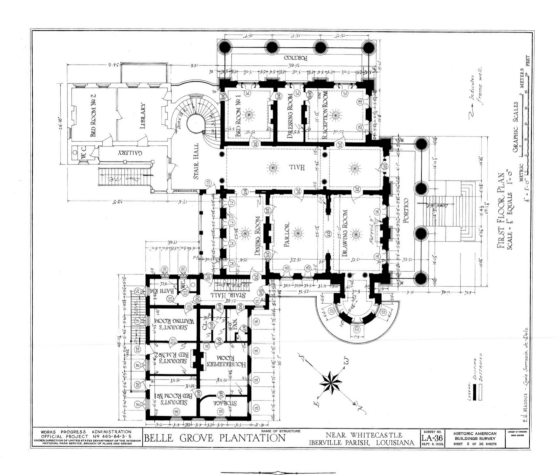

Belle Grove in plan. The main floor, including the servant's wing, consisted of about a dozen rooms, plus the sixty-foot-long central hall.

<div align="center">OPPOSITE</div>

Although essentially Greek revival when viewed from the front, a side view reveals the eclectic composition of the Victorian mansion, 1936.

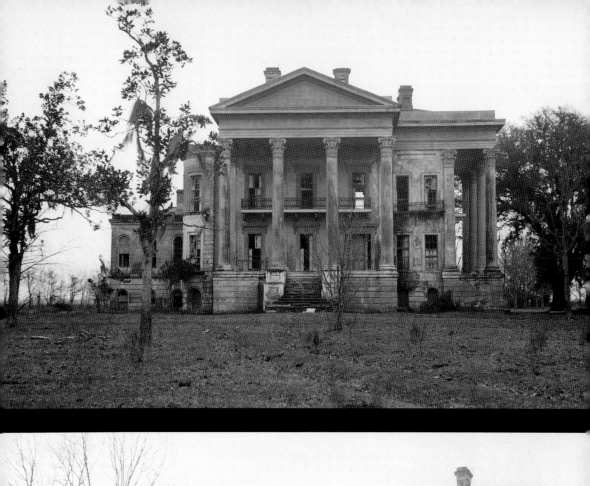
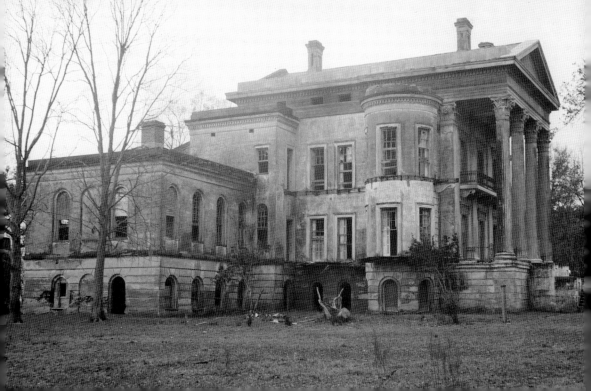

———◇———

The beauty is in the details.

———◇———

A missing column hardly detracts from the spectacle of the front drawing room. A few years
after this picture was taken, Belle Grove would be gone.

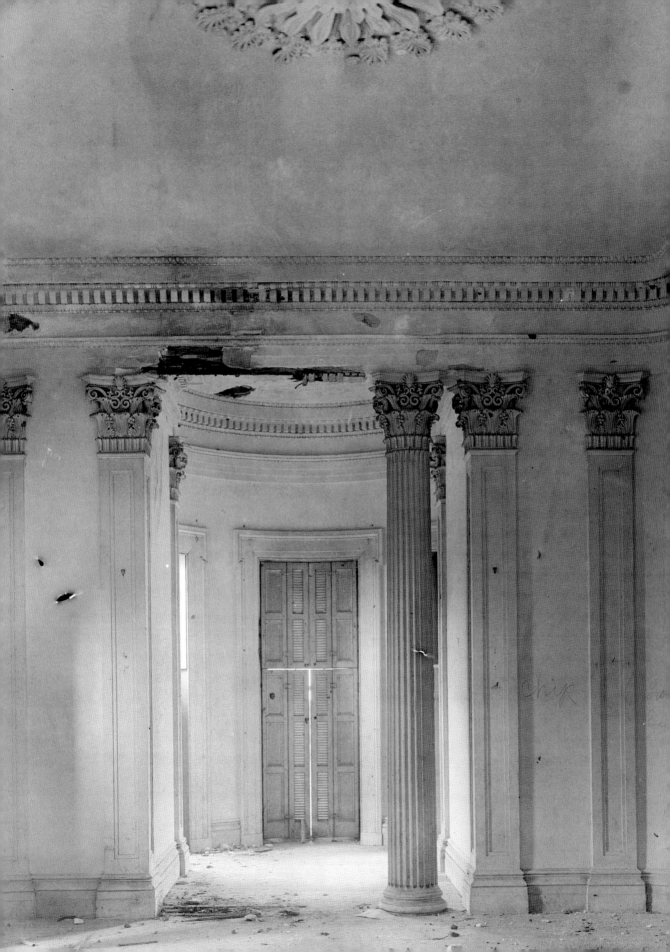

AFTERWORD

How did you like our little tour?

Was the air dank enough? Were the rooms sufficiently dim? Could you hear the echoes of your footfalls, or those of unseen others? Could you hear the music of the broken calliope, the chugging of long vanished locomotives, the gibbering of phantom lunatics? Did you catch the occasional whiff of popcorn, the smell of oiled machinery, or the moist earth of a cellar? Could you feel the hard, damp surface of stone walls or the parched, dry earth, cooked from below by a hidden inferno? Could you almost see the cowboys, prisoners, slaves, engineers, and artists, or the movies flickering on tattered screens?

Then our tour was a success.

Perhaps the things you saw will leave a lingering impression. Perhaps you may now regard them in a somewhat different light. One can only hope.

After all, buildings are people too.

Please watch your step in exiting the book.

And mind the bones.

❧ ACKNOWLEDGMENTS ❧

A ll books are a collaborative effort, this one perhaps more so than most.

The photos contained herein are the product of many photographers over the course of years; some are skilled professionals, others gifted amateurs. Although I would like to thank everyone who was gracious enough to allow the use of their material, some of them deserve special recognition: I'd like to thank Thom Johnson for his fact checking and spectacular photos of Bannerman's Castle; John Gray, for his creepy and wonderful pictures of Danvers State Hospital; Shaun O'Boyle and Gerry Weinstein, for their flawless pictures of the Ship Graveyard; Bill Frisk, for his always amazing pictures of Chippewa Lake Park and Idora Park; David and Diane Francis, for their priceless images of the good old days at Chippewa Lake Park; and Mike Hauser, for allowing the use of his Hudson's photos and permitting me to accompany him into the ruin of the great department store so many times. In all cases I wish I'd been able to use more of your work. I'd also like to thank Patrick Austin, Fred Folger, Anthony Murray, David Kohrman, Elise Robinson, Dave Phillips, Alyn Thomas, and Ray Reilley for their special contributions. Also special thanks to the staff of Eastern State Penitentiary, who allowed me access to the prison.

Many photos were also obtained courtesy of The Library of Congress, which houses the photographic material of The Historic American Buildings Survey and Historic American Engineering Record. Among the talented and dedicated professionals whose work is represented from their collections are: Jet Lowe (Bethlehem Steel), Jack E. Boucher (Wyndcliffe and West Baden Springs), Joseph Elliot (Delaware River Viaduct), David Sagarin (City Hall IRT), Cortlandt V. D. Hubbard (Eastern State), and many others.

Special thanks to Jennifer Jamieson, who typed her fingers to the nub and dealt with the evil computers on my behalf, her husband David, Chase Taylor, and all their co-workers, who helped in my mad pursuit.

Last but not least, I'd like to thank Scott Tennent and Jan Haux of Princeton Architectural Press, who distilled voluminous text and hundreds of images down to a manageable, readable size.

Any factual errors are mine, and are completely unintentional.

H. S.

❧ PHOTO CREDITS ❧

Author 38, 41, 43, 51, 60–62, 67, 74, 78–79, 102, 108, 111–14, 118 right, 119–21, 138, 141, 143–45, 152, 157, 166, 169, 177–78, 181, 194, 196–199, 204, 205 bottom, 207
Author's Collection 46 top, 64 top, 70 top, 76 left, 92–93, 98, 116, 154 top, 155, 168, 174, 180, 184 top, 210–11

Patrick Austin (http://splatterfish.com) 66
Buffalo & Erie County Historical Society 58 bottom, 76 right, 77
Courtesy of Burton Historical Collection, Detroit Public Library 42 bottom, 140, 203 top
John S. Coburn 142
Danvers Archival Center, Danvers, Massachusetts 104
Courtesy of Detroit Public Library, National Automotive History Collection 64 bottom, 65 bottom
Fred Folger 50
David & Diane Francis Collection 160–62
William Frisk 158, 163–65, 208, 212–15
John Gray (www.grayphotography.net)(www. danversstateinsaneasylum.com) (www.metropolitanstatehospital. com) 105–07
Michael Hauser 200, 205 top, 206
Davis Hillmer Collection, Detroit Historical Museum 202, 203 bottom

Thom Johnson (www.bannermancastle.org) 2, 4, 22, 82, 84–89
Albert Kahn Associates 65 top
David Kohrman 90, 94–95
Library of Congress, HABS/HAER 1, 28–29, 44, 47–48, 52–53, 68, 71, 73, 117, 118 left, 122, 124–27, 130, 133–37, 146, 148–49, 182, 184 bottom, 185, 216, 218–21
Manning Brothers Historical Collection 42 top, 154 bottom, 156
The Mariner's Museum 34
Anthony Murray 70 bottom, 72
Museum of the City of New York 46 bottom
Museum of Science and Industry, 172,
Museum of Science and Industry/Chicago Architectural Photographing Company 175–76
Niagara Falls Public Library, Niagara Falls, Ontario, Canada 56, 58 top, 59
Shaun O'Boyle (www.oboylephoto.com) 35–37
Ray Reilley 110
Walter P. Reuther Library, Wayne State University 40
Rhinebeck Historical Society, Rhinebeck, NY 132
Elise Robinson 96, 99
Utah State Historical Society, All Rights Reserved 188, 190–93
Gerry Weinstein 32